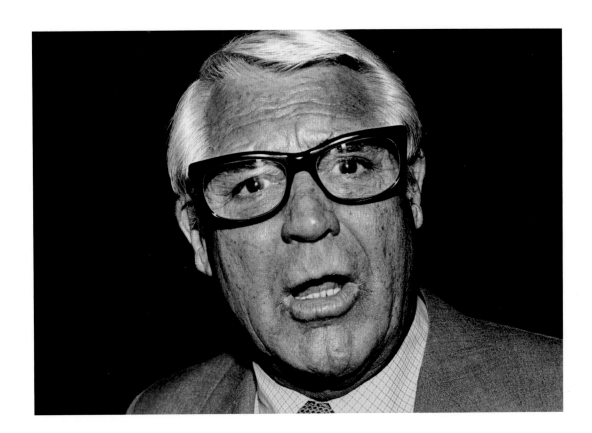

Beverly Hills
WOOD & OTHER PERVERSITIES

POP CULTURE OF THE 1970s AND 1980s

PHOTOGRAPHS BY GEORGE ROSE

TEN SPEED PRESS
Berkeley | Toronto

Ten Speed Press
PO Box 7123
Berkeley, California 94707
www.tenspeed.com

Distributed in Australia by Simon and Schuster Australia, in
Canada by Ten Speed Press Canada, in New Zealand by
Southern Publishers Group, in South Africa by Real Books,
and in the United Kingdom and Europe by Publishers Group UK.

Book design by Jennifer Barry Design, Fairfax, CA
Layout production by Kristen Hall
Photo on page 6 by Larry Armstrong, used with permission.

Page 1: Cary Grant, Beverly Hills, 1980
Pages 2–3: Hollywood Sign, Hollywood Hills, 1983

Library of Congress Cataloging-in-Publication Data
Rose, George, 1952–
 Hollywood, Beverly Hills, & other perversities : pop culture of
 the 1970s and 1980s / George Rose.
 p. cm.
 Summary: "A collection of black-and-white photographs portraying
celebrity culture in the 1970s and 1980s, mostly in Los Angeles, taken
by an award-winning photojournalist"—Provided by publisher.
 ISBN-13: 978-1-58008-924-1
 ISBN-10: 1-58008-924-0
 1. Celebrities—California—Los Angeles—Portraits. 2. Portrait
photography—California—Los Angeles. 3. Rose, George, 1952–
I. Title. II. Title: Hollywood, Beverly Hills, and other perversities.
 TR681.F3R677 2008
 779′.20979494—dc22
 2008000673
Printed in Singapore
First printing, 2008

1 2 3 4 5 6 7 8 9 10 — 12 11 10 09 08

CONTENTS

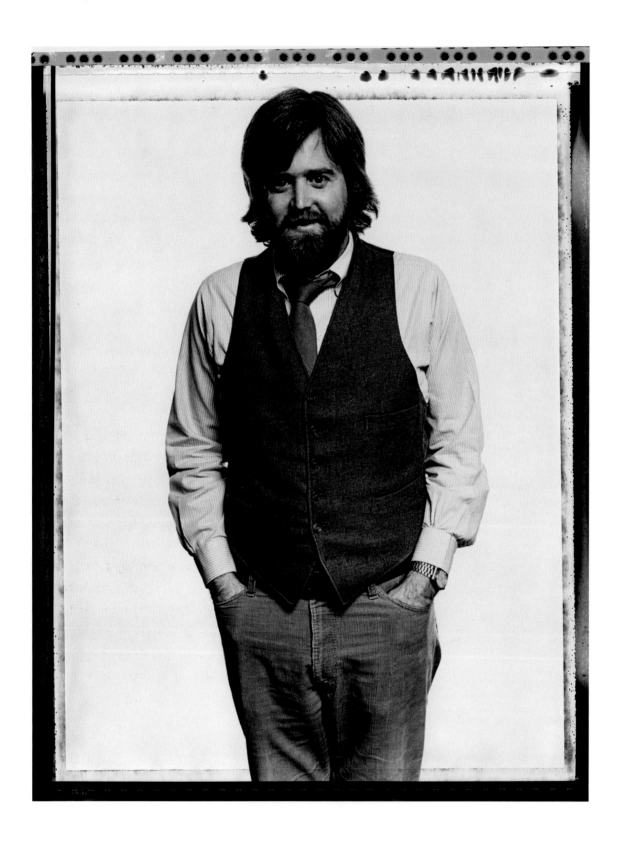

George Rose, Los Angeles, 1980

WHEN I STARTED WRITING for the *Los Angeles Times*, the best advice

I received from my elders about how to get my stories on the front of the Calendar section had nothing to do with anything they teach in journalism school. "If you want to get good play," I was told, "make sure George Rose takes the photo."

On staff at the *Times* from 1977 through 1983, Rose was the go-to photographer for capturing the raucous edges of punk rock and showbiz culture that made Los Angeles a melting pot for nearly every new permutation of pop culture in America. Traveling light—he rarely used any lighting besides an on-camera strobe—Rose became the master of what he called "the five-minute portrait shot."

Blessed with an uncanny instinct for being in the right place at the right time, Rose was always where the action was, as if you'd transplanted Weegee from the 1940s-era Bowery to the 1980s-era Sunset Strip. As this gallery of photos attests, whether Rose was in a tiny room at the Chateau Marmont or at the edge of the stage at a sold-out show at the Forum, he could always capture a revealing or unguarded moment, be it a playful grin from Richard Pryor, a brooding stare from Robert Redford, or a lascivious pose from Queen's Freddy Mercury. Thousands of photographers cover the Academy Awards every year, but it was Rose who captured Dustin Hoffman backstage, slyly holding his Oscar in front of a giant Oscar statuette—at groin level—giving the illusion that the statue had grown a glorious golden penis.

At the end of the 1970s, Los Angeles was full of tumult, some inspired by the *Raging Bull*–era of the New Hollywood, some sparked by the burgeoning punk scene that swept the local music clubs. When I came to town in 1979, fresh out of college, I was amazed to discover that you could go out every night and never catch up to all of the action, whether it was a mesmerizing new film or a noisy new band headlining one of the dozens of clubs that had sprung up all over town.

There was a raw, infectious energy in the air, inspired by a sense that the cultural world was shifting under our feet. Adventures were to be had—morning, noon, and night. I remember tumbling out of the Hong Kong Cafe, a popular punk club in Chinatown, half deaf from the loud music, and walking straight into a local gang fight, actually seeing a knife glint in the light of the moon. Flashes of danger were followed by moments of enchantment. After a long evening at the Whisky a Go Go, I went home with one of the waitresses, only to suddenly stop the car as we wound up into the Hollywood Hills, startled by the sight of the glorious art-deco apartment Elliot Gould inhabited in *The Long Goodbye*. You couldn't even have a midnight tryst without being bedazzled by the sight of a striking location from a Robert Altman film.

In the same way that Rose learned to be quick on his feet as a photographer, I learned to go with the flow as a reporter. Arriving for an interview with Harry Dean Stanton at his house one morning, I found him in his bathrobe on the roof, communing with spirits only he could see. Inside,

the house was full of empty bottles and debris from a party that had clearly only ended a short time before. In the kitchen was Stanton's pal Jack Nicholson, still going strong, making coffee with a couple of remaining revelers.

Wherever I went, I'd bump into Rose, who'd do almost anything to get a photo, whether it meant braving the mosh pits at punk clubs or hanging out of a hotel window. His best work is all here, from a Bible-toting Little Richard to John Travolta with a spit curl to a moody portrait of X punk queen Exene Cervenka. We also see Phil Alvin of the Blasters, backstage at the Whisky a Go Go, in the midst of a mad rockabilly holler that seems so timeless it could just as easily be Jerry Lee Lewis at Sun Records in 1957.

Rose never knew how much time he'd have, so he learned not to dawdle. His introspective portrait of Susan Sontag, her eyes blazing and black, was made in two minutes flat. "I could've spent hours with her," he says. "But I was looking for one moment, one expression, not twenty. I was cocky enough to think I could get into a room, put the subject in the situation I wanted, and get the definitive photo in five minutes or less. Sometimes I'd visualize what I wanted, to achieve before it happened. I'd see the light, I'd say, 'I want you to stand here' and, bing-bang, I'd get the shot."

Rose was at his best working with Robert Hilburn, the *Times*' longtime music critic, who took Rose on a host of assignments. In the office, they were full of mischievous banter, like a pair of old vaudeville comics. But Hilburn admits it took a while to find the right equilibrium for their working relationship.

"With George, you didn't just have a photographer, you had a partner, and we sometimes clashed," Hilburn recalls. "I knew what the story was and I'd say to George, 'Take this shot,' because I thought it would fit the story. But George was only interested in the great photo. We'd get into arguments, but he had a process and you had to respect it. He had a game plan, which was always to get the best picture."

Hilburn came to appreciate that under Rose's affable exterior lurked a deep reservoir of artistic ambition. "George was the first photographer I was around who wouldn't let the paper or the reporter set his agenda. No one else had his seriousness or sense of purpose. He was always pushing to get more."

Rose came to the *Times* when newspapers were still in their glory days. He never wore a tie and never went to bed until long after midnight. "A lot of the older guys took me under their wing by teaching me how to drink," Rose recalls. "Starting at around 4 p.m., we'd begin with screwdrivers in the back darkroom." At night, the guys would often meet up at Dan Tana's, a popular hangout for musicians almost next door to the Troubadour. "You'd walk in and see someone like Bruce Springsteen right across the room," says Rose. "After I'd finish an assignment, I'd show up there at midnight for dinner."

The *Times* had a great reach. A lead story in the Sunday Calendar was a publicist's dream. But when it came to visual arts, the newspaper was something of a stodgy institution. Despite being at the height of its economic power—during Rose's day it had sixty-five photographers on staff—the *Times* saw photography as a news medium, not an artistic one. Many of the wonderful photos in this collection—the one of Sontag, the one of Hoffman with his Oscar—never made it into the newspaper. Nor did a waggish photo Rose took of David Lee Roth in concert, his crotch apparently crammed with Kleenex, which makes him look like a campy Cowardly Lion in a road-show production of *The Wizard of Oz*.

"The paper made an effort to collect the news, but it often didn't run it," says Rose. "This was pre–*USA Today*, old-school journalism, where the paper was oriented to the stories, not the art. A lot of the best stuff just went into the files."

The photos that did run sometimes ruffled a few feathers. Rose took a series of pictures of Mary Tyler Moore in 1979, then at the peak of her career. The one that ran in the paper showed every wrinkle in her face, not to embarrass her, Rose insists, only because the ink from the printing process blotted on every line in her face.

"She went on *The Tonight Show* the night after the photo ran and complained that this photographer from the *Times* had tried to make her look bad," Rose recalls. "But it was simply the paper's printing process, which was our Achilles' heel in those days. I've never been one to make a fool out of people. That's not my style."

How times have changed. Today the best way to sell a picture is by snapping a starlet getting out of a limo without any panties on. Rose's photos take us behind the celebrity facade, but with a sense of grace that's out of fashion in today's brazen era of paparazzi stalkers. "I always wanted to blend into the scenery, to not call attention to myself," he recalls. "I liked to hang back in the shadows and shoot my pictures."

It's telling that perhaps the best example of Rose's canny instincts as a photographer isn't represented by a celebrity photo, but by his coverage of the 1978 Malibu fire, a conflagration fueled by Santa Ana winds that destroyed hundreds of homes in its path. The next day, the front page of the *Times* led with one of Rose's dramatic photographs, which he managed to get to the paper by deadline by having a helicopter land on Will Rogers State Beach to pick the film up.

Rose braved smoke and flames to get the best shots of the fire. But his real inspiration, as with so many of his showbiz photographs, was about being in the right place at the right time. Most photographers would have raced up into the canyons, where the winds were blowing the hardest. But Rose headed up the Pacific Coast Highway and got into position near the beach. He somehow knew what every good firefighter in Los Angeles knows—when the Santa Anas are blowing, the fire always goes to the ocean.

Rose trusted his instincts. He let the fire come to him.

— *Patrick Goldstein*

WORKING THE HOLLYWOOD NIGHT SHIFT

IT'S HARD TO BELIEVE that I consciously threw a perfectly successful and exciting Hollywood photography career out the window. This irrational decision was due to an idealistic notion that there was more to life than vicariously channeling some drugged-out pop star or over-the-hill movie queen's every moment through a lens darkly.

Although it's all a little blurry now, my fellow journalistic colleagues will attest that I burned a wide swath along the streets of Hollywood and Beverly Hills. I have the pictures and the memories chemically etched on Kodak film in case anyone would like to see the evidence.

For seven magnificent years, I lived a life clearly not my own. By virtue of the power of the press, this young, naive news photographer was plopped squarely onto the sandy beach of America's cultural wasteland. The experience would change me profoundly, imprinting my memory with everlasting images made in a prolific time of my life. These were intensely creative years filled with dancing, prancing, and posing characters, all memorialized in places few people with cameras were ever allowed to enter.

Nearly every person alive today has been touched by the cinematic words and visions of the creative hacks portraying a Hollywood version of life on the beaches in Malibu and the lifestyles of the rich and famous who reside in the villages of Beverly Hills, Toluca Lake, Bel-Air, and Culver City. So while the money to pay for all this creativity is generated by East Coast power brokers, the people with most of the ideas are still holed up somewhere on the left coast of California, sipping margaritas and experiencing golden sunsets from the patio at Malibu's Moonshadows restaurant.

There was an influential power to Bob Seger's "Hollywood Nights" raging full tilt on my Porsche's stereo, as I gently eased off the accelerator on my many trips down La Cienega Boulevard from Sunset Boulevard. Whether I was headed for an assignment or in search of a good party, it seemed that I always had to cross La Cienega and Sunset. And though I once fancied that Don Henley's hypnotic "Boys of Summer" was about me, I now understand that it really was a statement about the superficiality of Southern California.

The exhilarating, fast-paced life of a news photographer set loose upon the City of Angels was pretty heady stuff for a wide-eyed twenty-three-year-old. Los Angeles, after all, was in the throes of an artistic rebirth. What better place to reinvent oneself than in one of the world's great cultural epicenters. Though I grew up a mere thirty miles east, Hollywood was worlds away from my suburban, middle-class upbringing. Here, I was allowed to take my place alongside a budding array of painters, musicians, actors, architects, poets, and writers.

From about 1976 until 1984, Southern California was experiencing an artistic witching hour of sorts. There was a confluence of new rock-and-roll acts like Tom Petty, X, the Motels, and Fear, all polishing their performances on the west Hollywood club circuit. The maturing television industry was flexing its global muscles while pumping out formulaic pap. And there was an extremely powerful film industry dominated by the likes of Coppola, Cimino, Spielberg, Beatty, and Nicholson. This new, exciting wave in Hollywood would ensconce itself as the epitome of cultural high- and low-brow entertainment that continues to be the scorn of today's terrorists and political leaders.

Call it youthful exuberance or just plain naïveté. I truly believed I was undertaking important documentary work. In fact, I distinctly recall having a heated conversation with a similarly idealistic photographer who seemed shocked that I could focus all my energy on something so clearly "outside the bounds of journalistic integrity."

Nevertheless, I believed that the work I was doing was every bit as important as anything Dorothea Lange, W. Eugene Smith, or Margaret Bourke-White had to say about the state of humanity. The only difference was that they placed a mirror up to reality, while I was living and photographing a somewhat fictitious world inhabited by real people. But after all, isn't that the essence of Hollywood— creating a romanticized and altered state of reality?

As the years passed, I came to realize how the work was transforming me as a person. After seven years of living and working in Hollywood and Beverly Hills, I was worn out and ready for a break. Waking up every day just to help keep the Hollywood publicity machine rolling had finally taken a toll on me.

Beckoning was a dream of publishing my own newspaper in northern California, a decision that, by accident, led to a long and fruitful career in the wine business. Call it the wisdom of maturity, but I felt there was something more meaningful I could do with my talent and life. Owning my own newspaper gave me more control over the way subjects were chosen, how the news was gathered, and how reality was presented.

At the tender age of thirty, I walked away from celebrity photography and one of the most exciting and intense periods in my life. Leaving one life and choosing another actually led to a third career that has been extremely rewarding. The wine business in many ways has its own cast of characters and much drama, not unlike a good Hollywood potboiler. Although I look back on my days in Hollywood with fondness, I certainly have no regrets about the paths I have chosen.

— George Rose

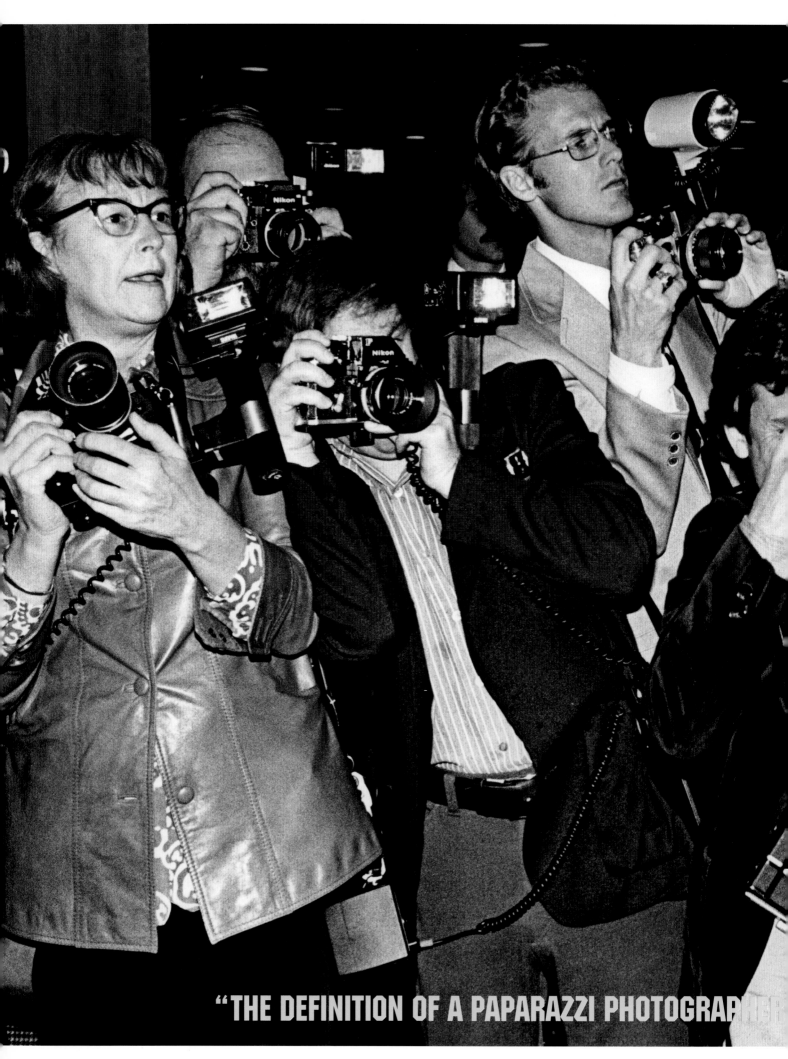

"THE DEFINITION OF A PAPARAZZI PHOTOGRAPHER

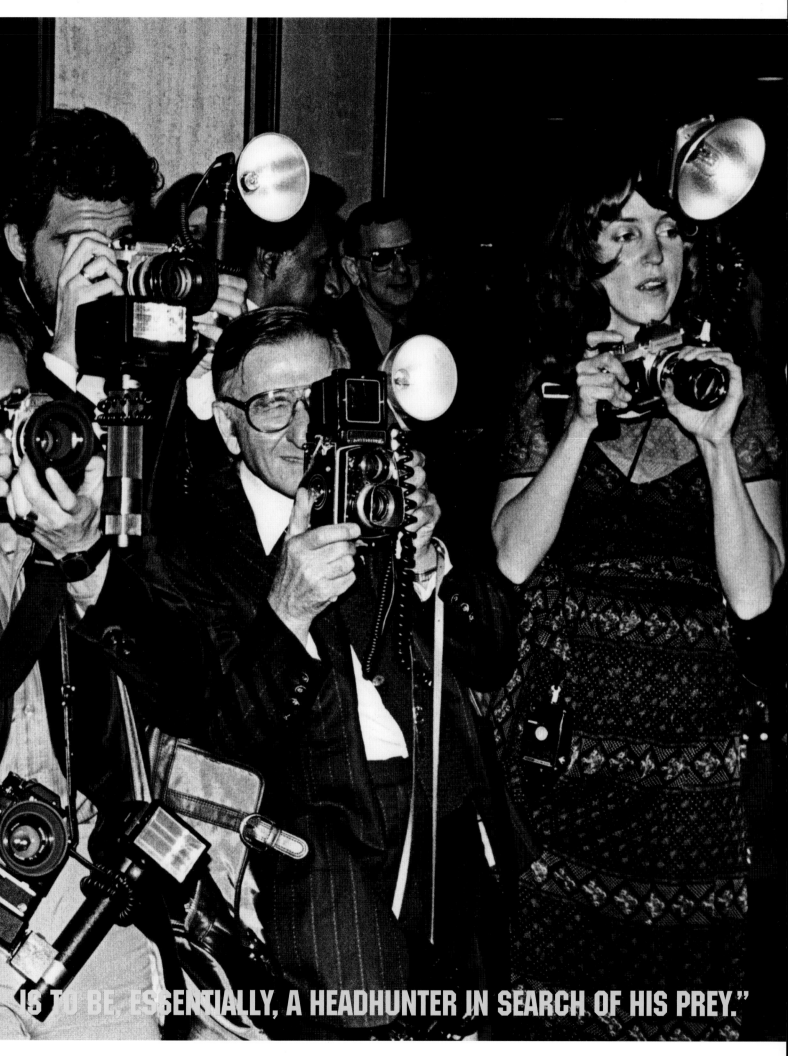

IS TO BE, ESSENTIALLY, A HEADHUNTER IN SEARCH OF HIS PREY."

Hollywood Paparazzi, Hollywood, 1973 13

"ACCESS IS EVERYTHING. CELEBRITIES AND THEIR HANDLERS

INTO THEIR LIVES FOR MUTUAL BENEFIT. BUT IN CELEBRITY

14

GRANT IT TO US, AND WE, AS PHOTOGRAPHERS, ARE ALLOWED

PHOTOJOURANLISM, TRUTH IS USUALLY THE FIRST CASUALTY."

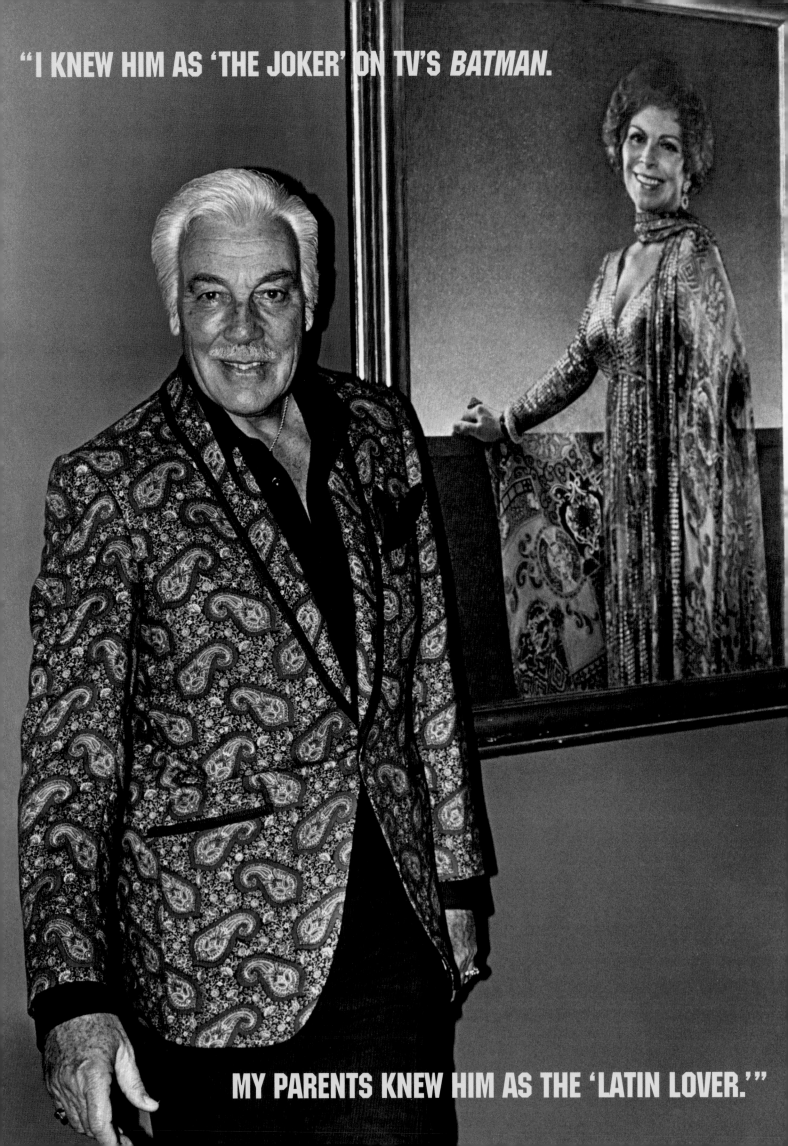

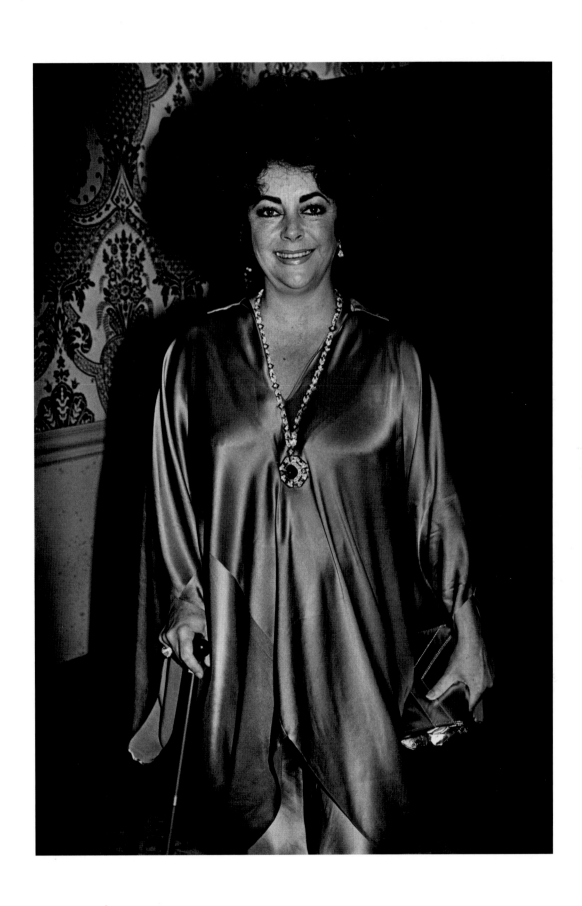

Left: Cesar Romero, Beverly Hills, 1979
Above: Elizabeth Taylor, Beverly Hills, 1979

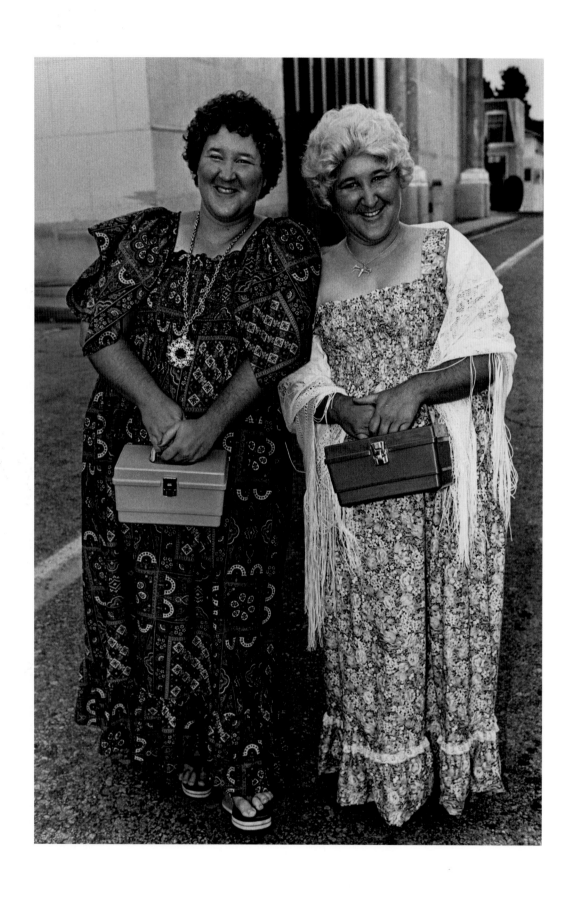

Above: Movie Fans, Hollywood, 1980
Right: Zsa Zsa and Eva Gabor, Los Angeles, 1979

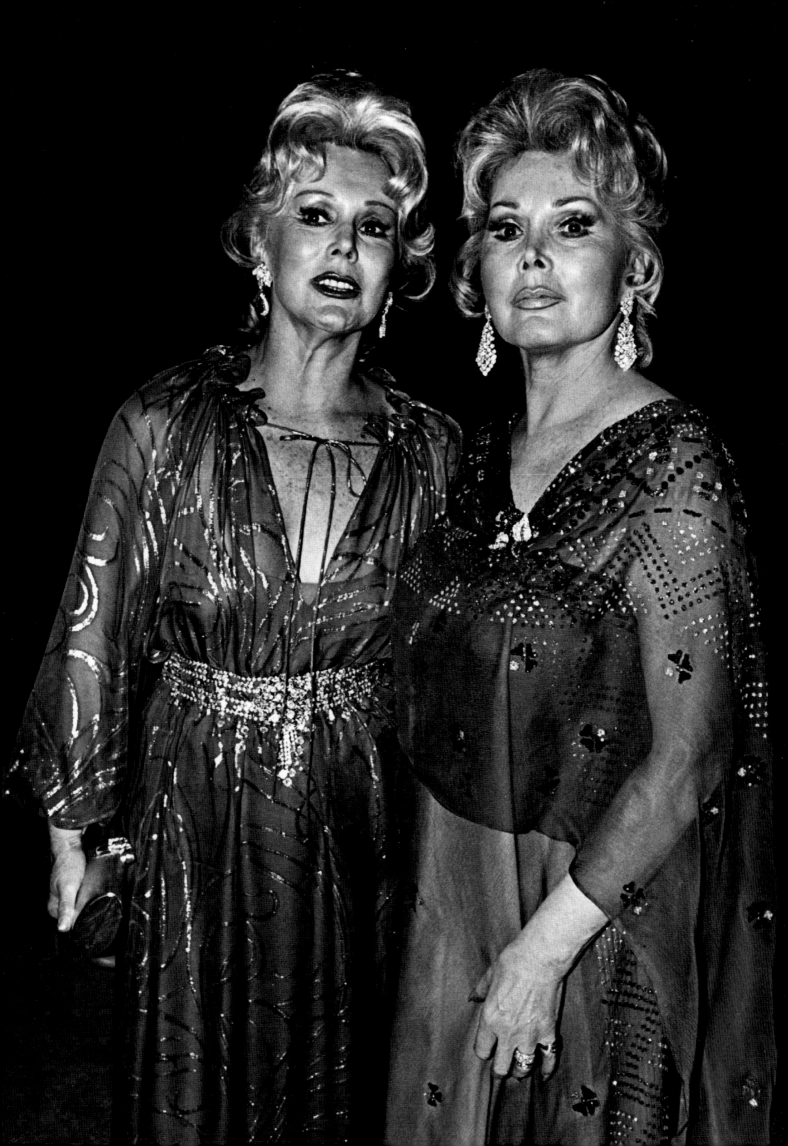

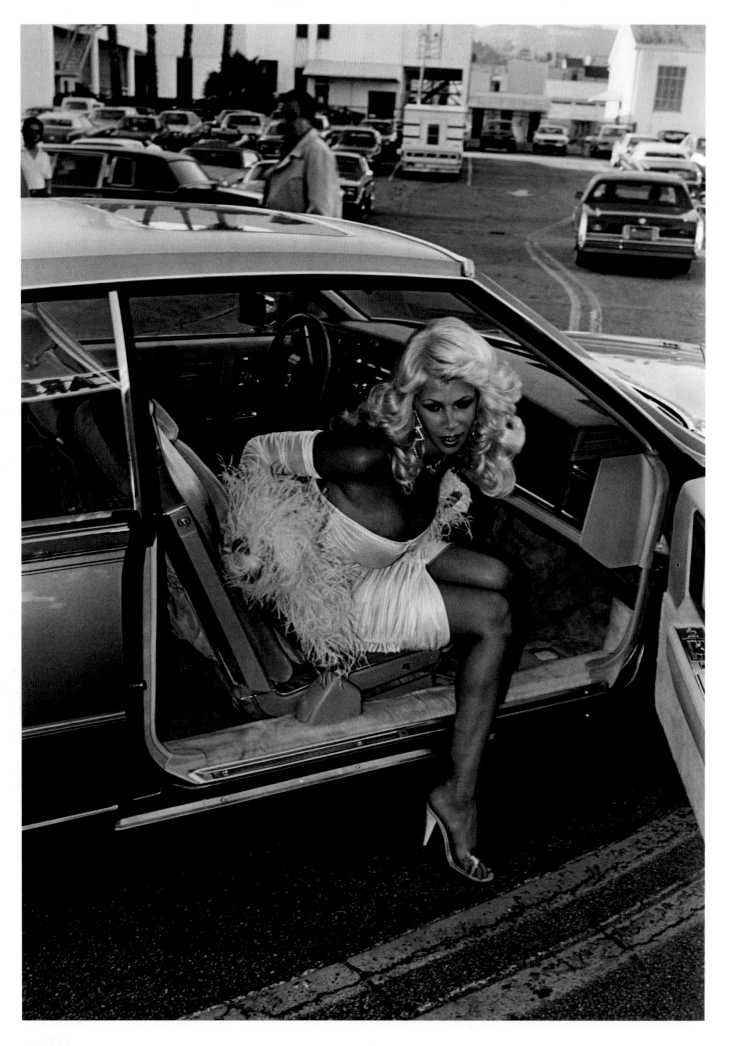

Above: Porn Star Arrives, Hollywood, 1980
Right: Dolly Parton, Universal City, 1981

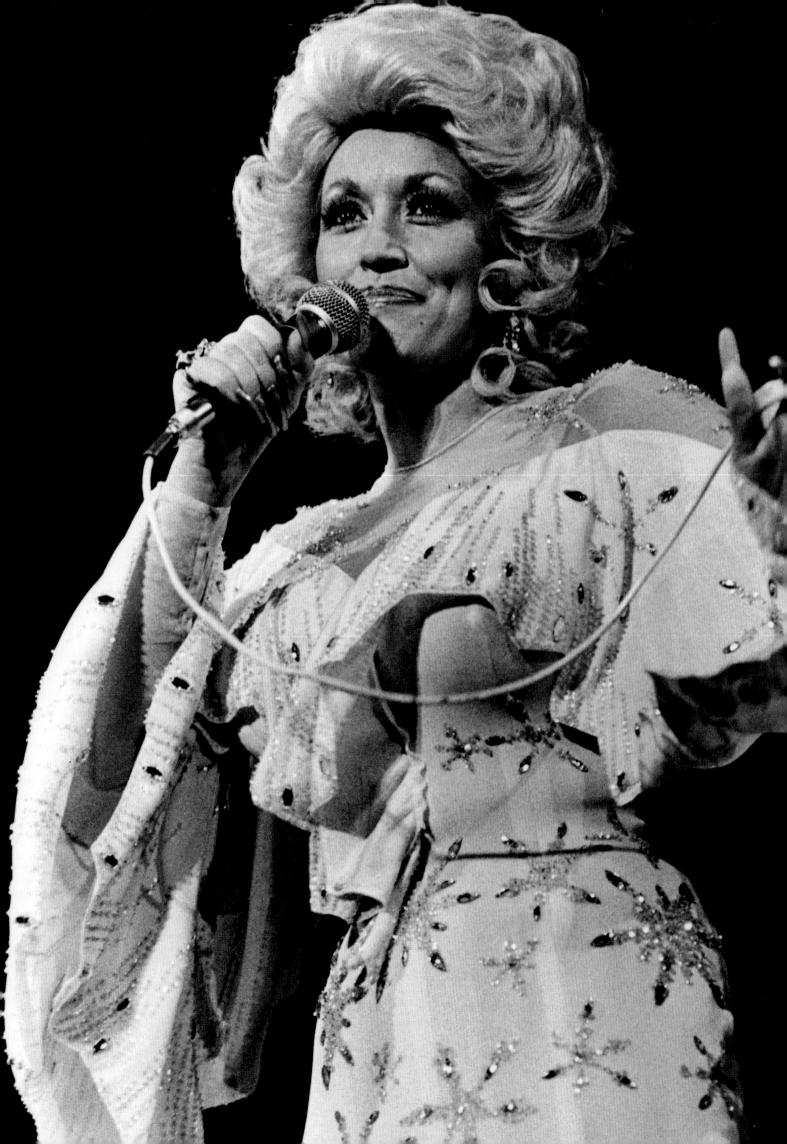

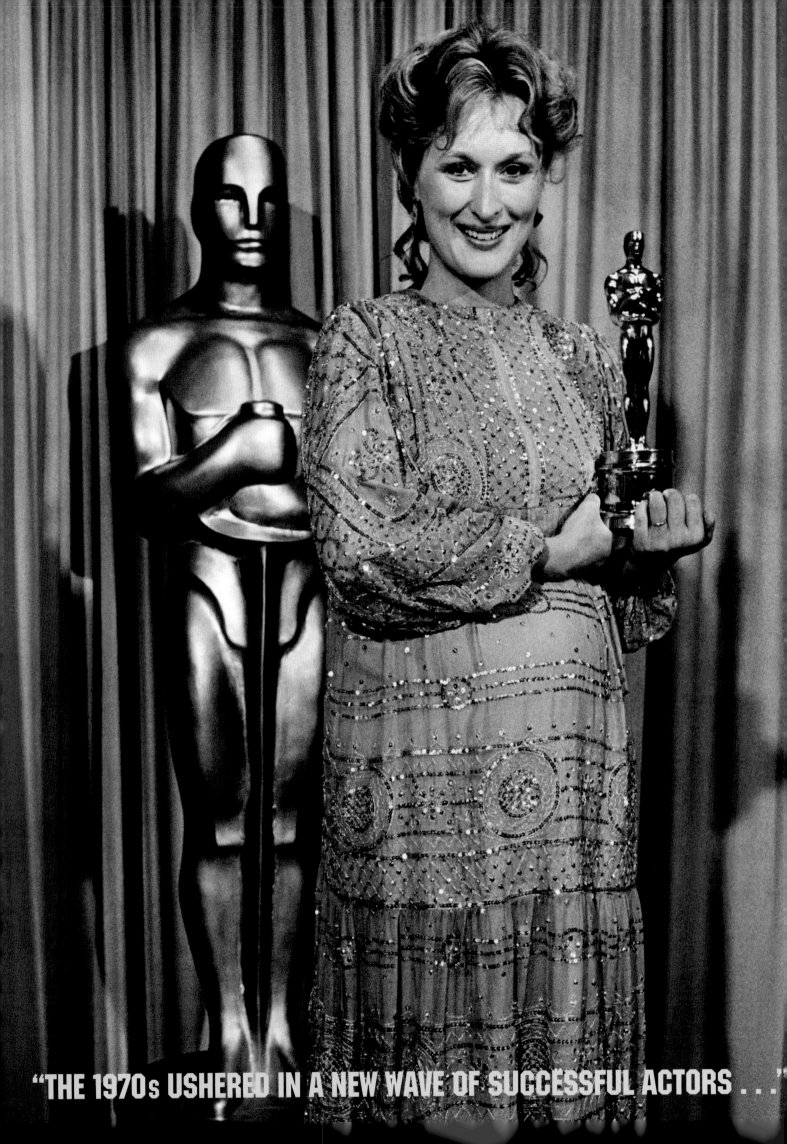

"THE 1970s USHERED IN A NEW WAVE OF SUCCESSFUL ACTORS"

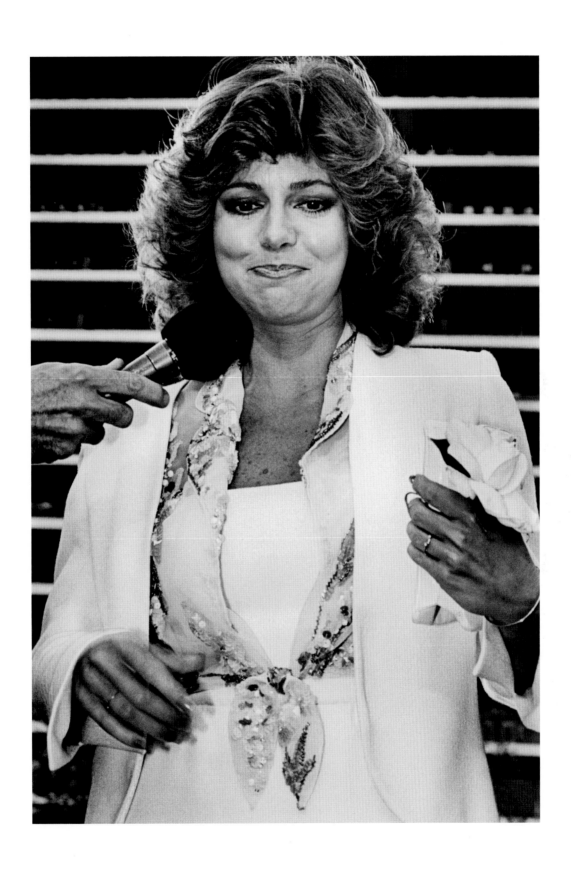

Left: Meryl Streep, Los Angeles, 1983
Above: Sally Field, Los Angeles, 1980

23

"...WHAT SET THEM APART WAS THEIR ABILITY TO TRANSCEND

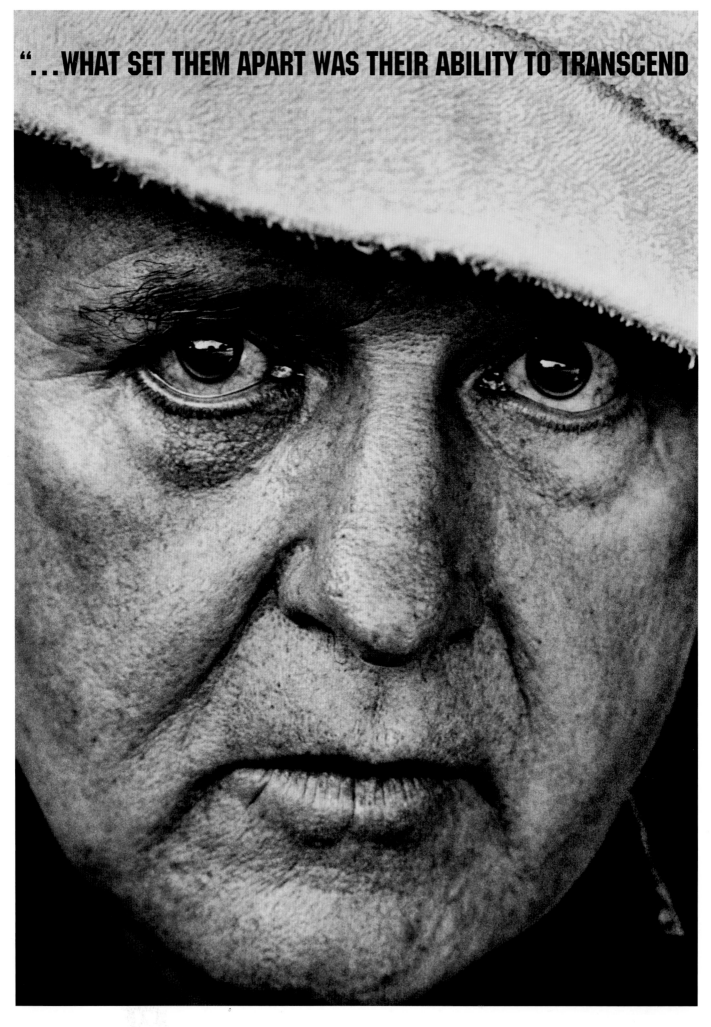

Above: Rod Steiger, Malibu, 1979
Right: Sidney Poitier, Beverly Hills, 1978

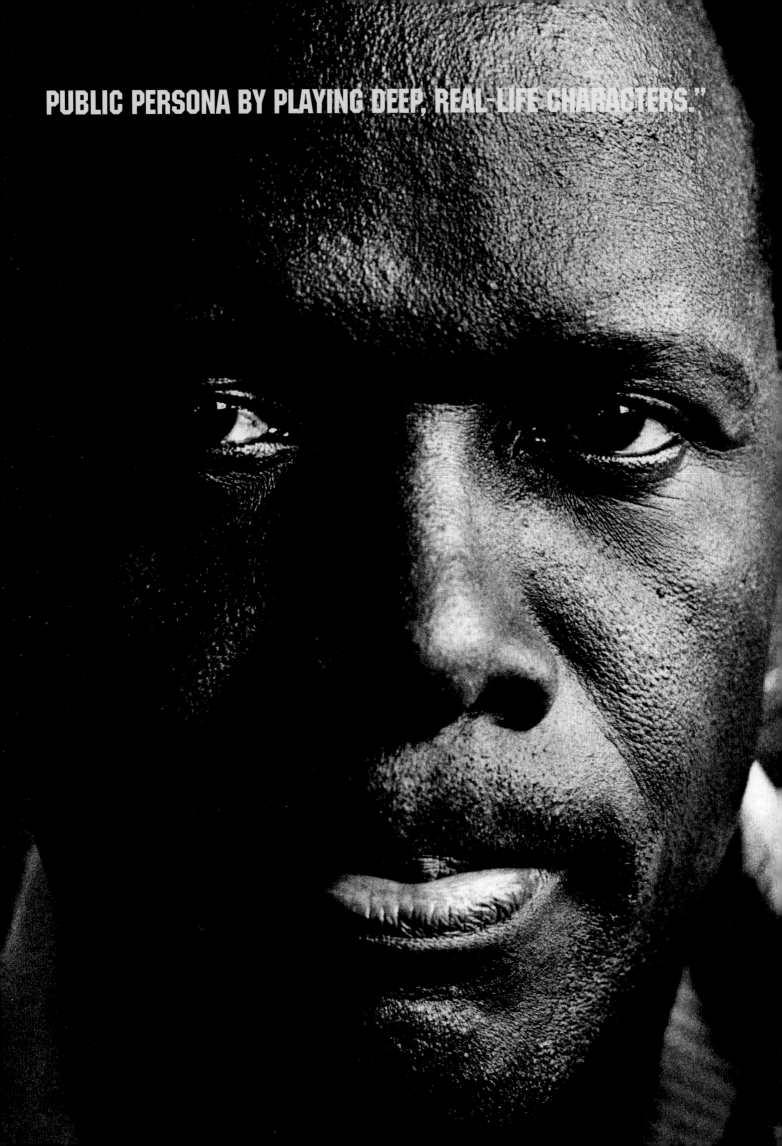

PUBLIC PERSONA BY PLAYING DEEP, REAL-LIFE CHARACTERS."

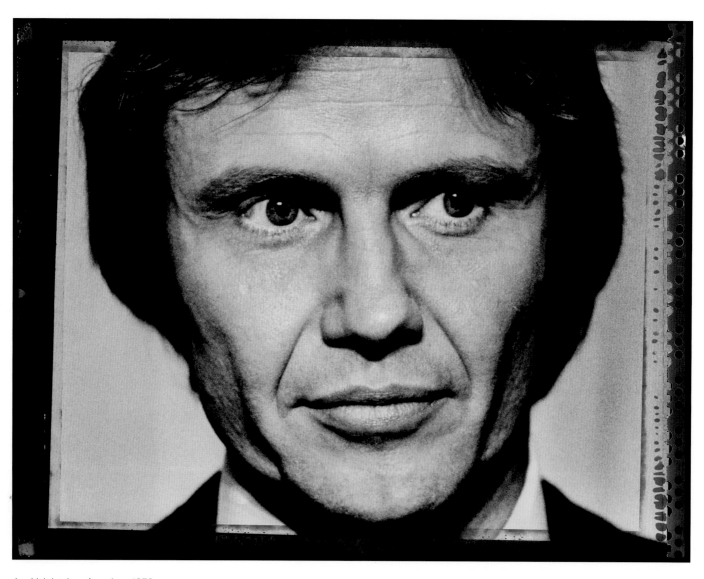

Jon Voight, Los Angeles, 1979

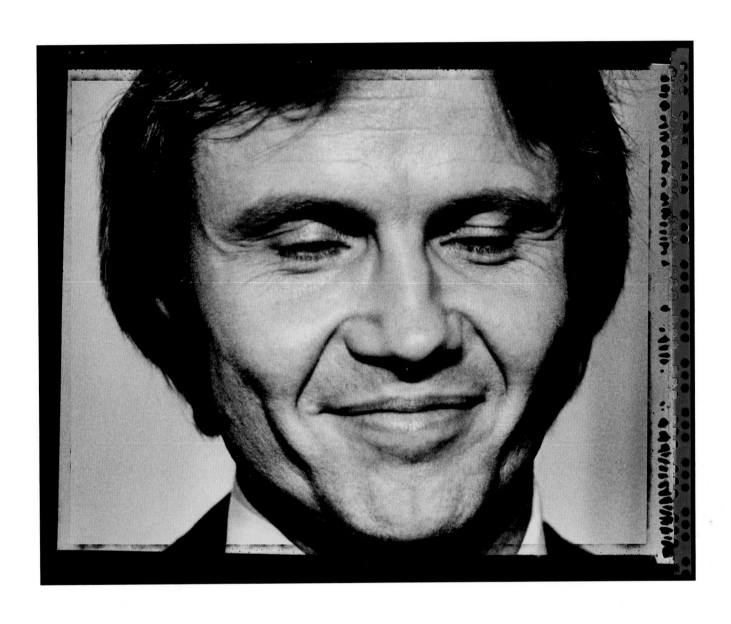

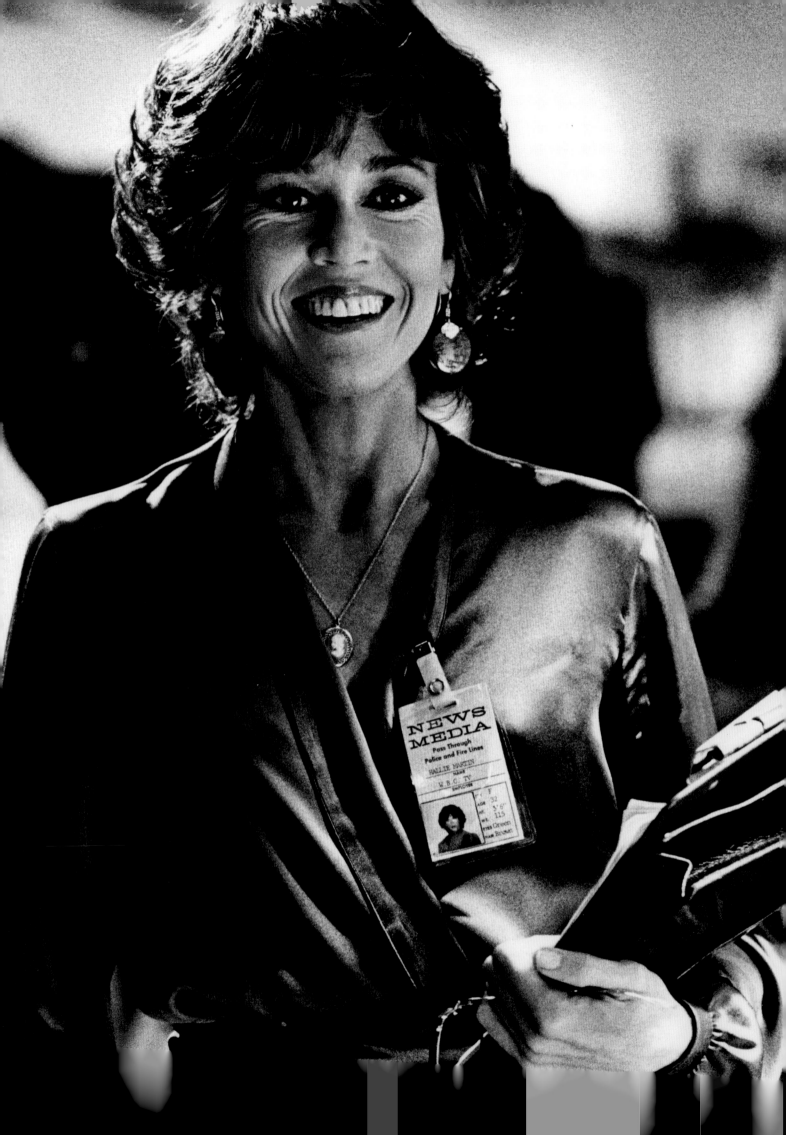

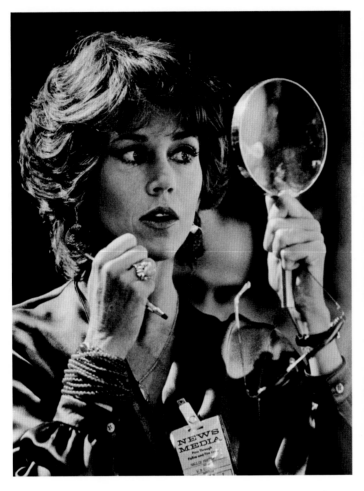
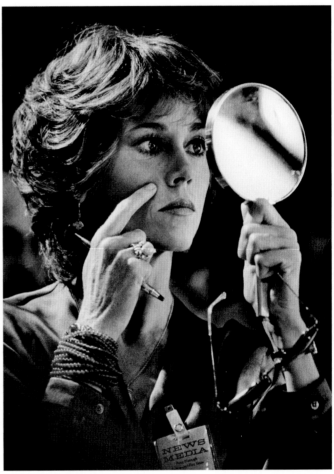

Jane Fonda, Las Vegas, 1978

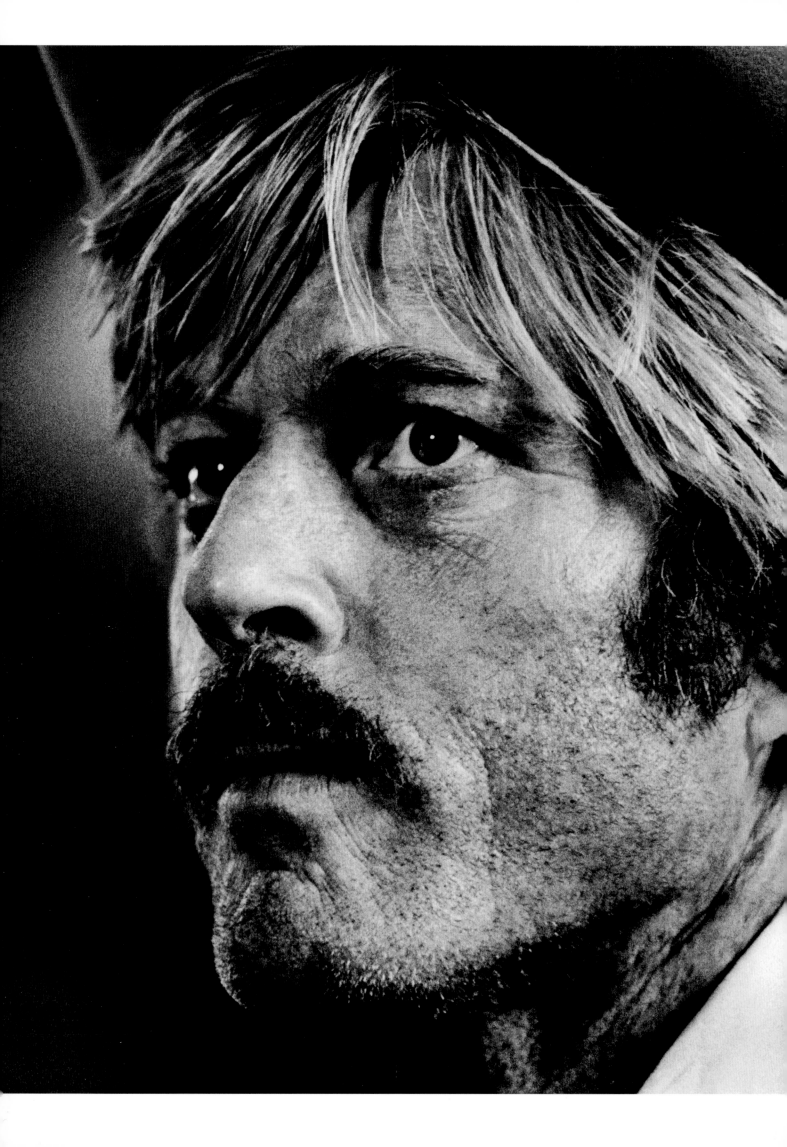

Robert Redford, Las Vegas, 1978 31

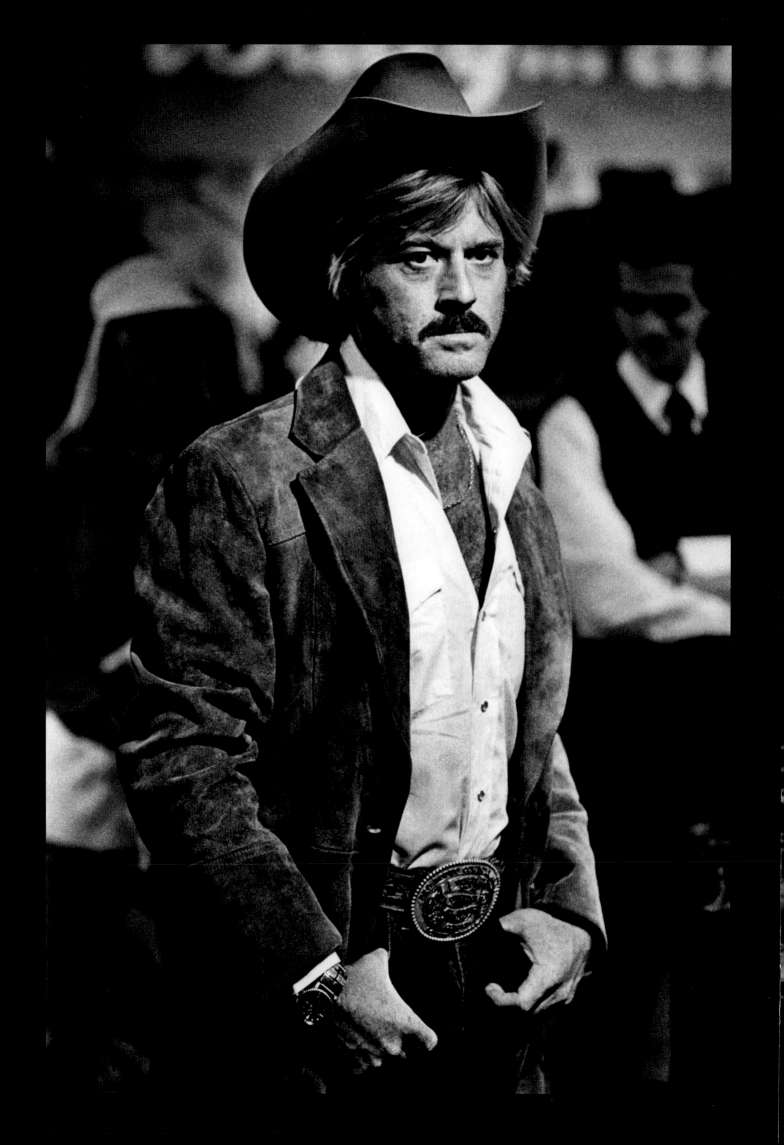

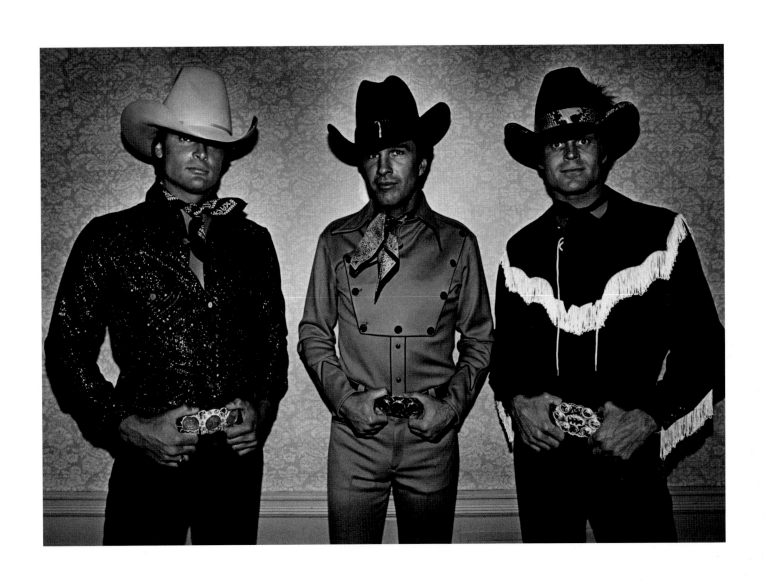

Left: Robert Redford, Las Vegas, 1978
Above: Cowboy Models, Beverly Hills, 1980

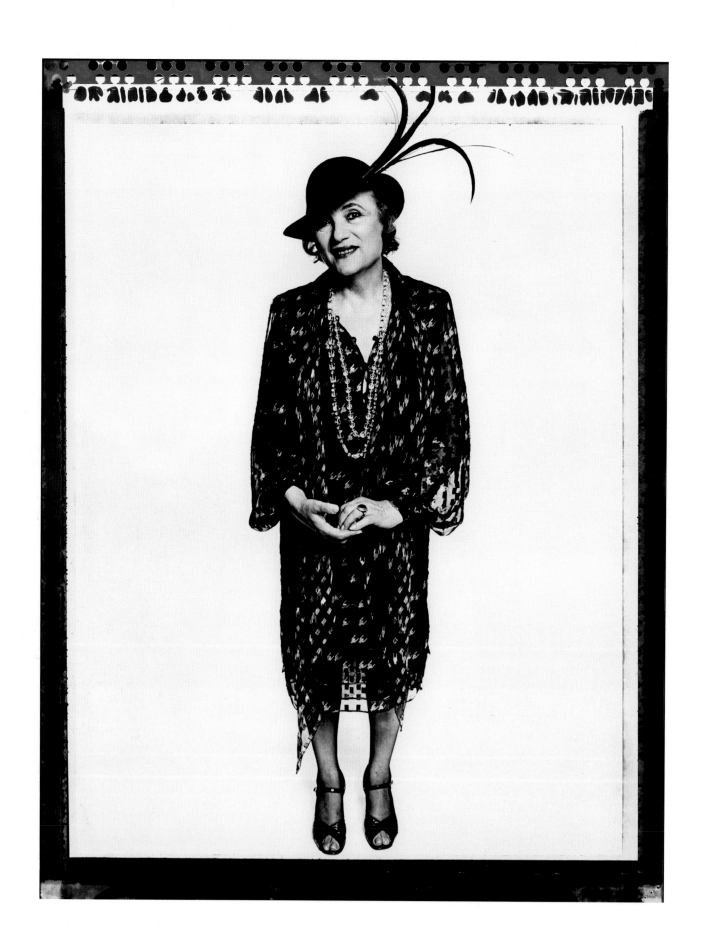

Above: Aida Grey, Beverly Hills, 1980
Right: Malcolm McLaren, West Hollywood, 1981

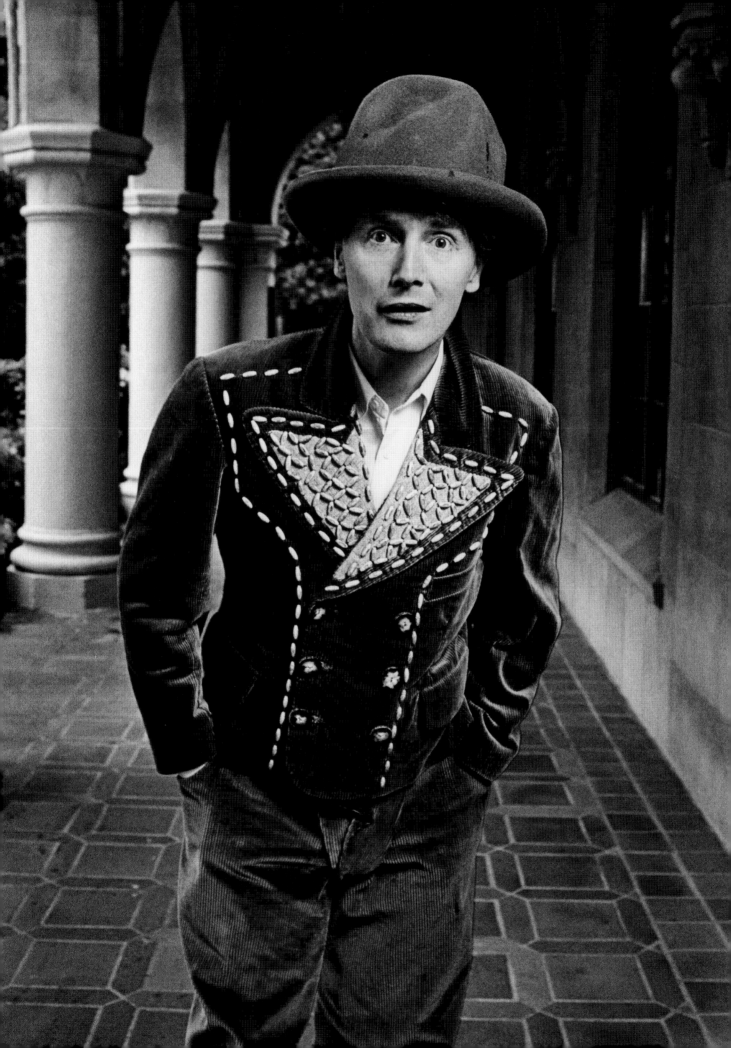

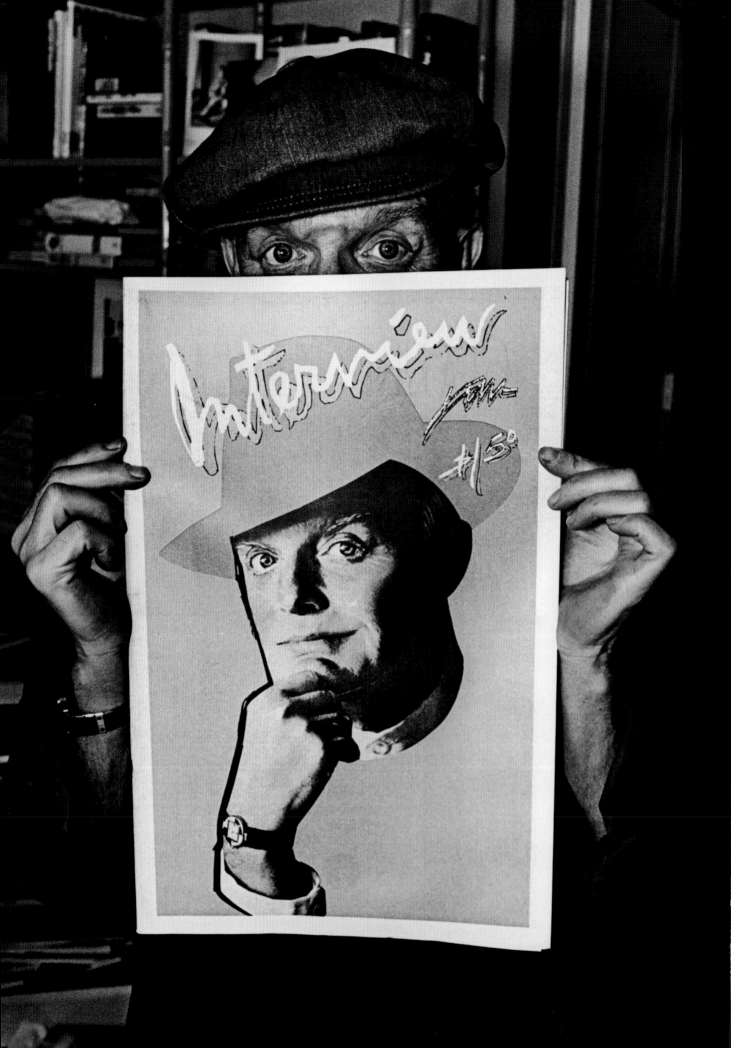

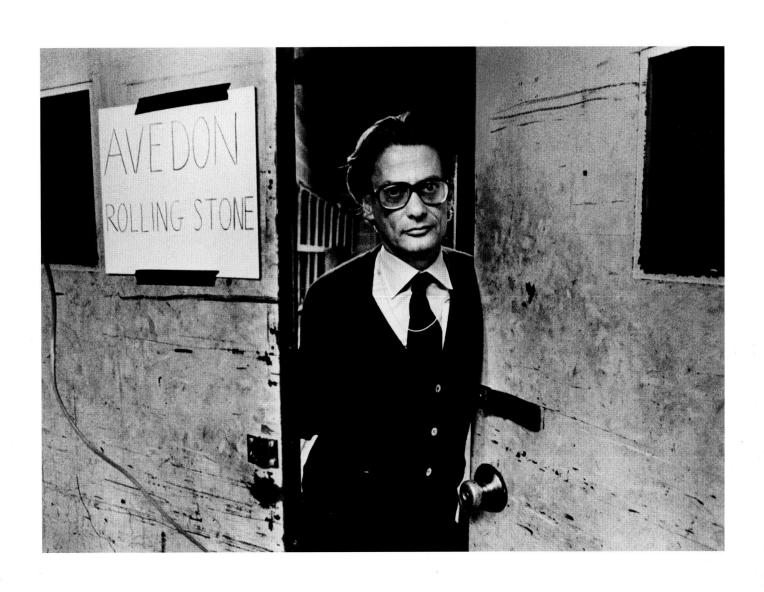

Left: Truman Capote, New York, 1980
Above: Richard Avedon, New York, 1976

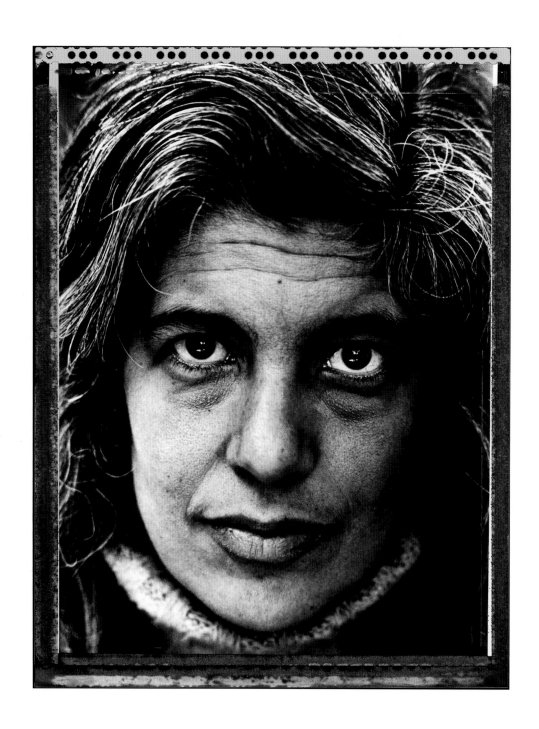

"THE BEVERLY HILLS HOTEL WAS THE MUST-STAY PLACE

Above: Susan Sontag, Beverly Hills, 1979
Right: Pete Hamill, Beverly Hills, 1979

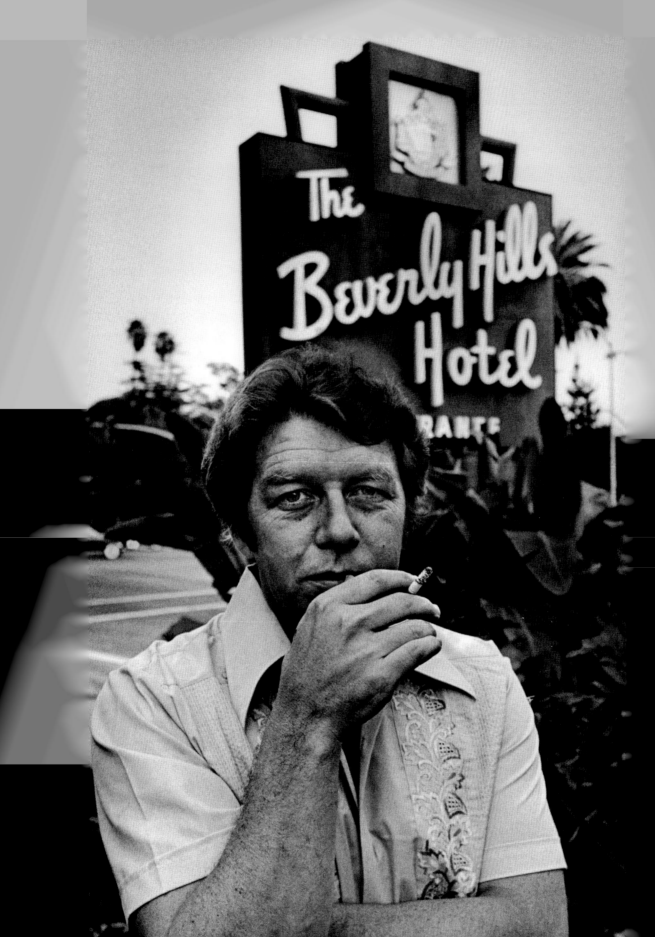

NEW YORK LITERATI WHEN VISITING THE WEST CO

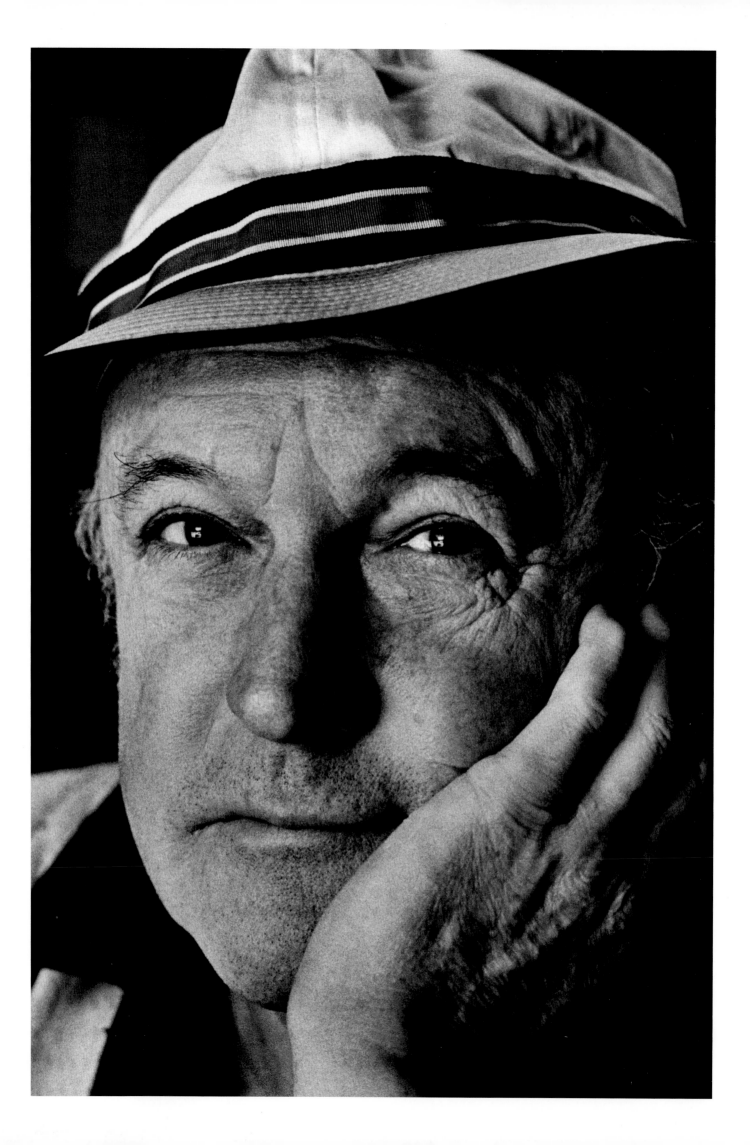

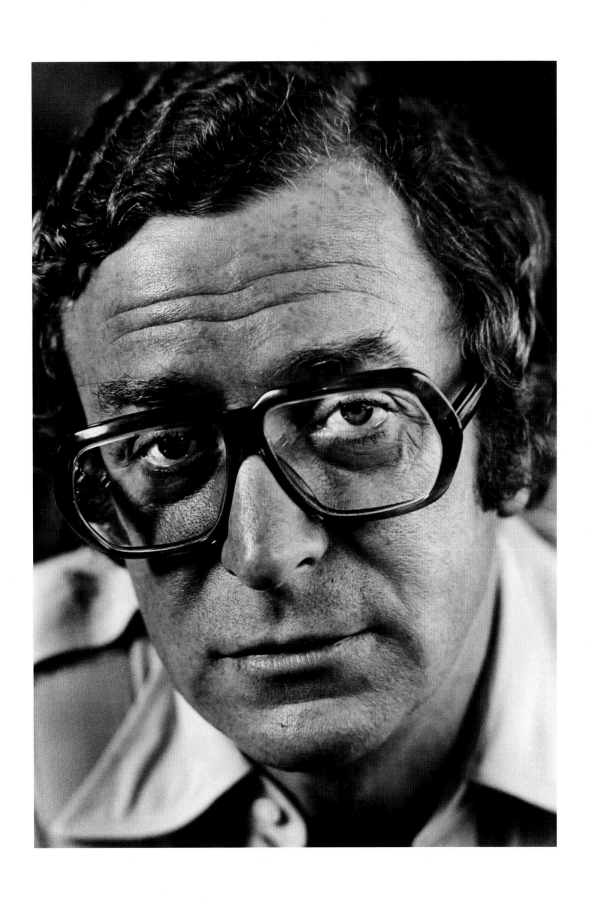

Left: Gene Kelly, Beverly Hills, 1979
Above: Michael Caine, Beverly Hills, 1982

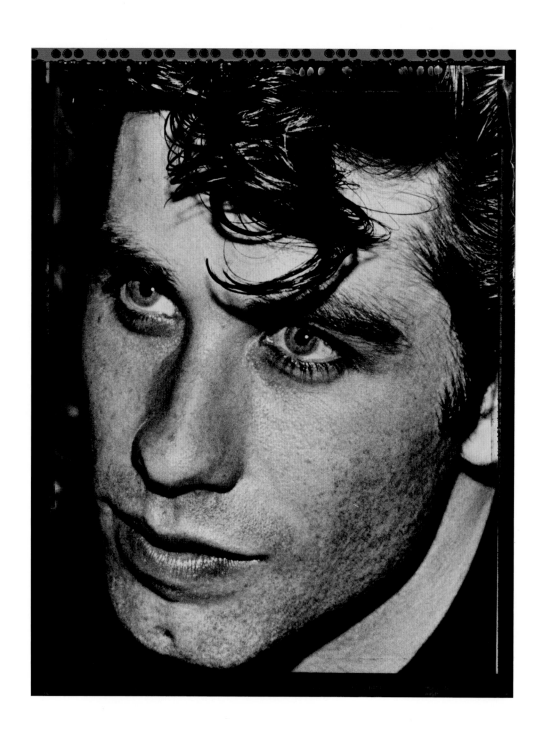

Above: John Travolta, Hollywood, 1978
Right: Deborah Harry, Century City, 1980

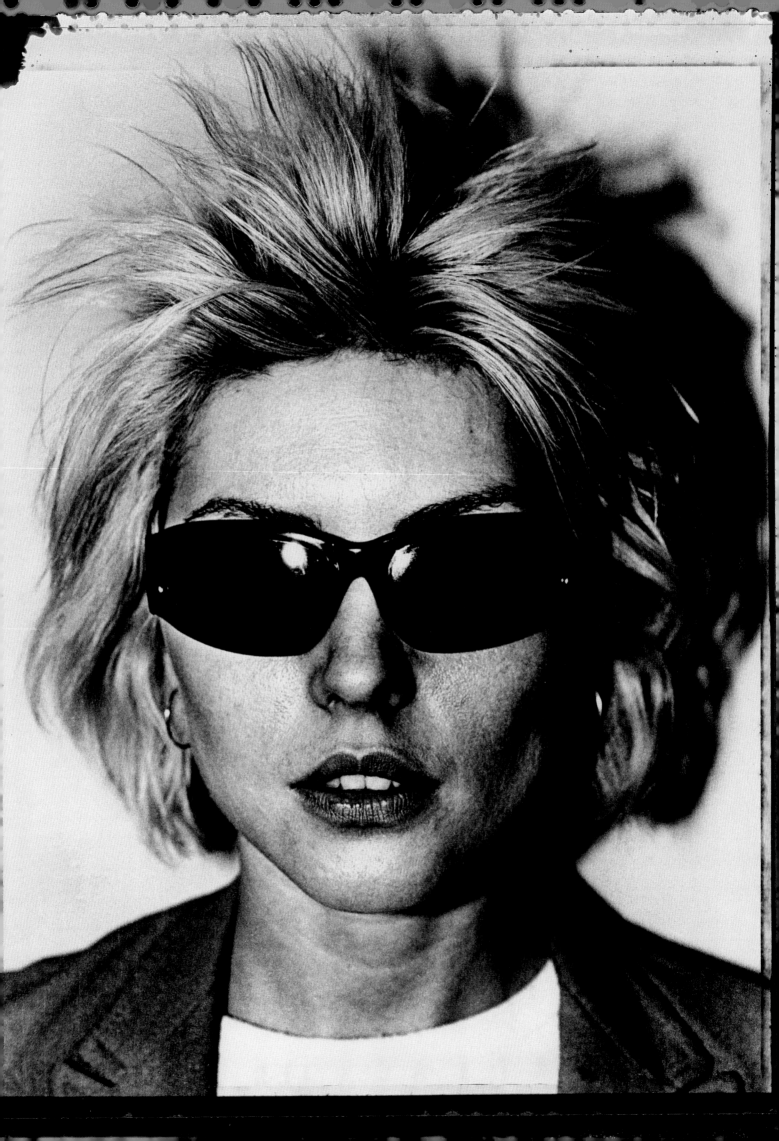

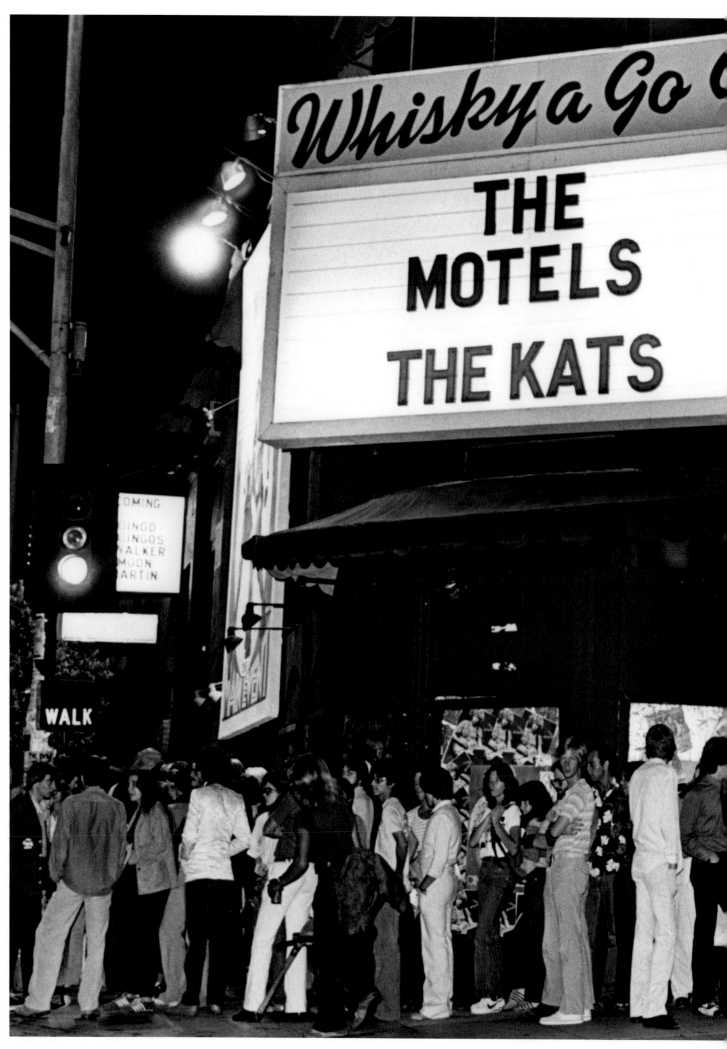

Outside the Whisky a Go Go, West Hollywood, 1979 45

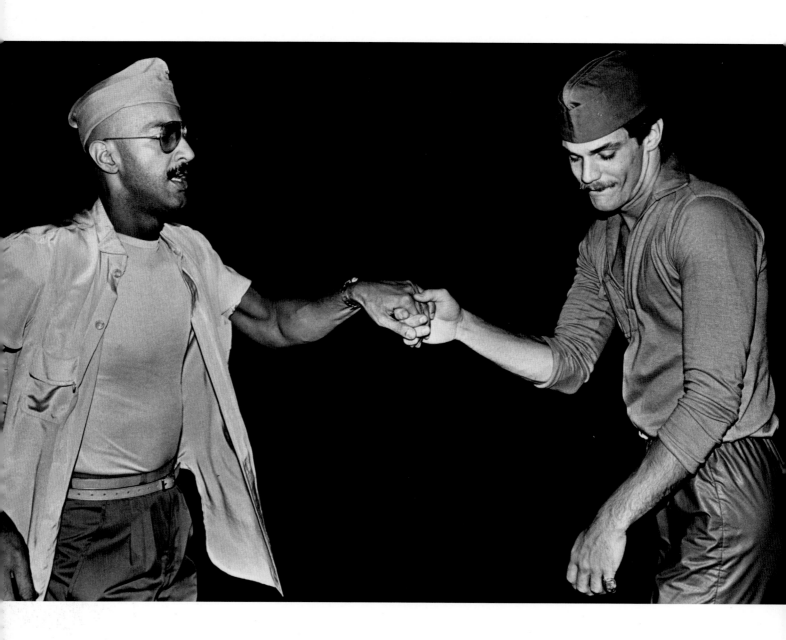

"THE PRE-AIDS WEST HOLLYWOOD PARTY SCENE WAS OPENLY DECADENT

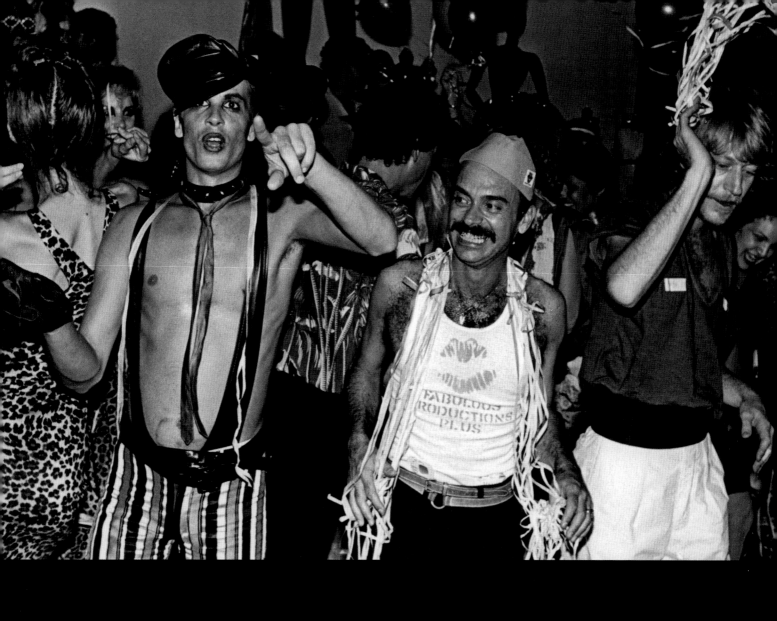

AND EXTREMELY INFLUENTIAL IN ALL ASPECTS OF THE CREATIVE ARTS."

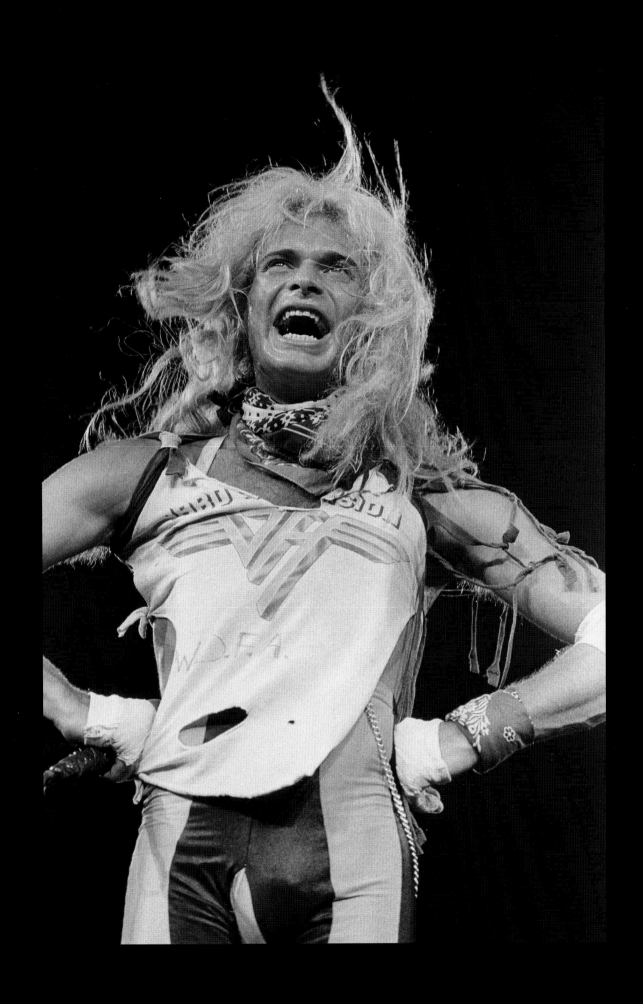

 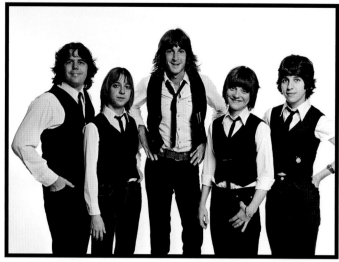

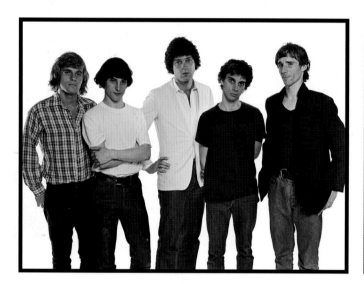 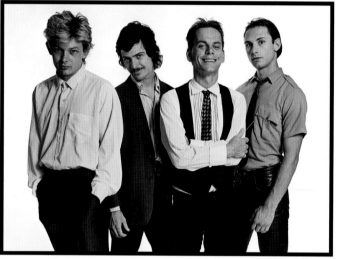

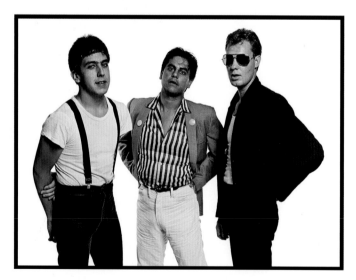 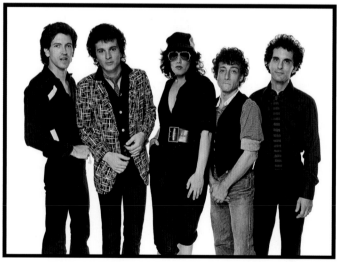

Above: New Los Angeles Bands, Los Angeles, 1980
Right: Exene Cervenka, Los Angeles, 1979

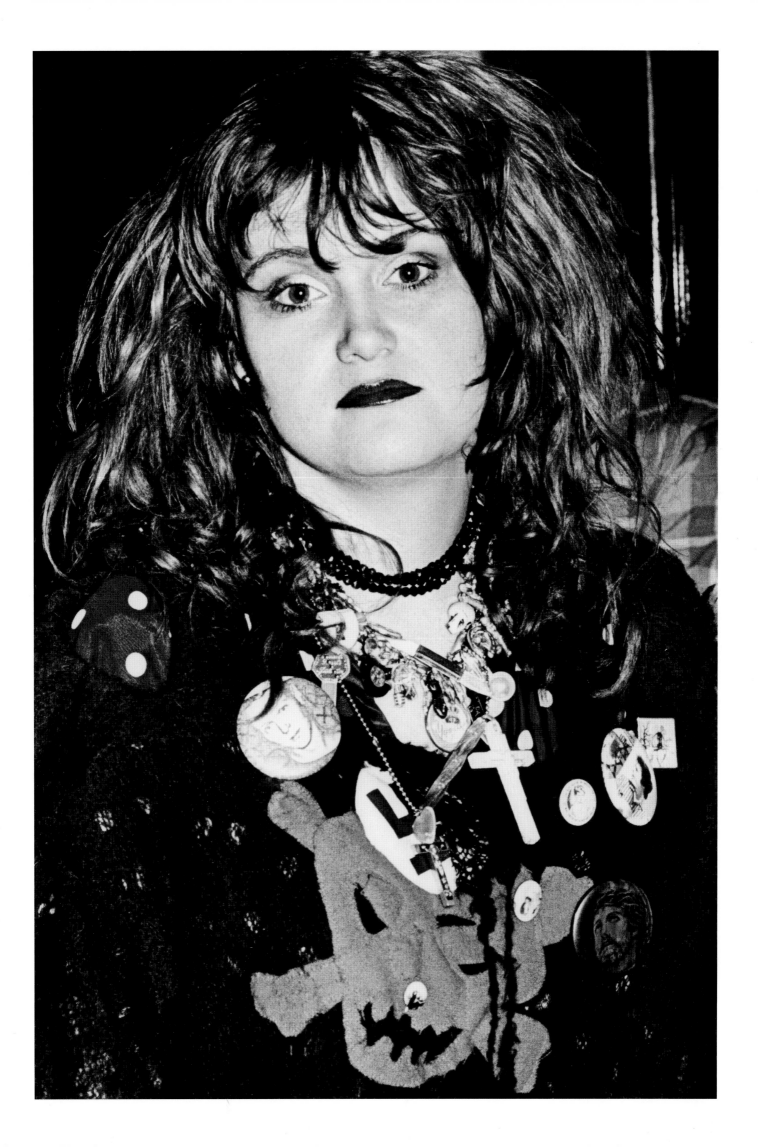

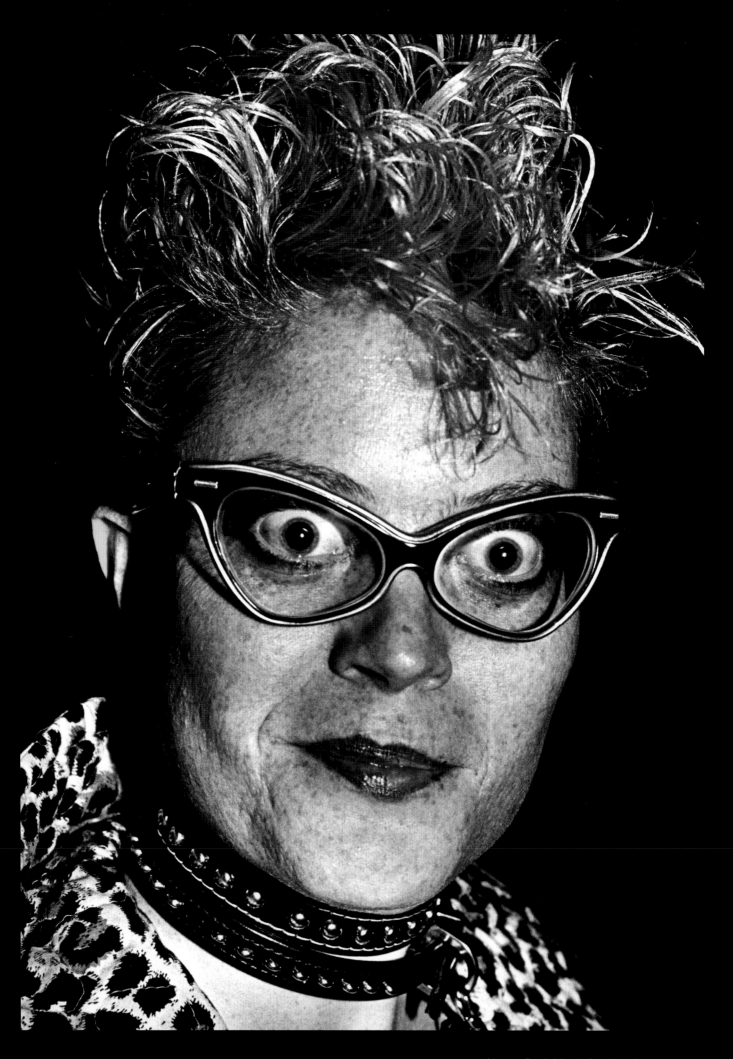

Above: Punk Music Fan, Los Angeles, 1979
Right: Lloyd Ziff, Beverly Hills, 1979

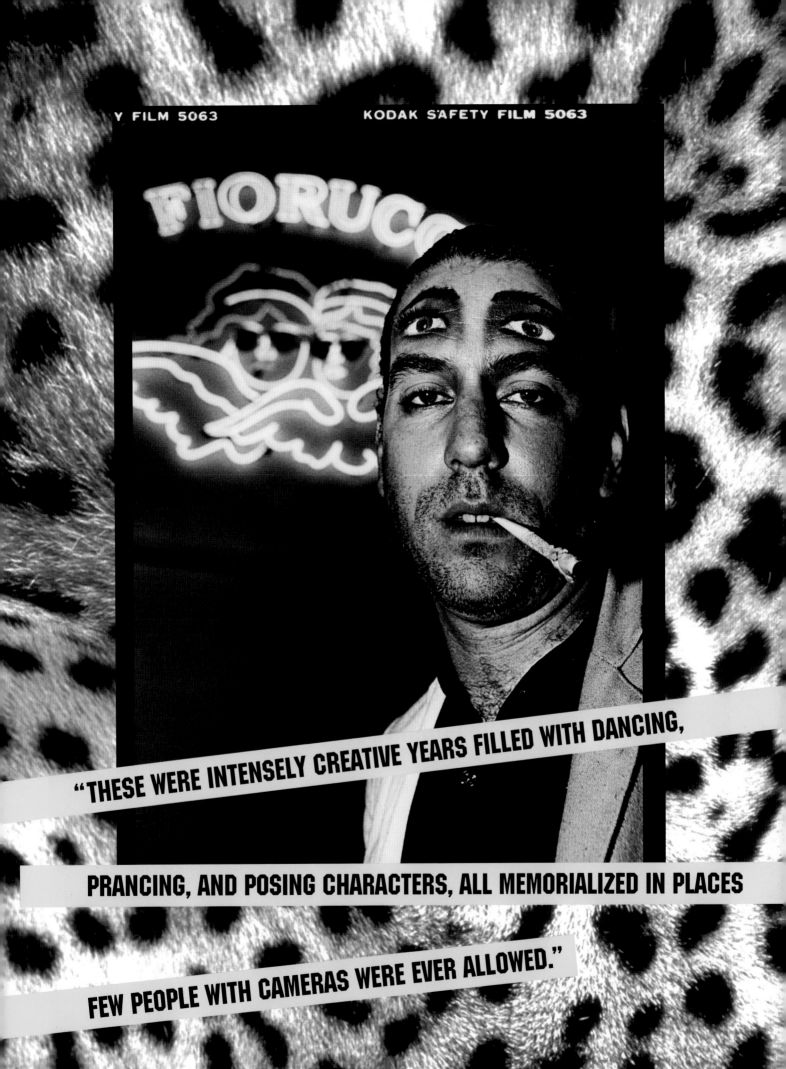

Y FILM 5063 KODAK SAFETY FILM 5063

FIORUCC

"THESE WERE INTENSELY CREATIVE YEARS FILLED WITH DANCING,

PRANCING, AND POSING CHARACTERS, ALL MEMORIALIZED IN PLACES

FEW PEOPLE WITH CAMERAS WERE EVER ALLOWED."

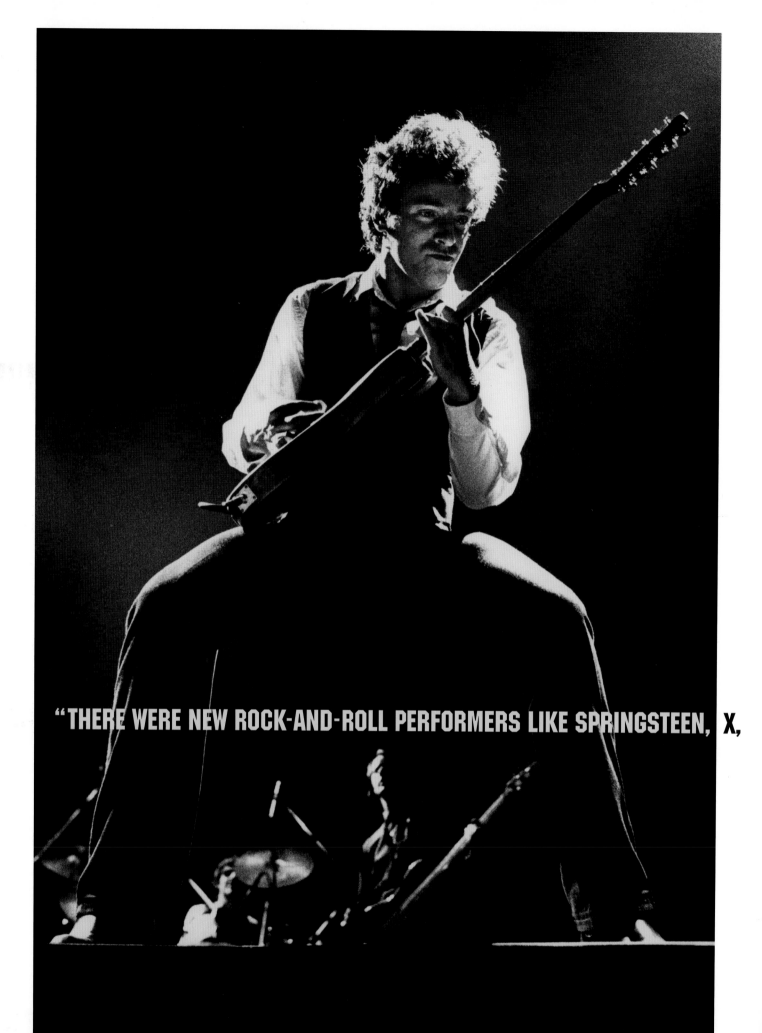

"THERE WERE NEW ROCK-AND-ROLL PERFORMERS LIKE SPRINGSTEEN, X,

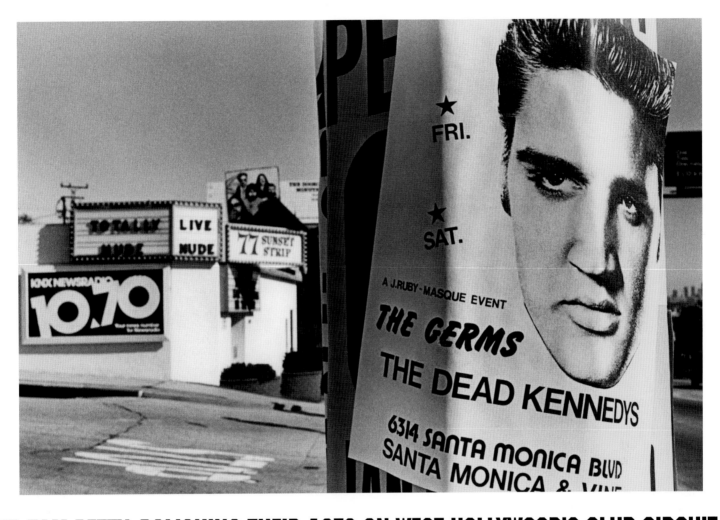

AND TOM PETTY, POLISHING THEIR ACTS ON WEST HOLLYWOOD'S CLUB CIRCUIT."

Left: Bruce Springsteen, Bloomington, Minnesota, 1978
Above: Punk Show Flyer, West Hollywood, 1979
Overleaf: Chuck Berry, Hollywood, 1980

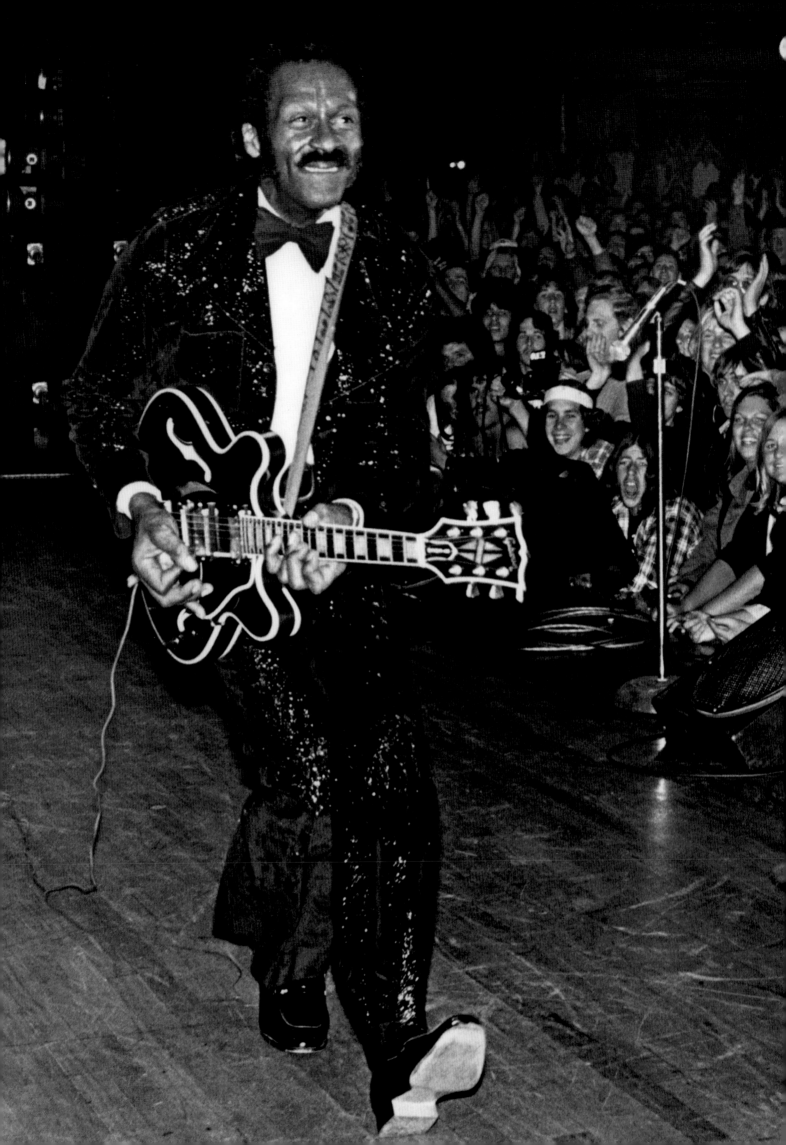

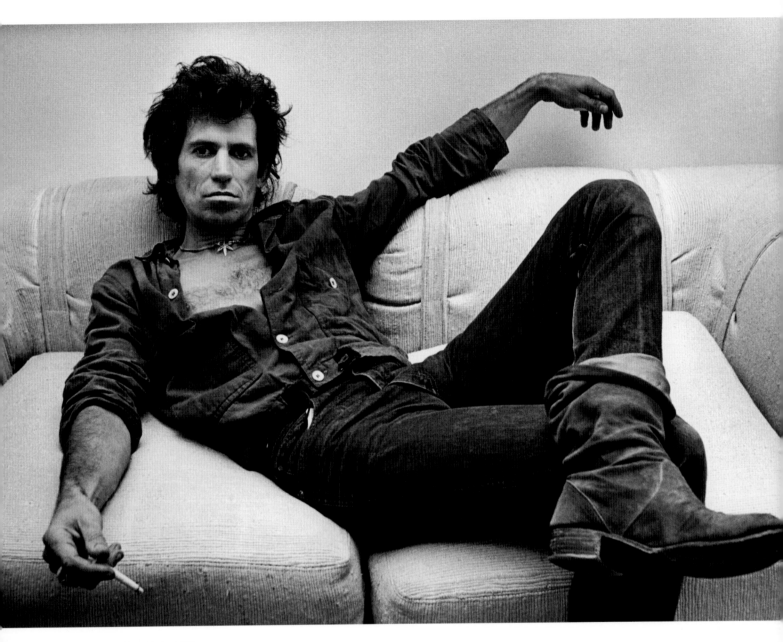

Keith Richards, New York, 1982

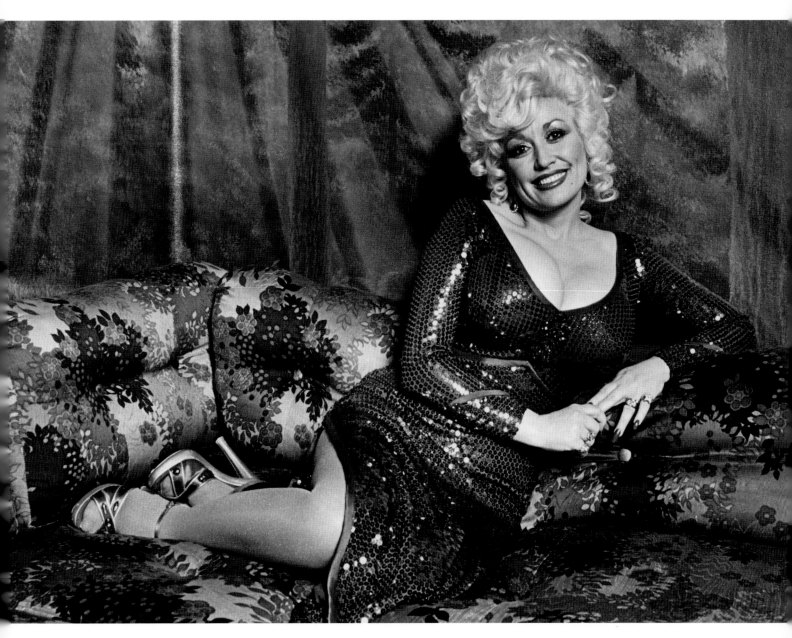

Dolly Parton, Lake Tahoe, 1980

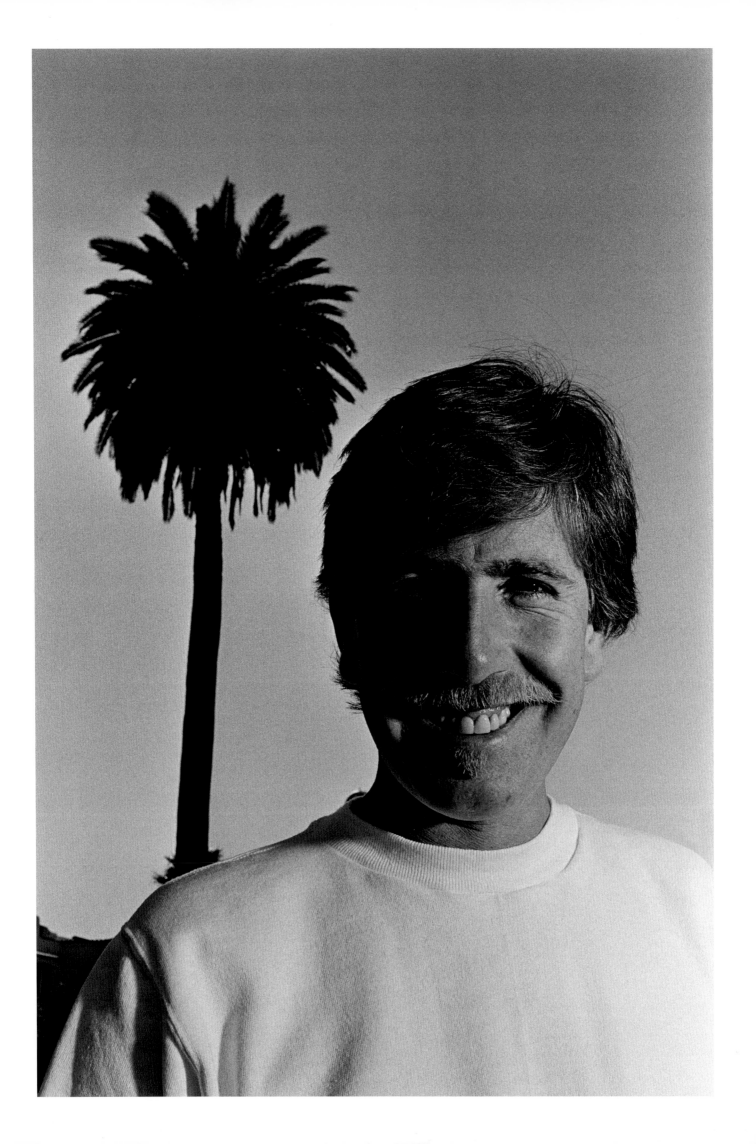

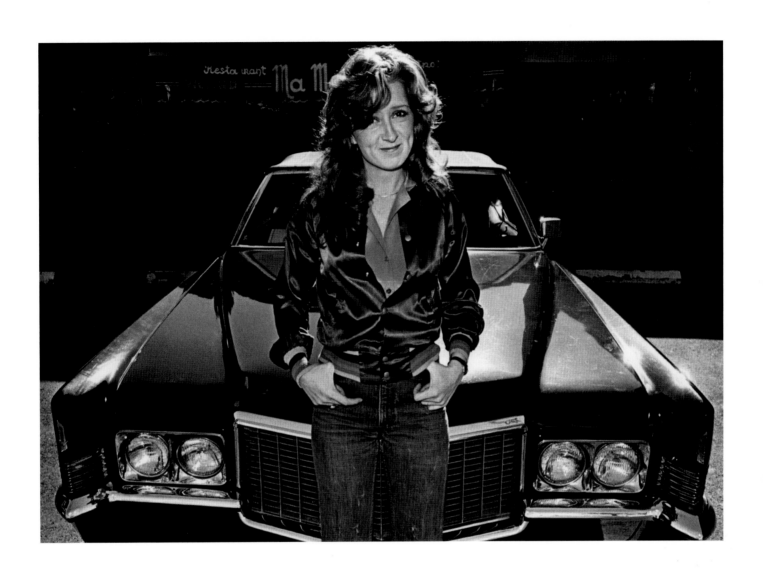

Left: Graham Nash, Los Angeles, 1982
Above: Bonnie Raitt, Los Angeles, 1980

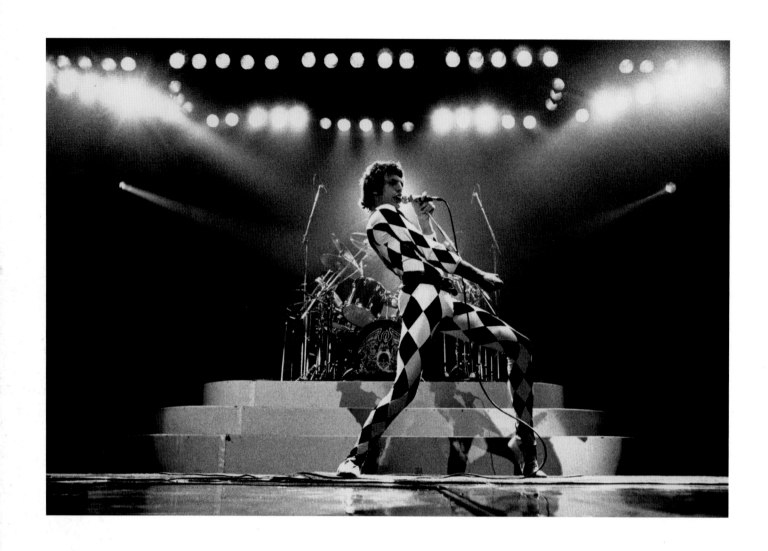

Above: Freddie Mercury, Inglewood, 1978
Right: Grace Jones, New York, 1981

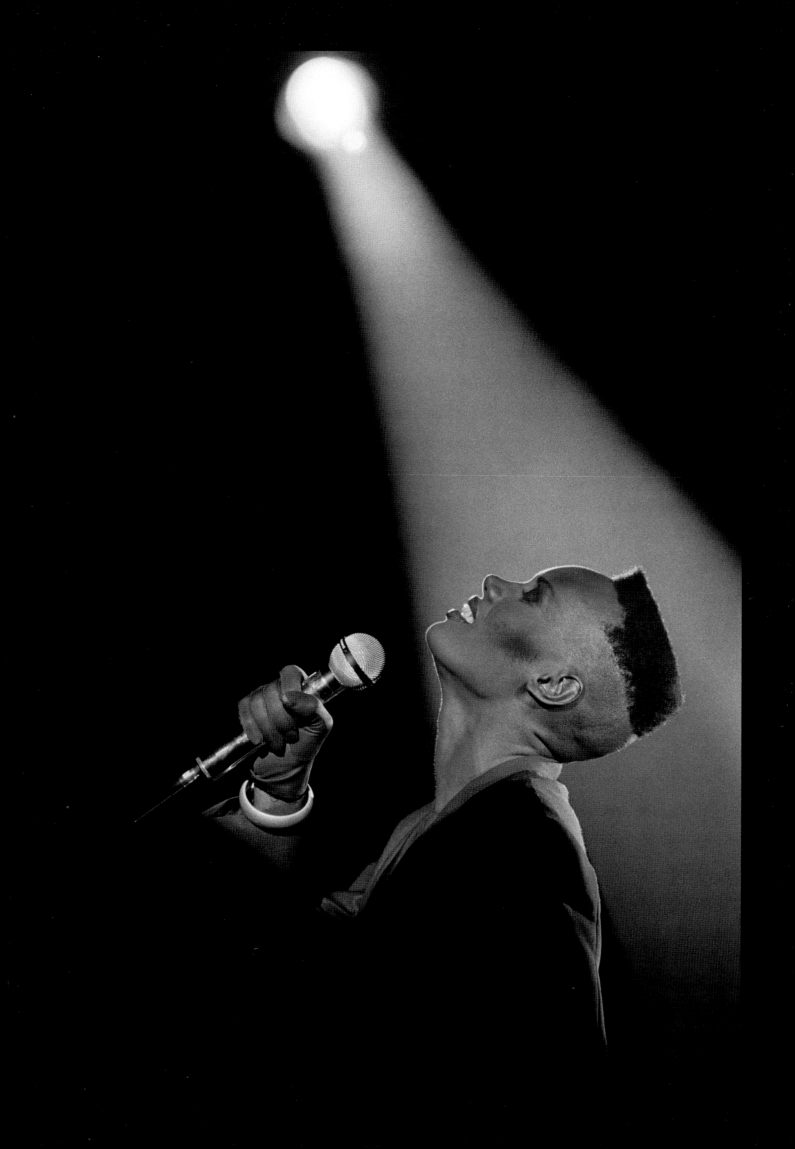

Pete Townshend, New York, 1982
Overleaf: Mosh Pit, Reseda, 1982

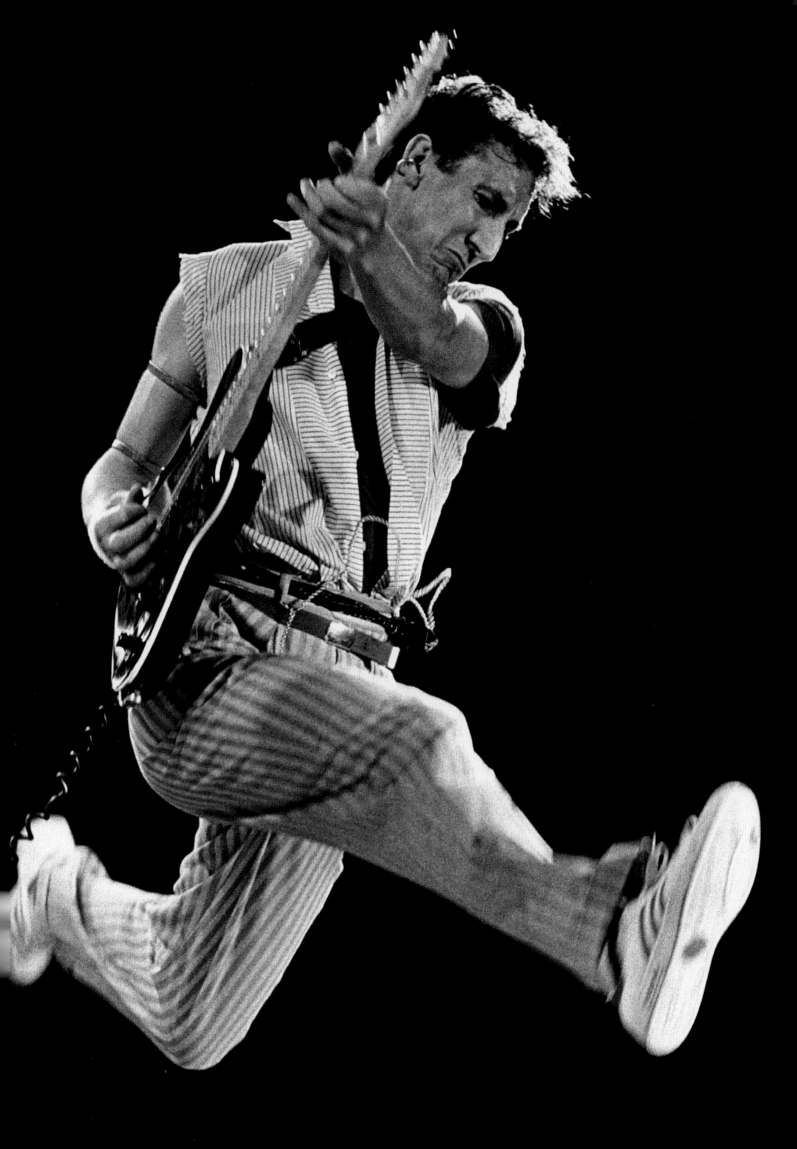

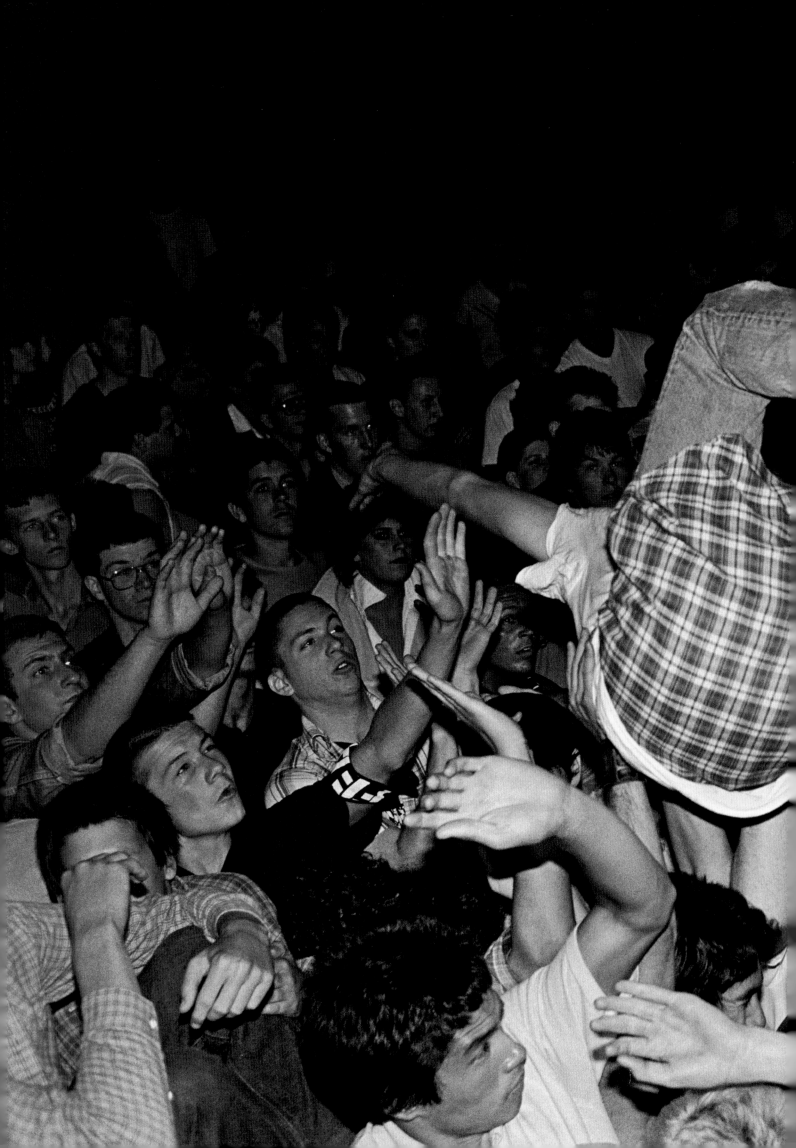

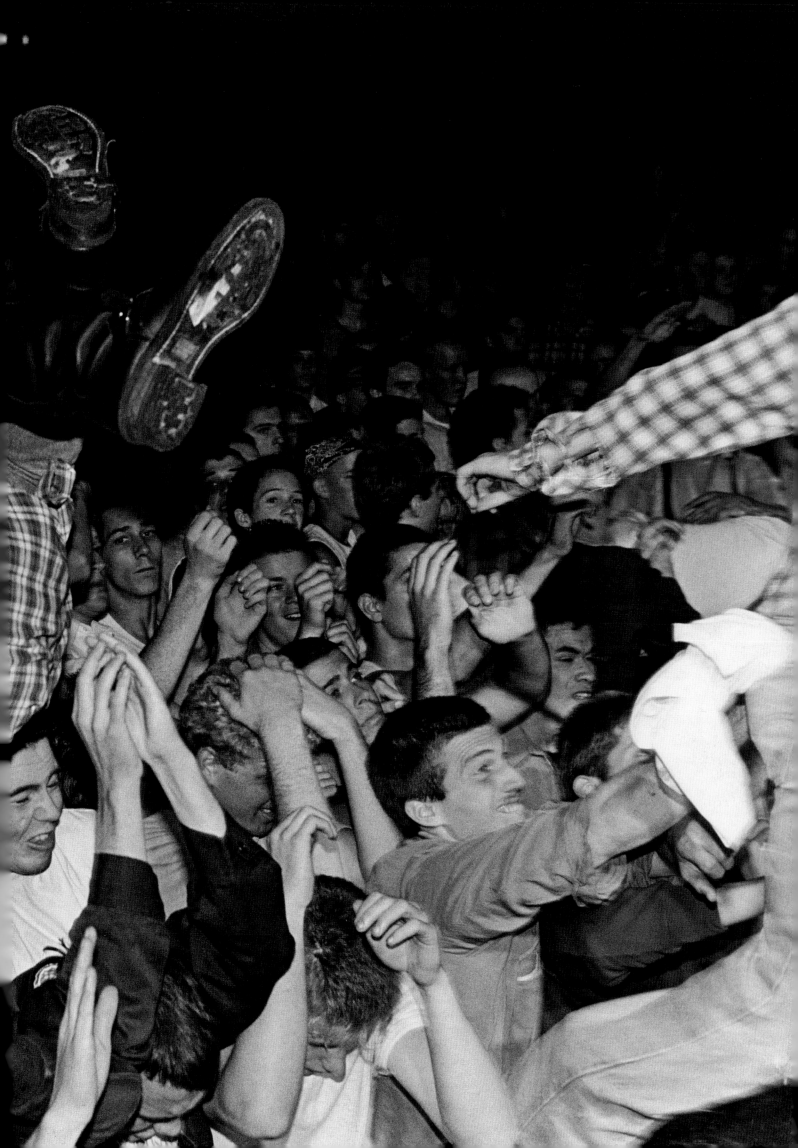

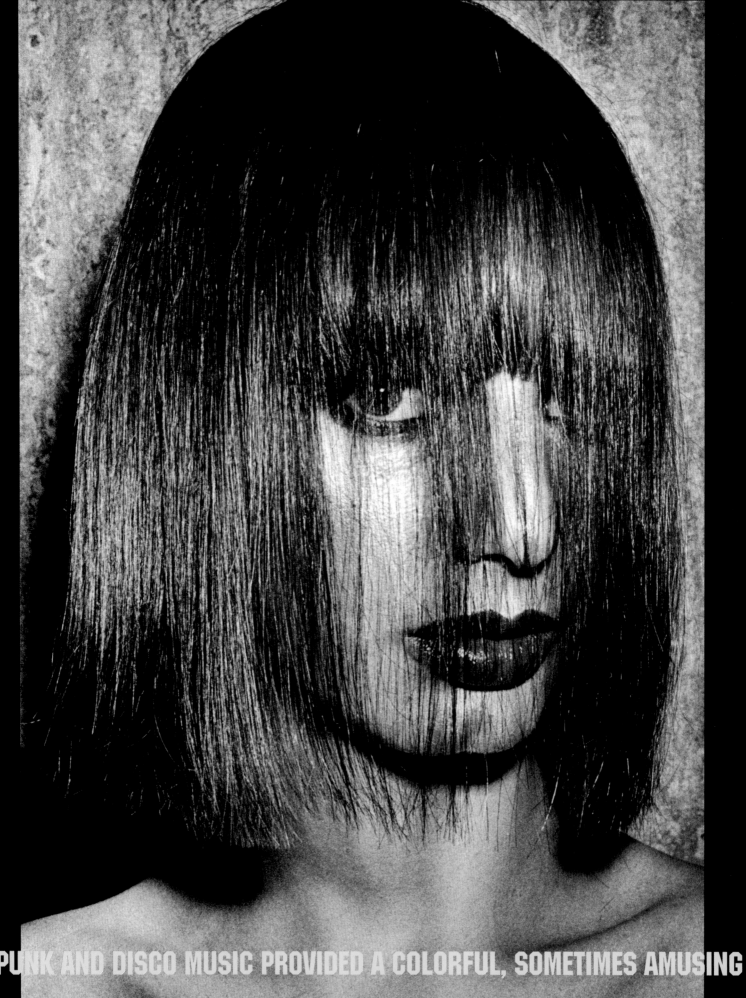

"PUNK AND DISCO MUSIC PROVIDED A COLORFUL, SOMETIMES AMUSING

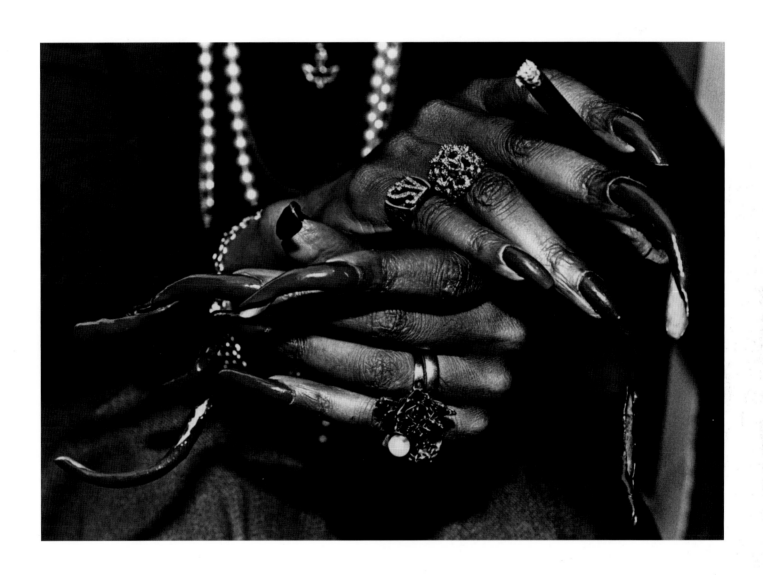

FASHION BACKDROP IN HOLLYWOOD THAT SPREAD ACROSS AMERICA."

Left: Disco Hairstyle, Beverly Hills, 1979
Above: Fingernails, West Hollywood, 1979

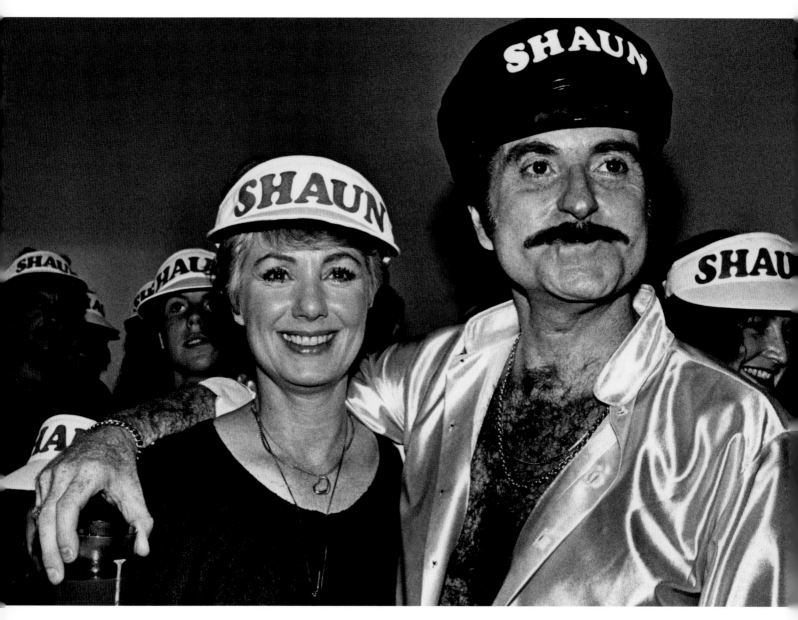

Shirley Jones and Marty Ingels, Anaheim, 1980

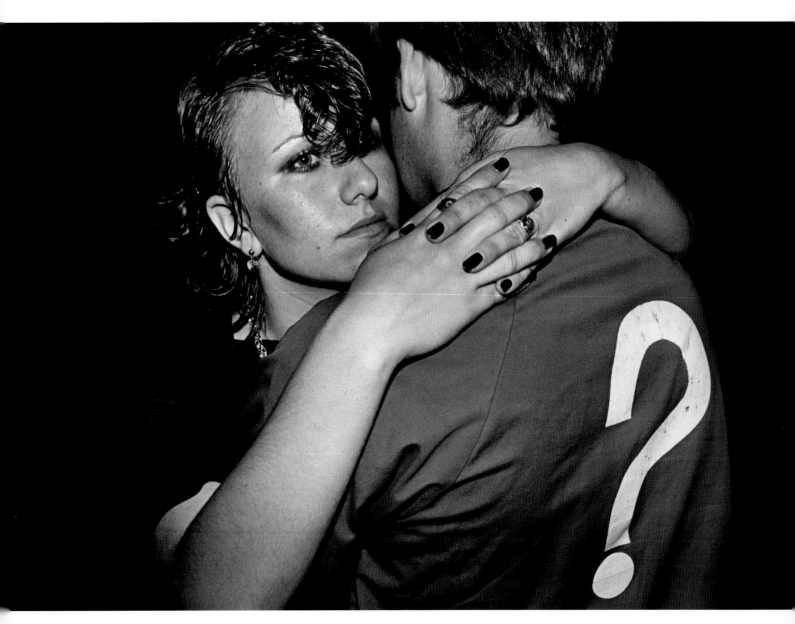

High School Sweethearts, Hollywood, 1979

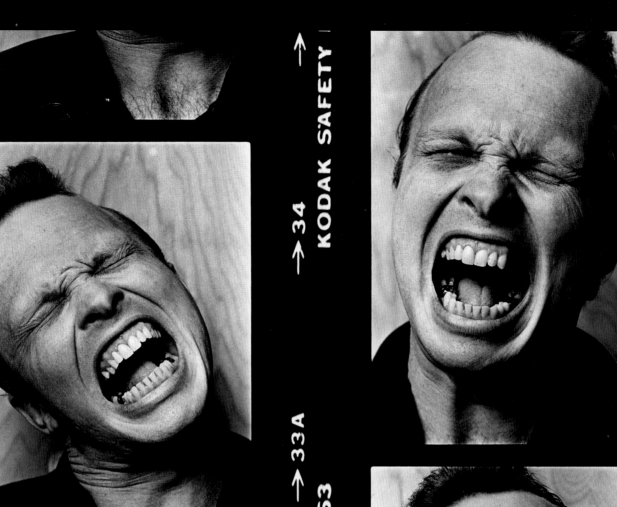

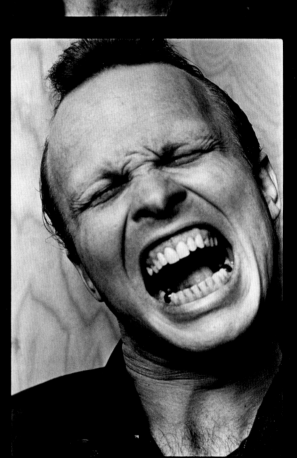

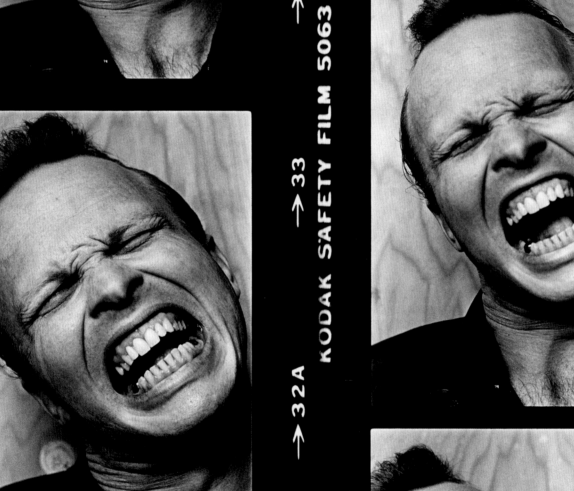

KODAK SAFETY FILM 5063

→32A →33 →33A →34

KODAK SAFETY FILM 5063

→32A →34A →34

Above: Phil Alvin, West Hollywood, 1982
Right: Spazz Attack, Los Angeles, 1980

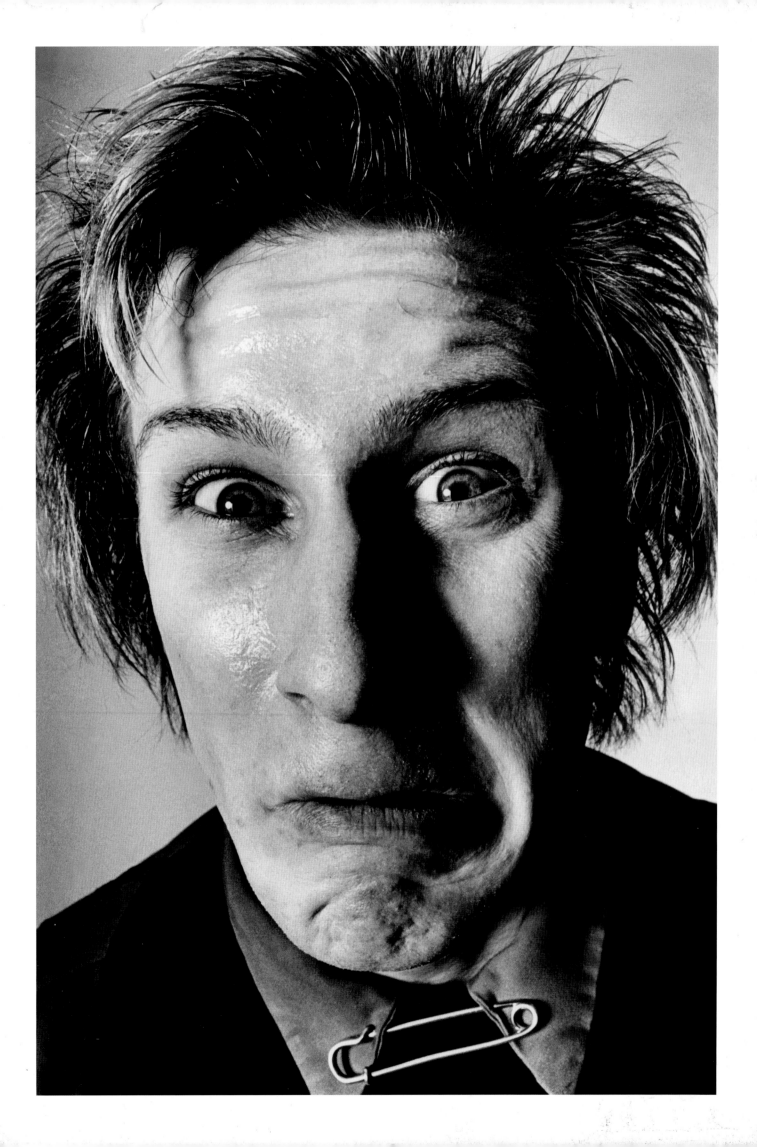

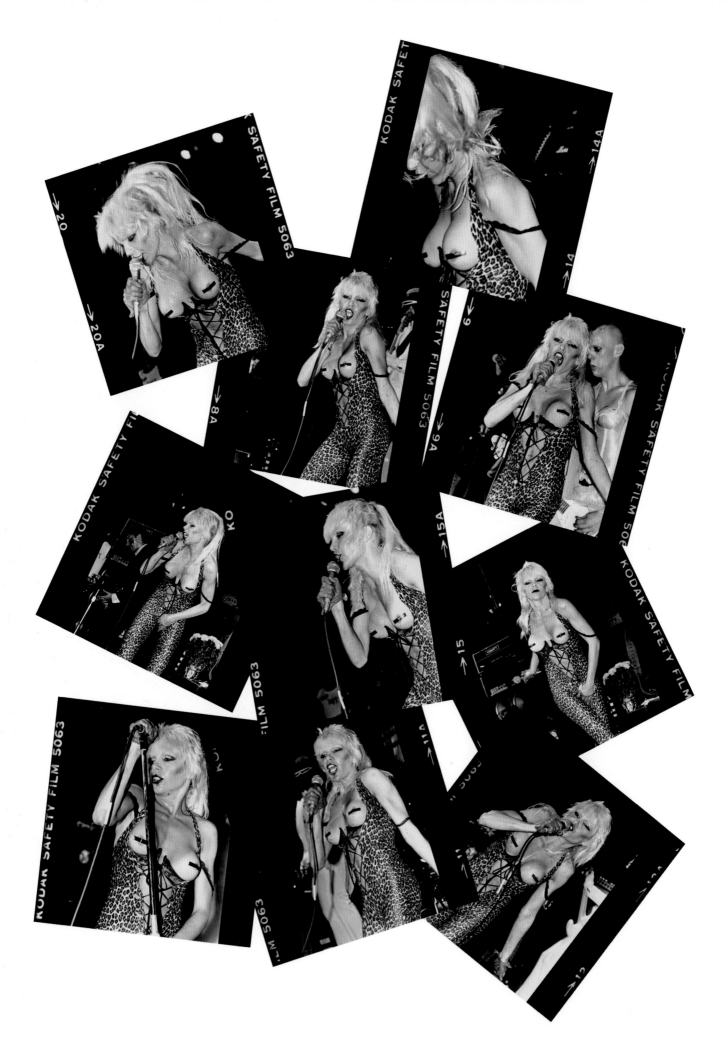

Above: Wendy O. Williams, West Hollywood, 1980
Right: Punk Rock Fan, San Francisco, 1978

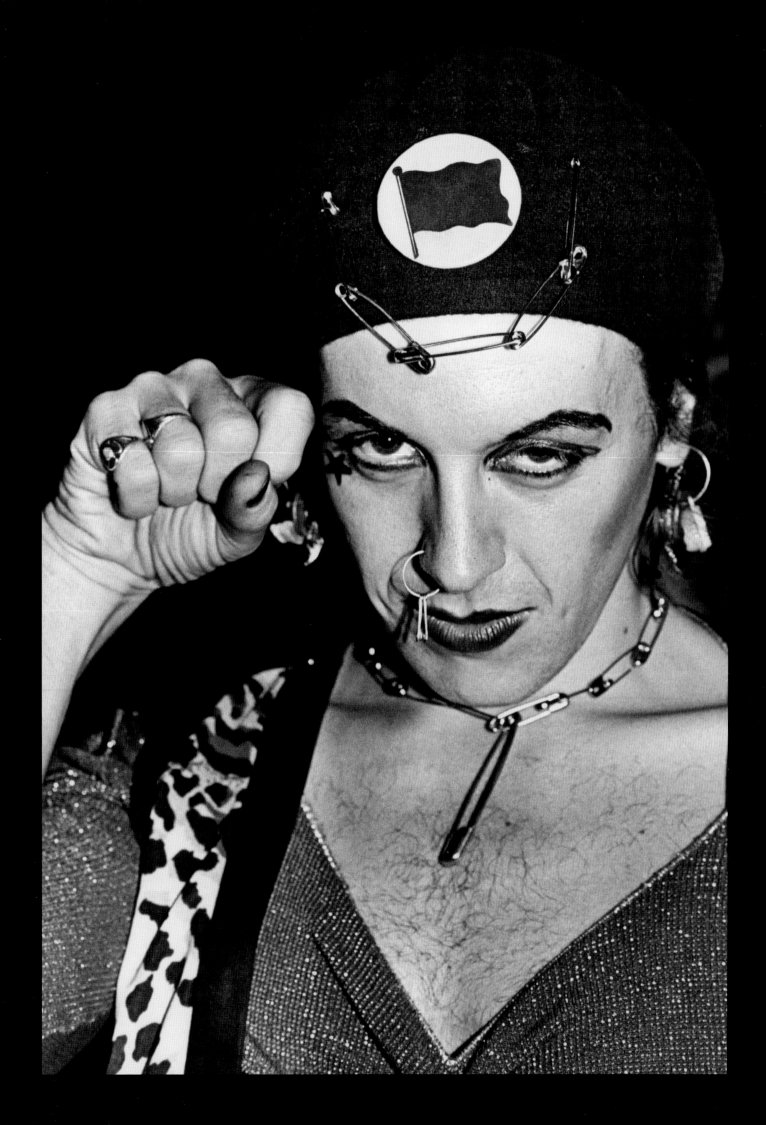

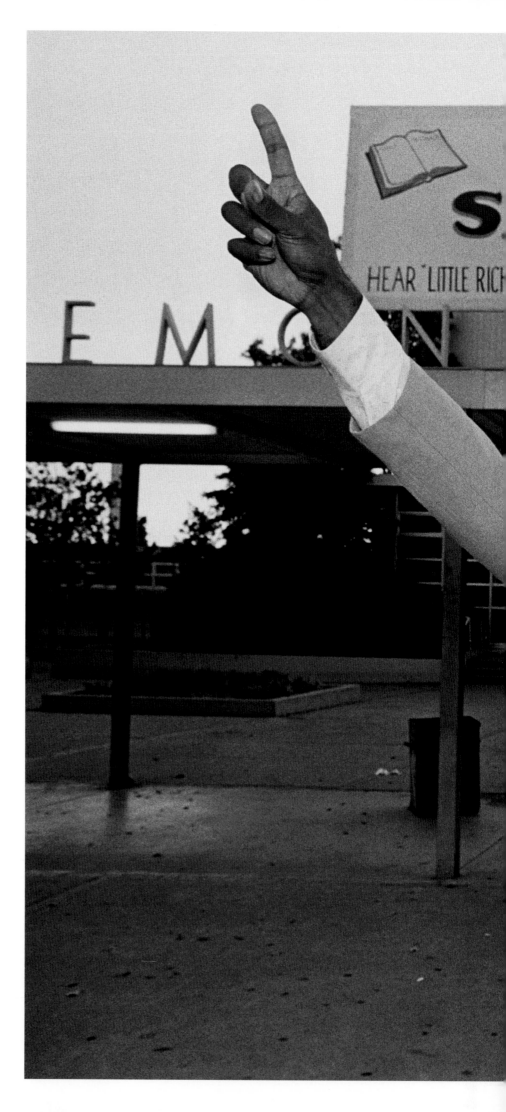

Little Richard, Oakland, 1981

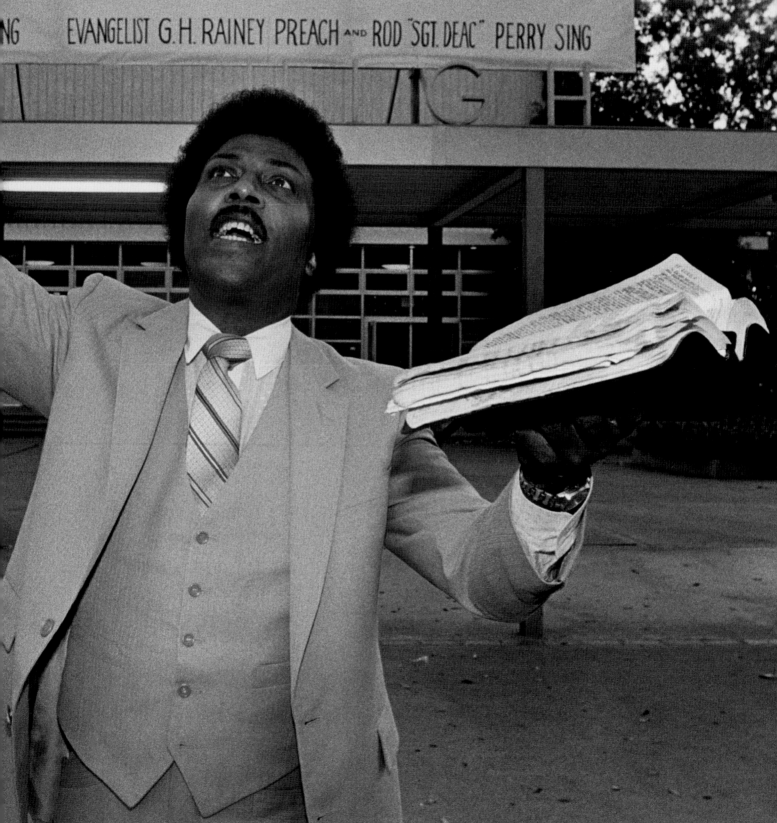

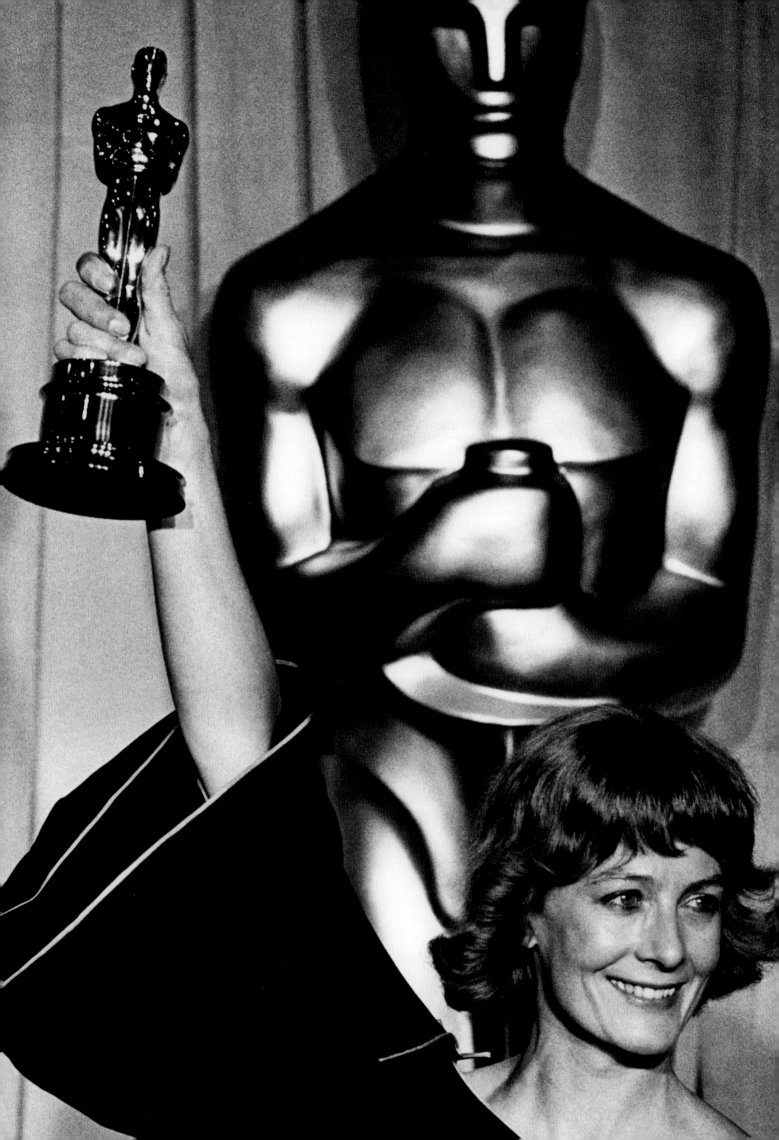

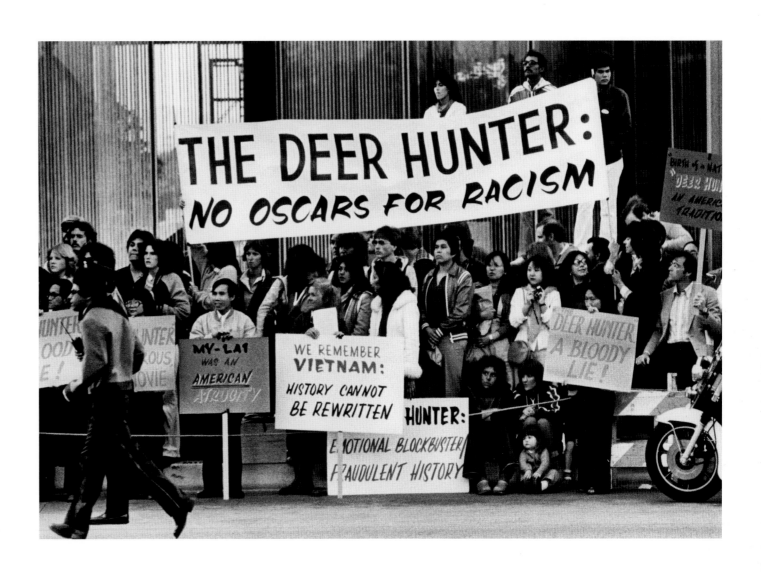

Left: Vanessa Redgrave, Los Angeles, 1979
Above: Academy Awards Protest, Los Angeles, 1979

"POLITICS HAS NEVER BEEN FAR FROM THE HOLLYWOOD SCENE . . ."

Jane Fonda, New York, 1976

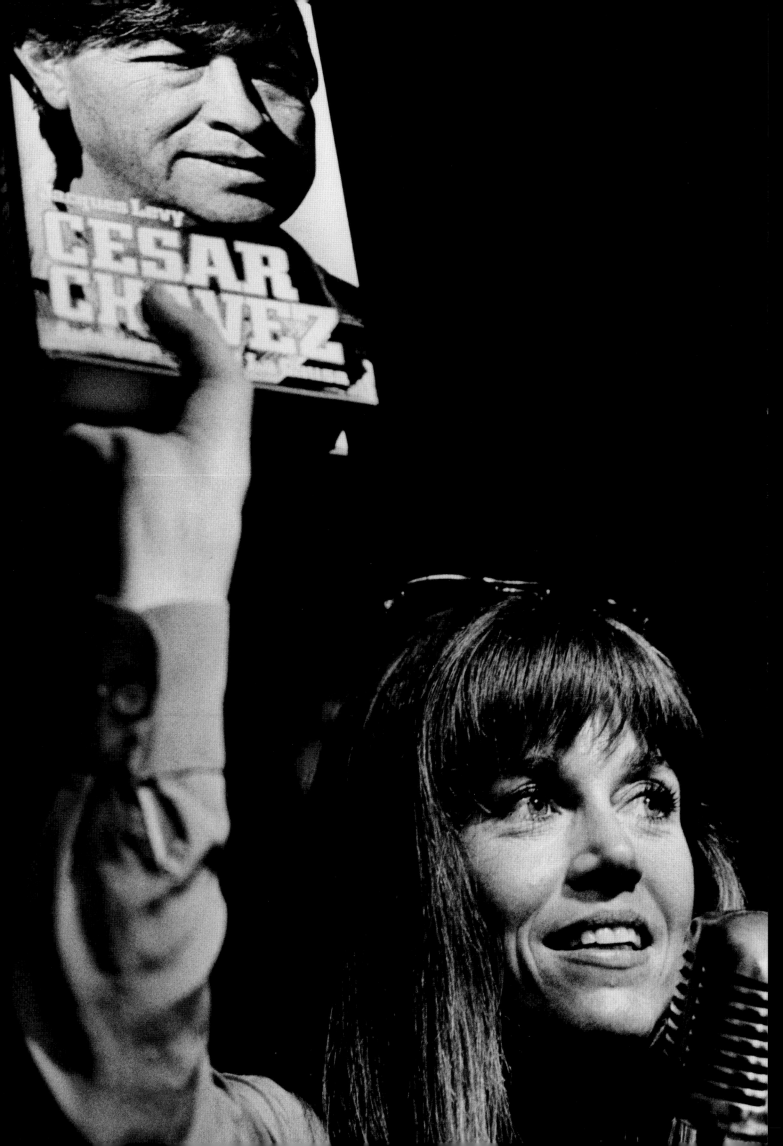

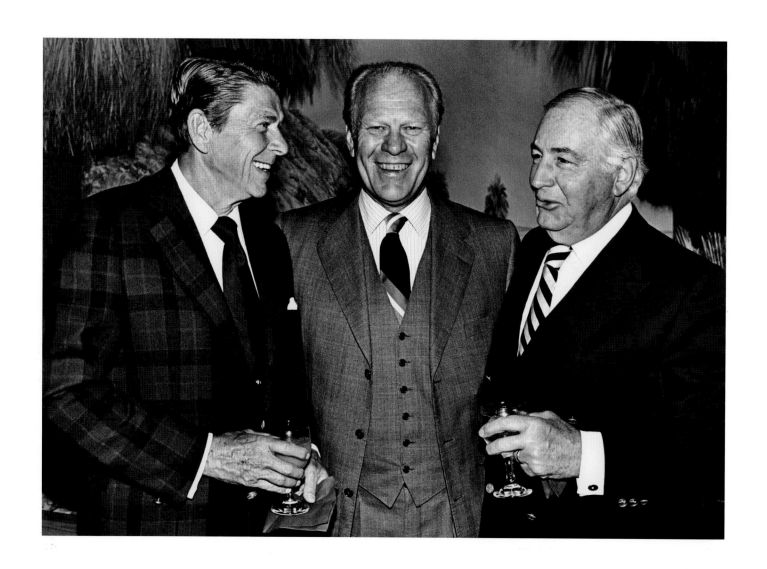

"... ACTORS AND PRESIDENTS GO TOGETHER LIKE BREAD AND BUTTER."

Above: Political Heavyweights, Palm Springs, 1979
Right: George H. W. Bush, Los Angeles, 1980
Overleaf: Queen Elizabeth, Yosemite, 1982

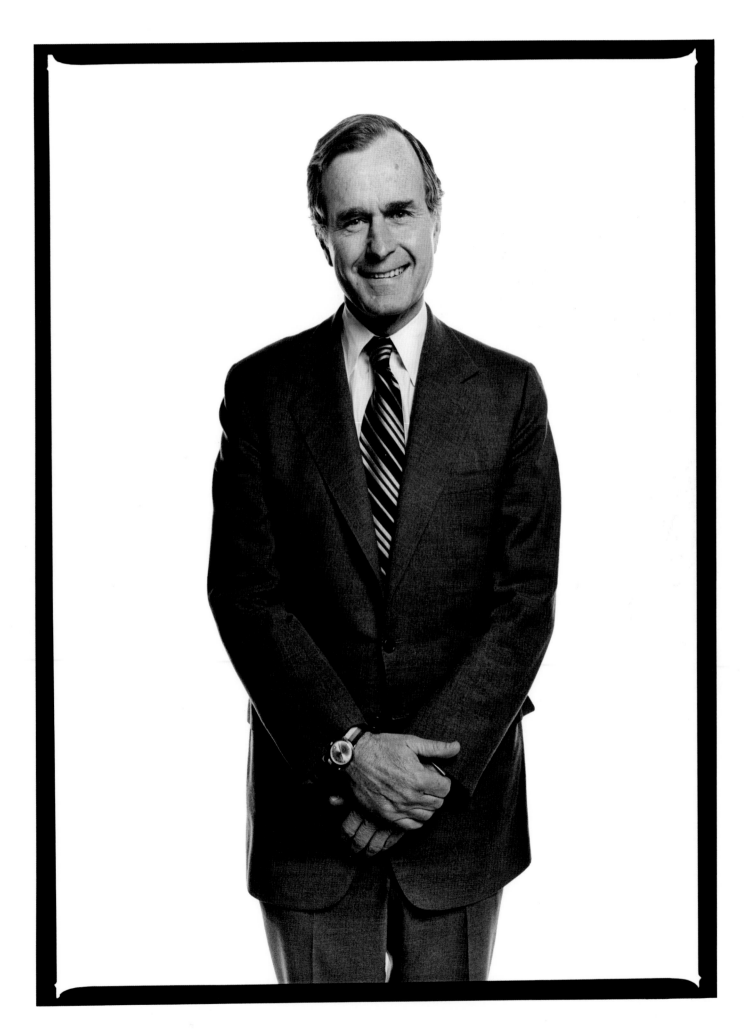

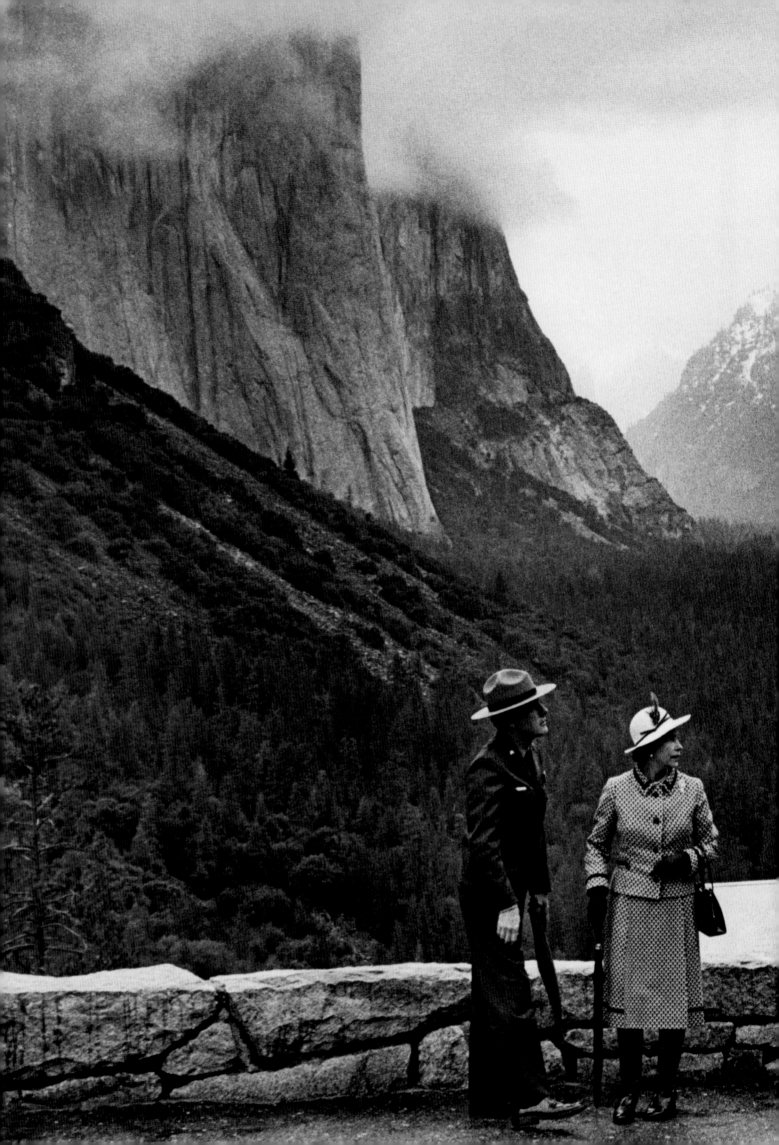

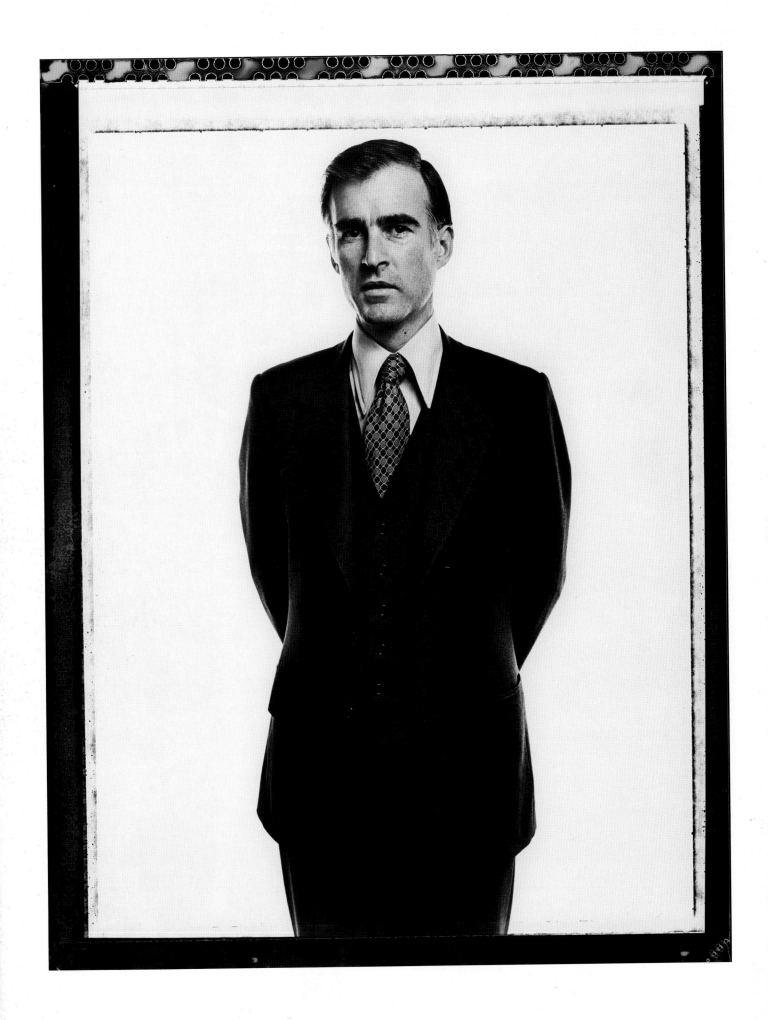

Above: Edmund "Jerry" Brown, Los Angeles, 1980
Right: President Gerald R. Ford, Palm Springs, 1979

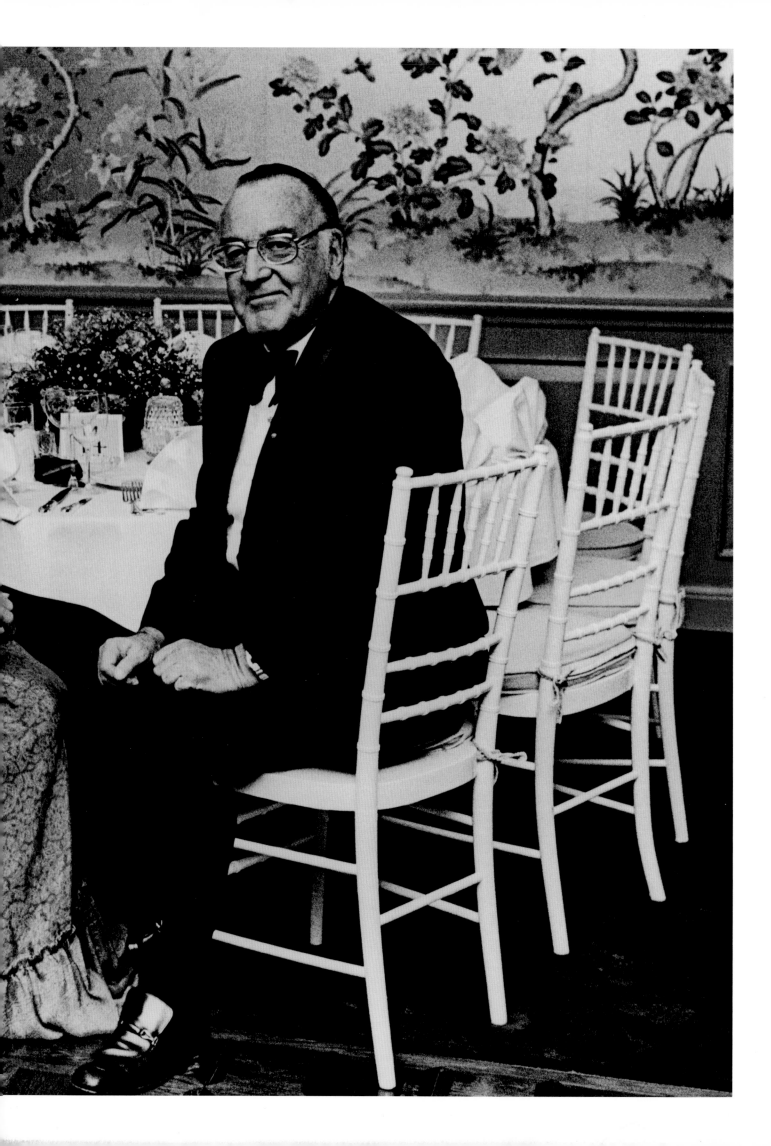

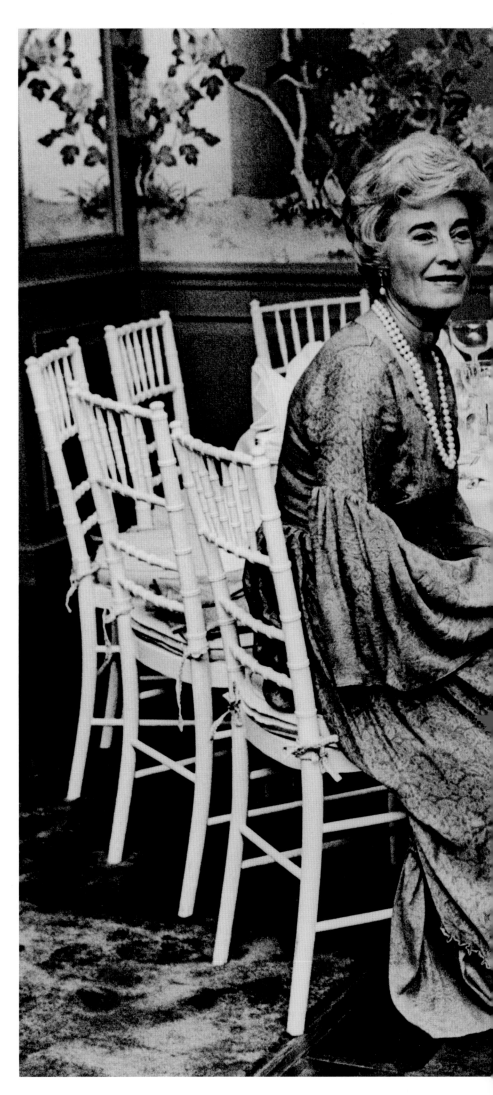

Edmund and Bernice Brown,
Beverly Hills, 1979

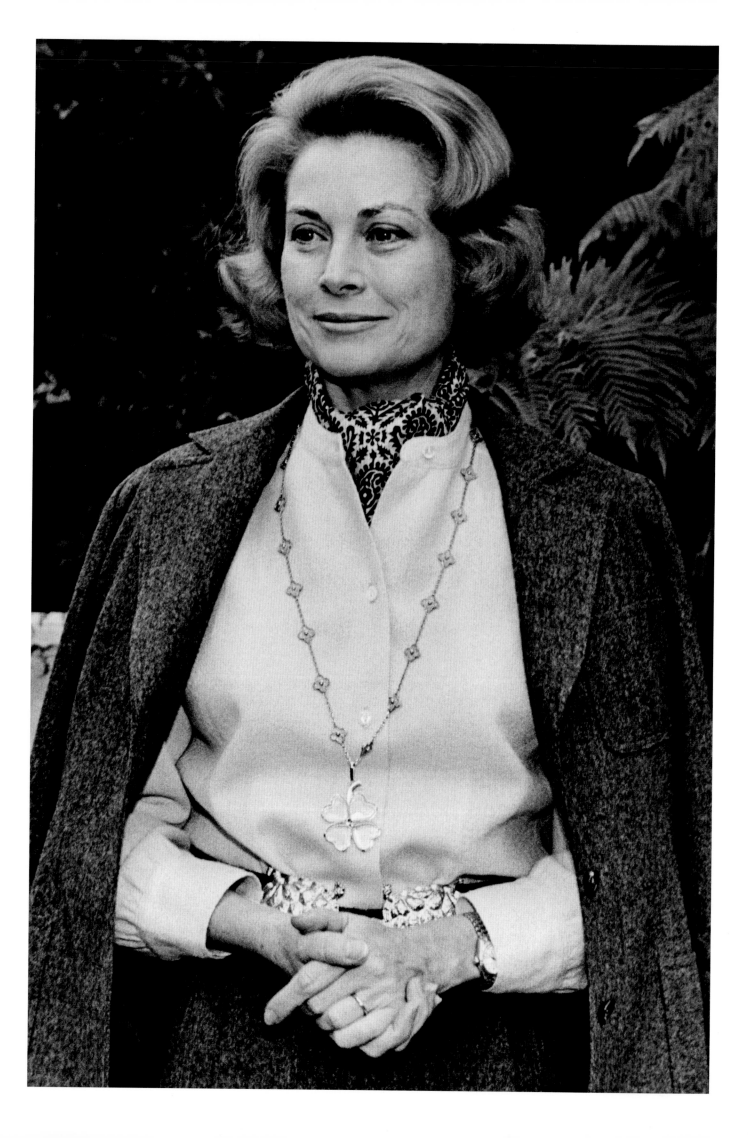

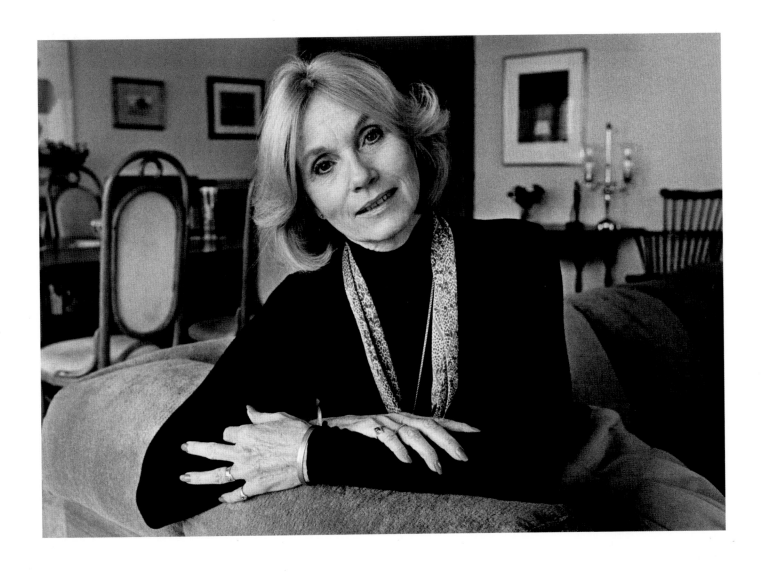

Above: Eva Marie Saint, West Los Angeles, 1979
Right: Princess Grace of Monaco, Bel-Air, 1978

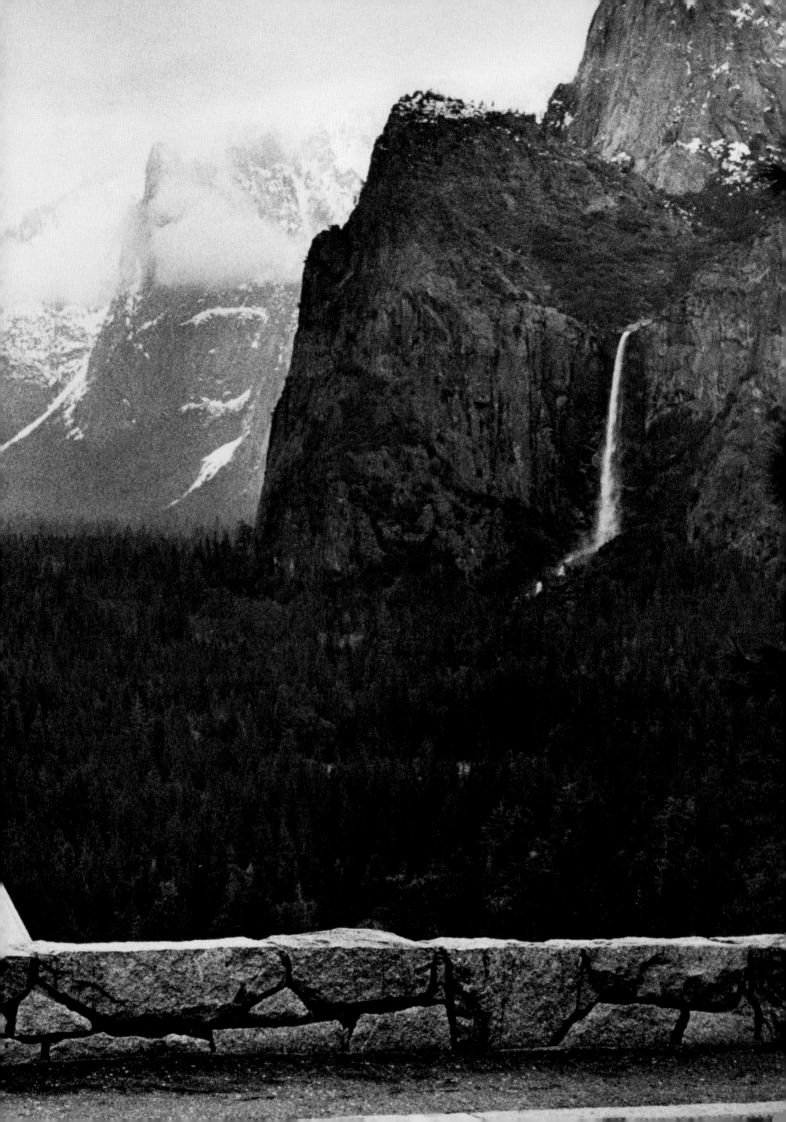

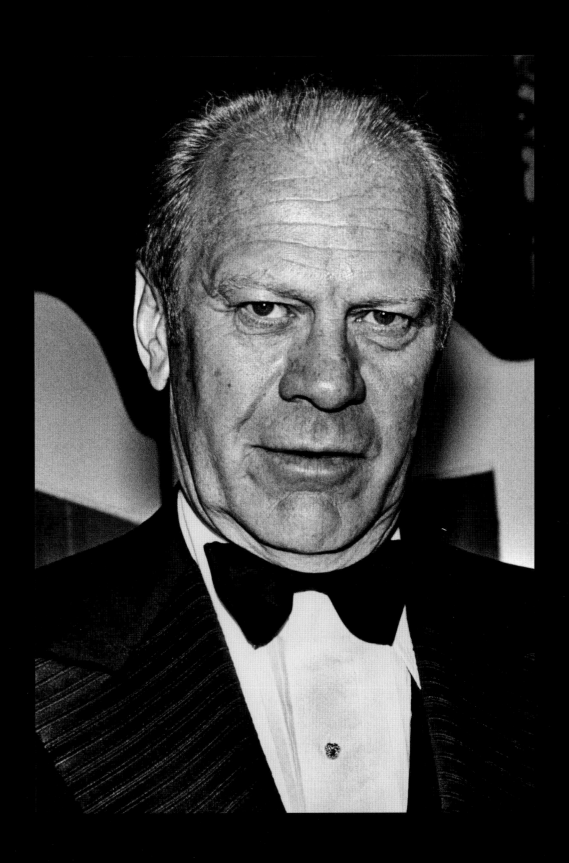

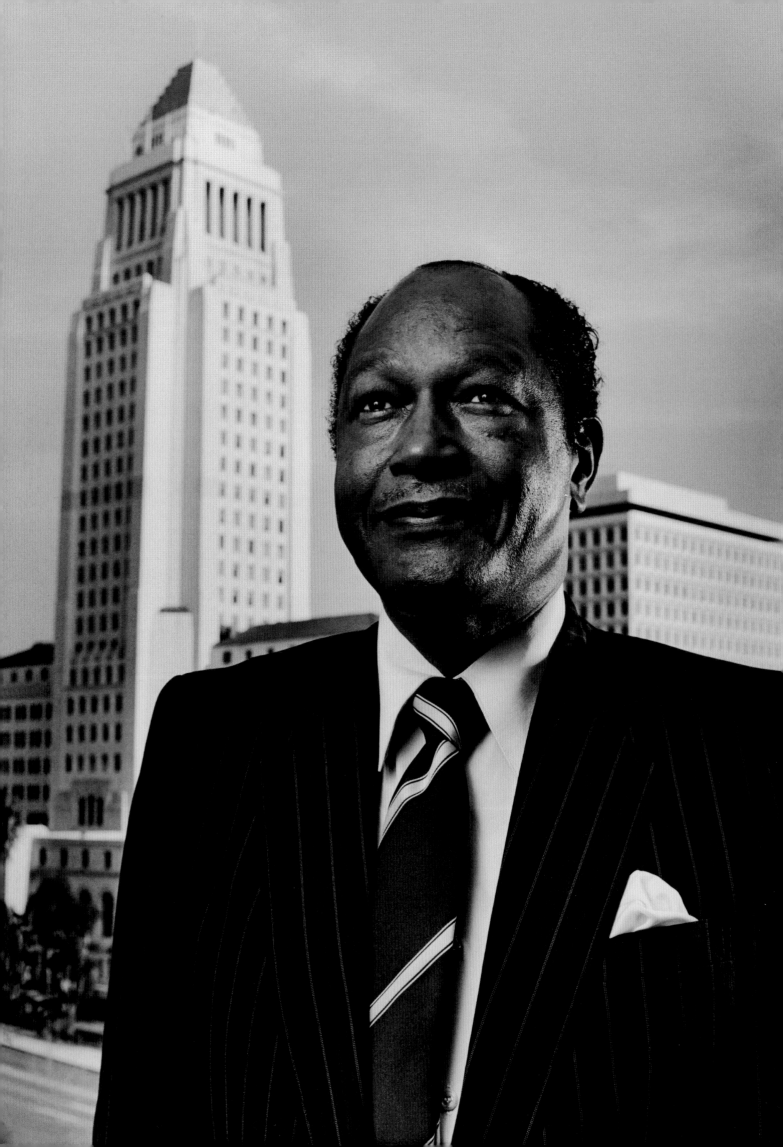

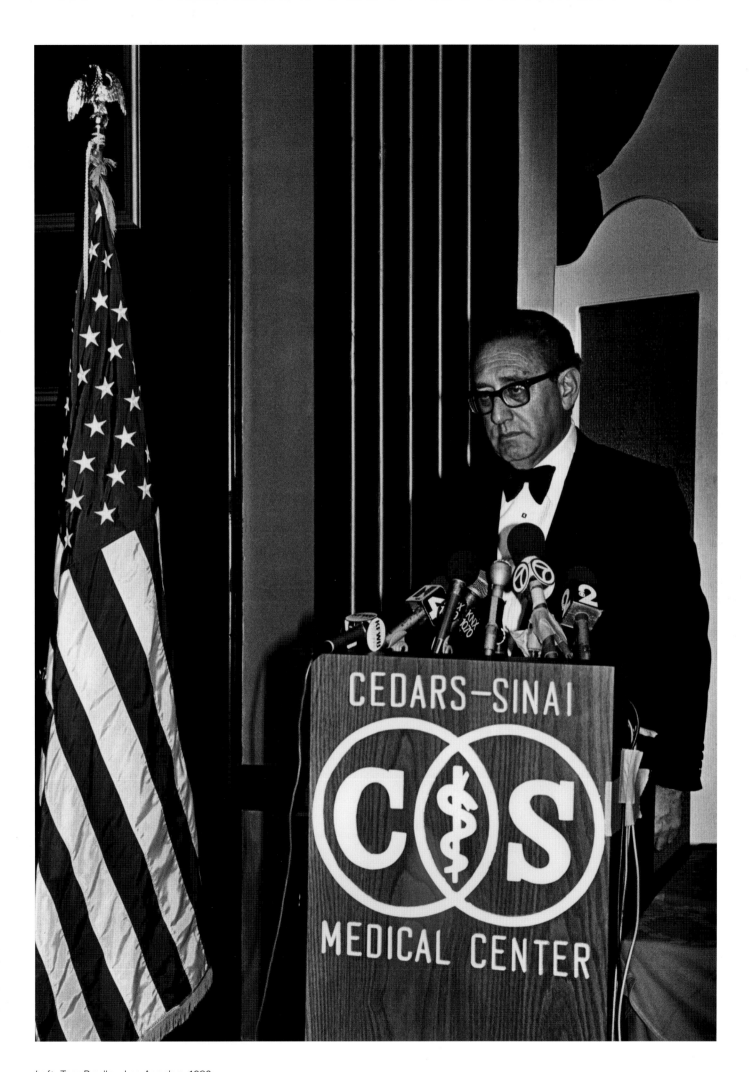

Left: Tom Bradley, Los Angeles, 1980
Above: Henry Kissinger, Beverly Hills, 1979

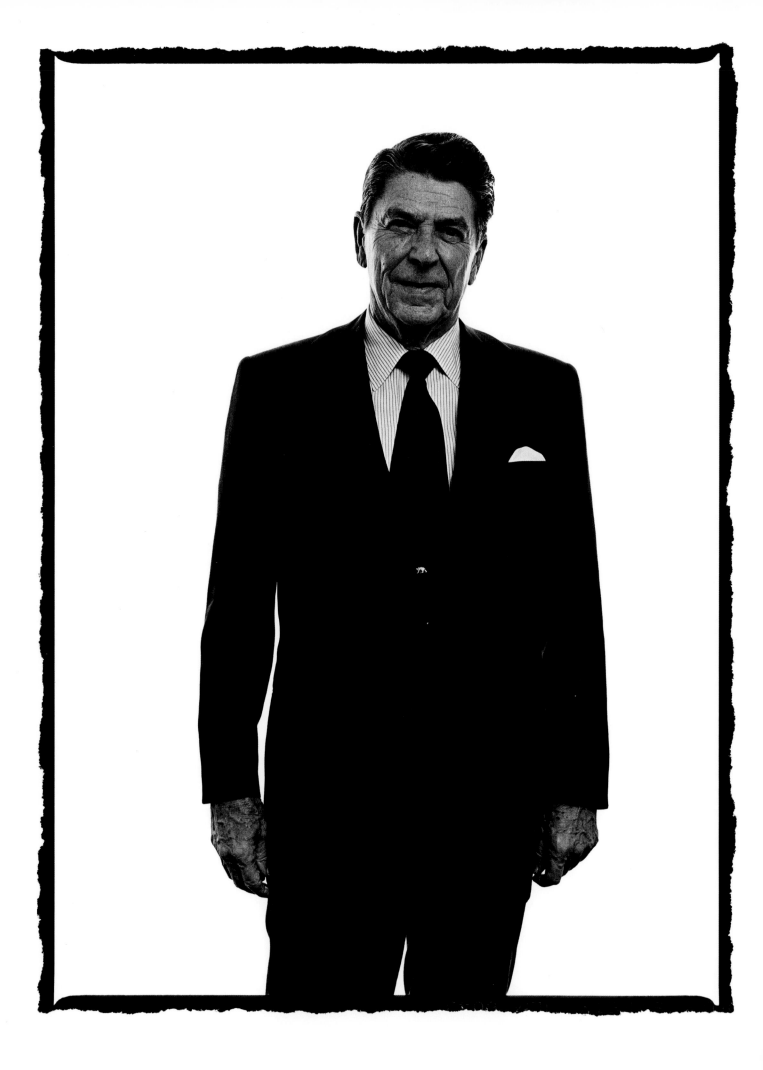

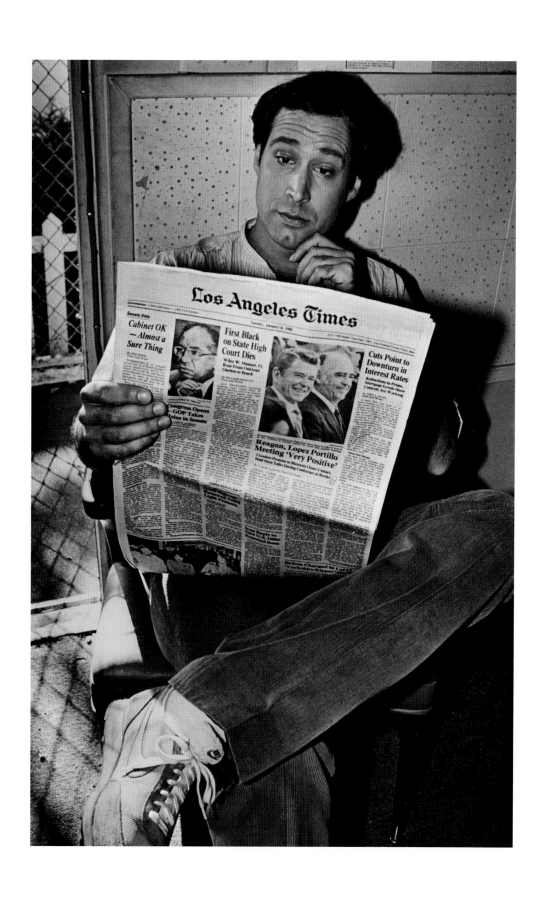

Left: Ronald Reagan, Century City, 1980
Above: Chevy Chase, West Hollywood, 1981

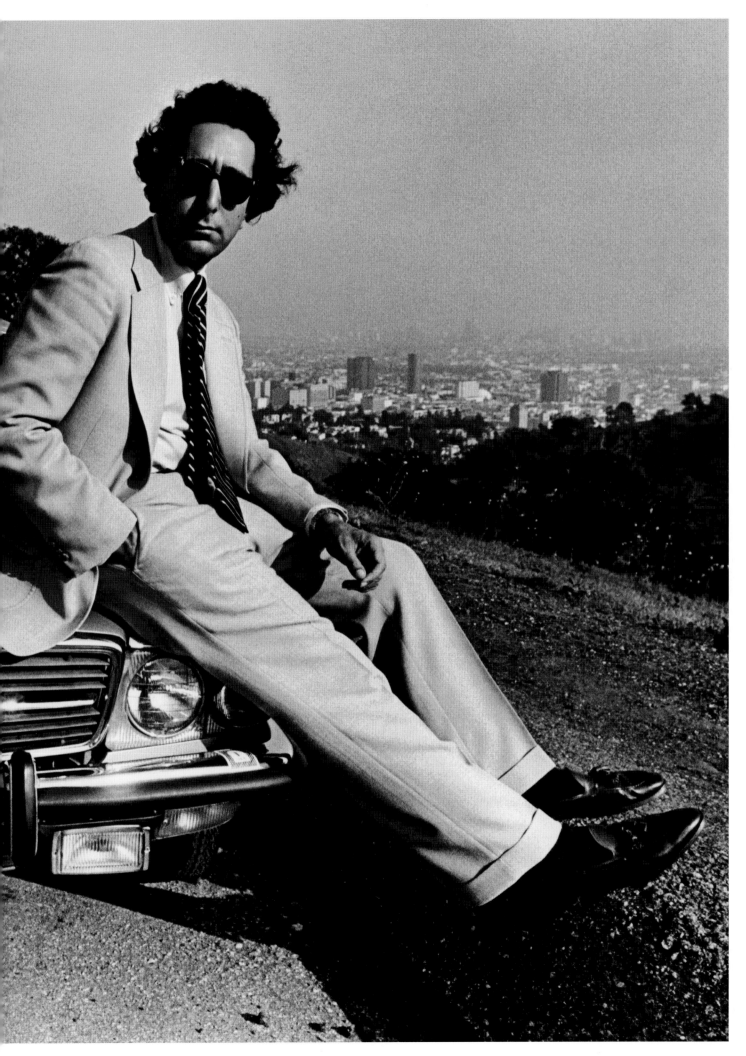

Ben Stein, Hollywood Hills, 1980

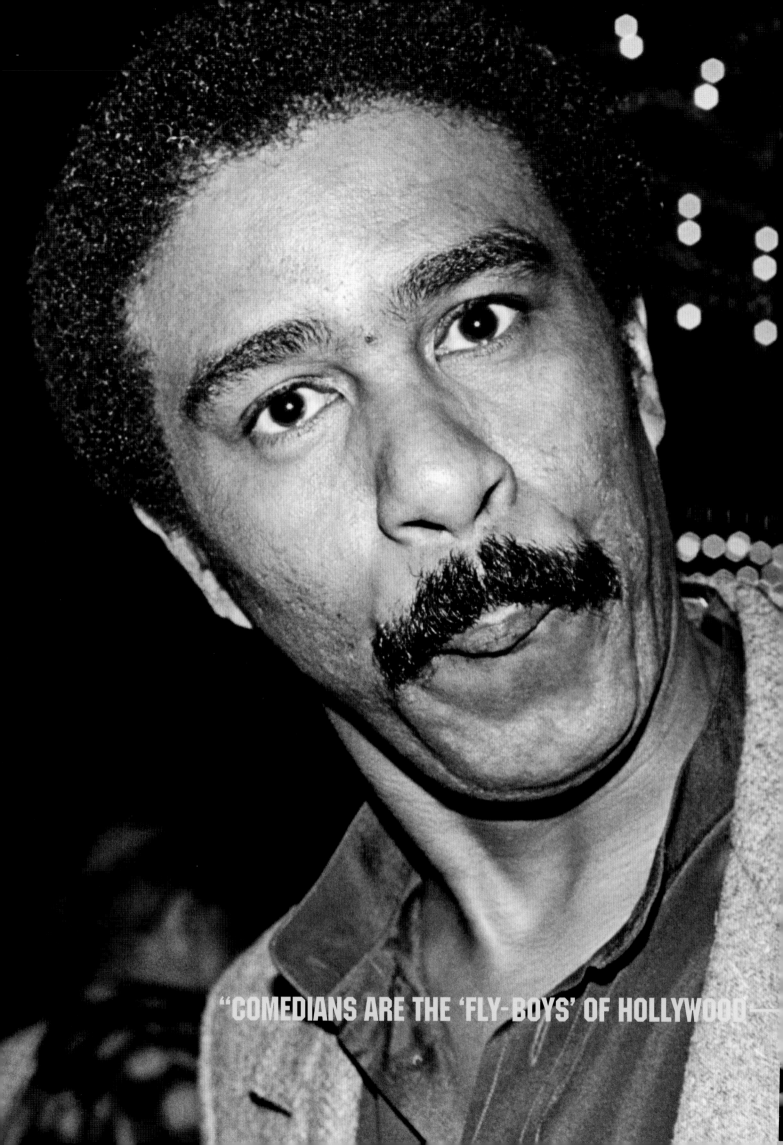

"COMEDIANS ARE THE 'FLY-BOYS' OF HOLLYWOOD

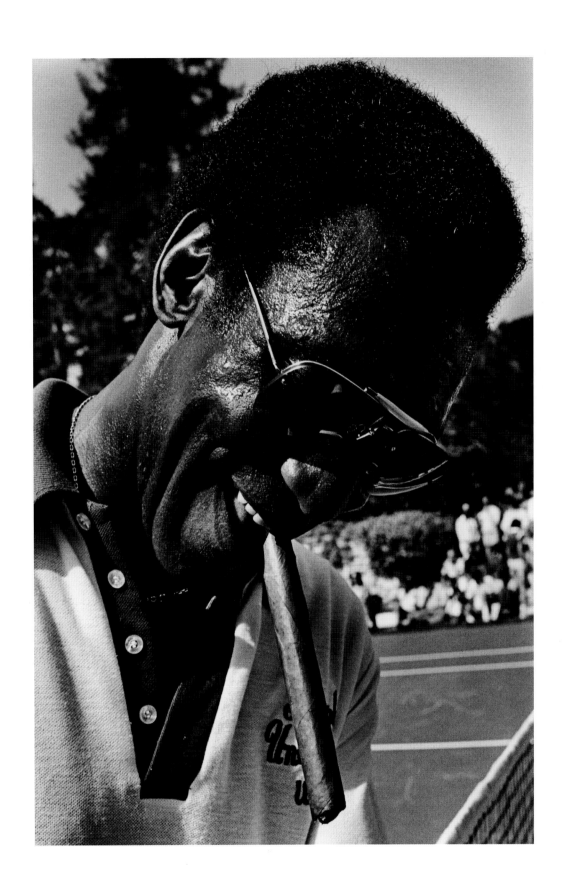

ENGAGING, THEATRICAL, AND ALWAYS MUGGING FOR THE CAMERA."

Left: Richard Pryor, Hollywood, 1979
Above: Bill Cosby, Los Angeles, 1978

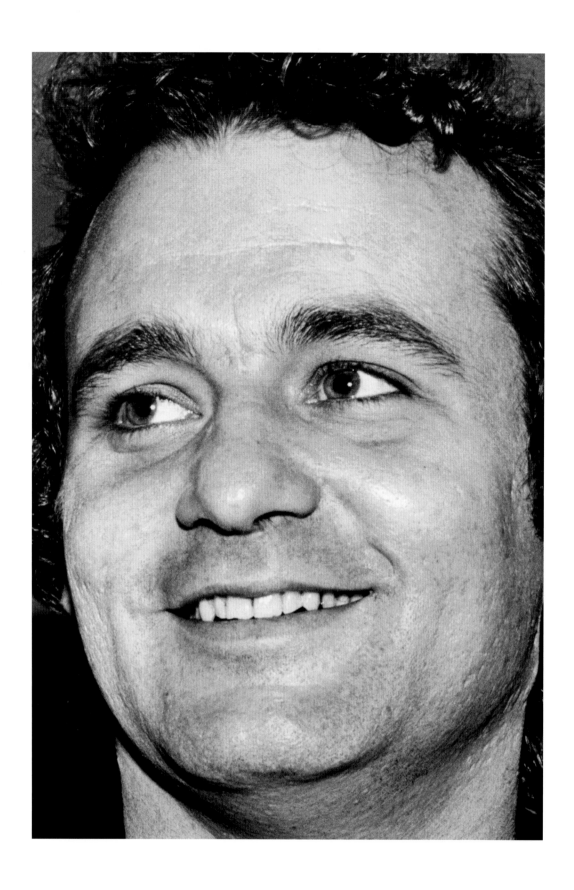

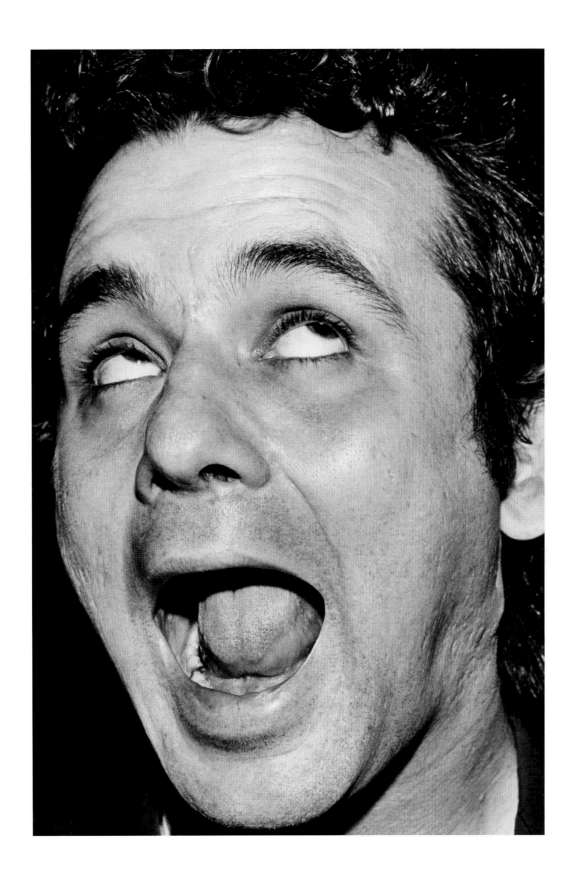

Bill Murray, Hollywood, 1979

Ivan Reitman, Hollywood, 1978

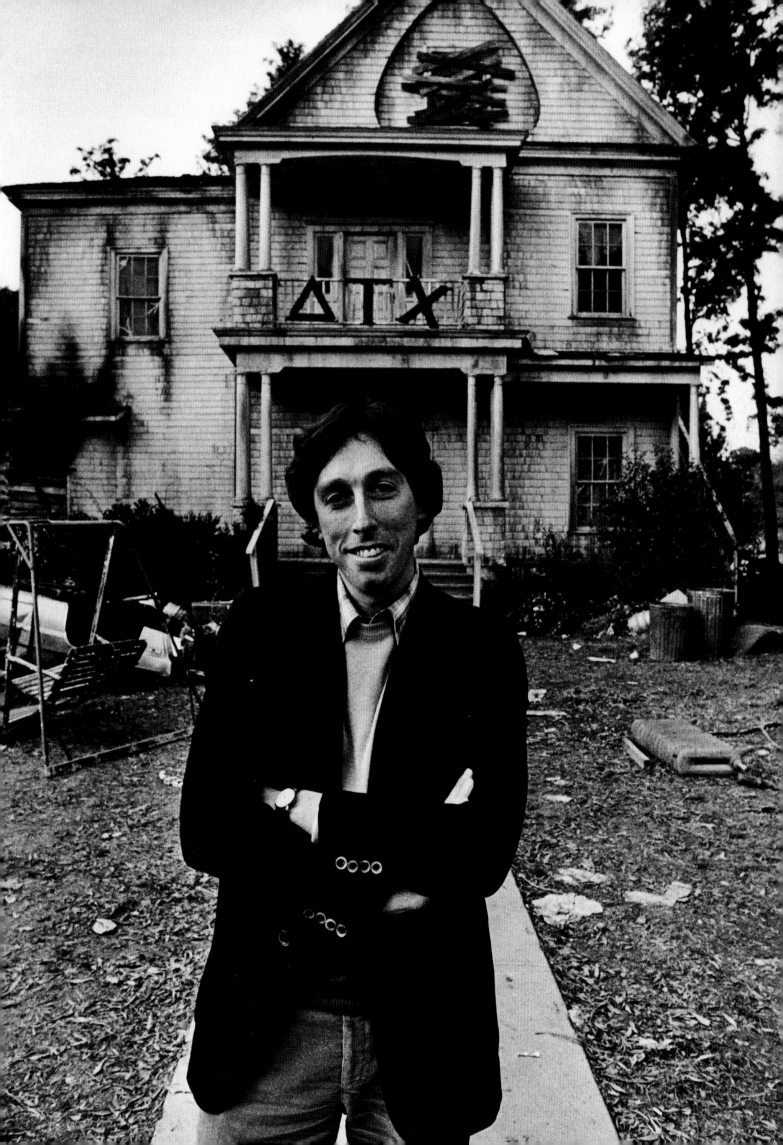

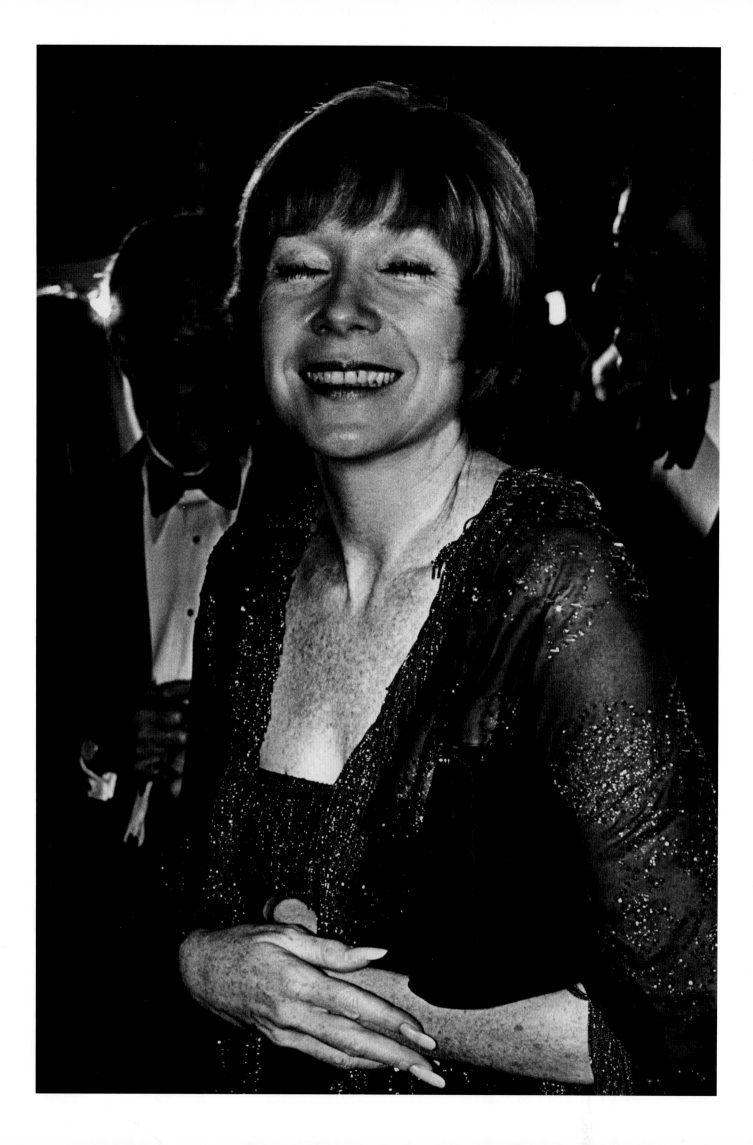

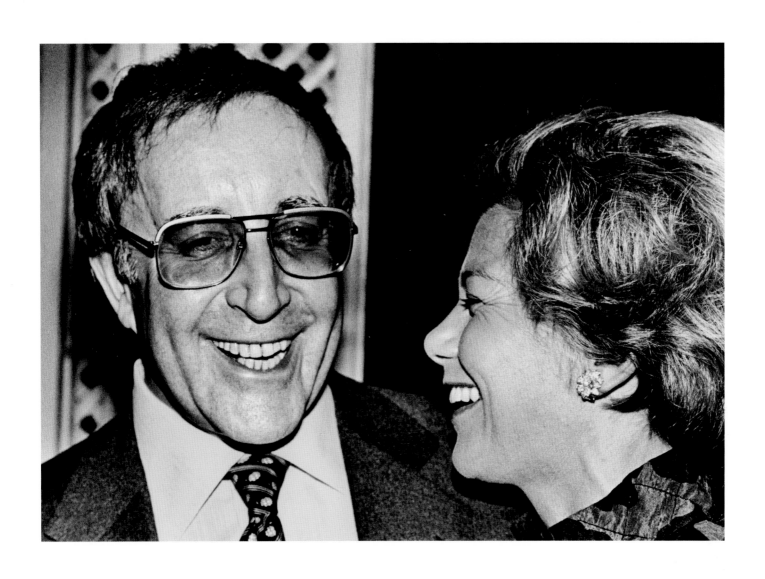

Left: Shirley MacLaine, Century City, 1979
Above: Peter Sellers and Marsha Mason, Beverly Hills, 1979

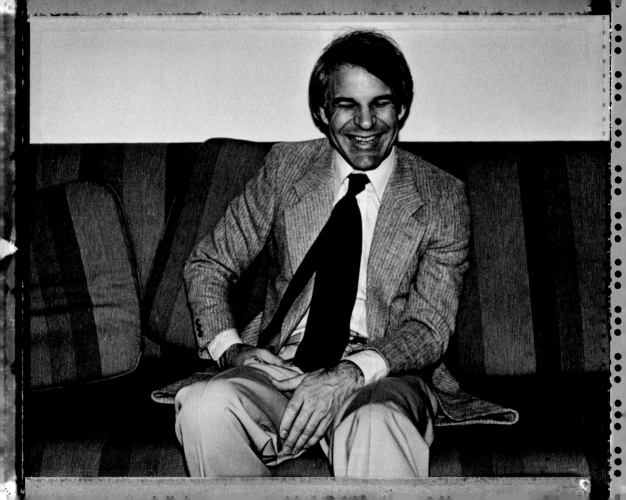

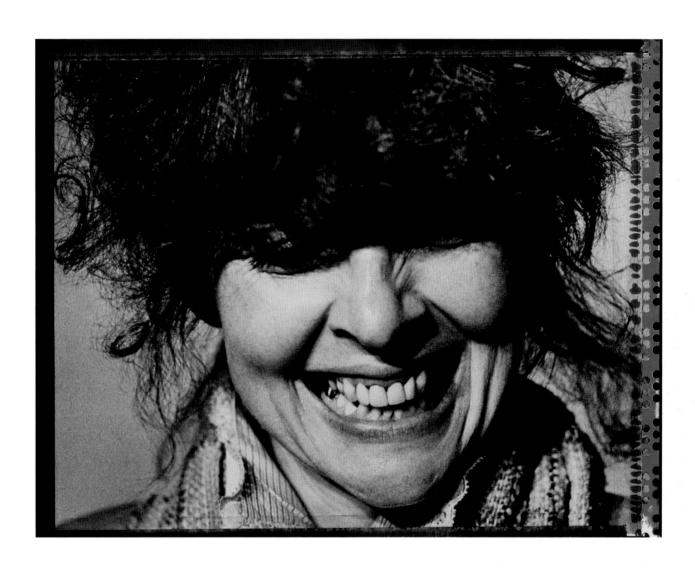

Left: Steve Martin, West Los Angeles, 1978
Above: Diane Keaton, Los Angeles, 1978

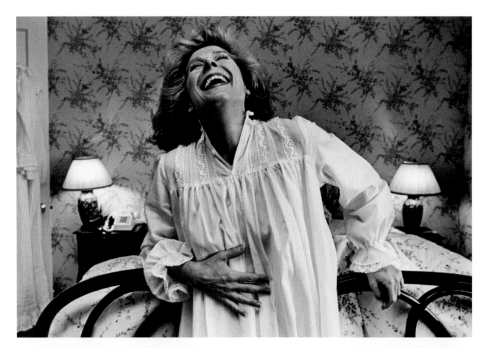

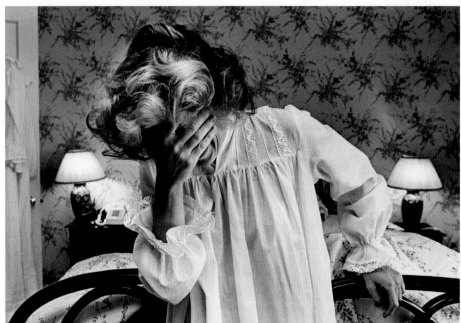

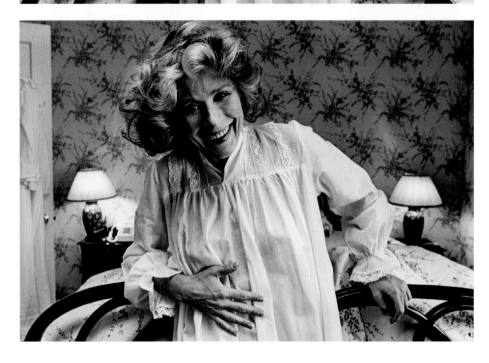

Above: Joan Hackett, Beverly Hills, 1978
Right: Karen Black, Los Angeles, 1982

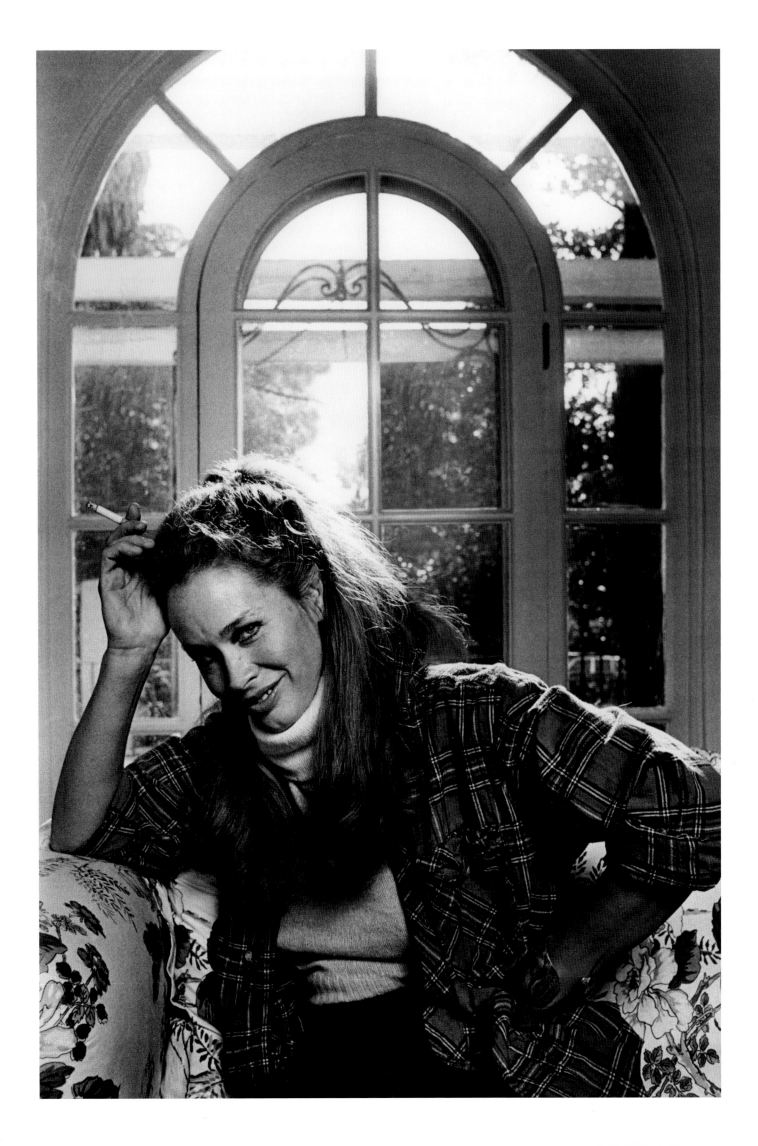

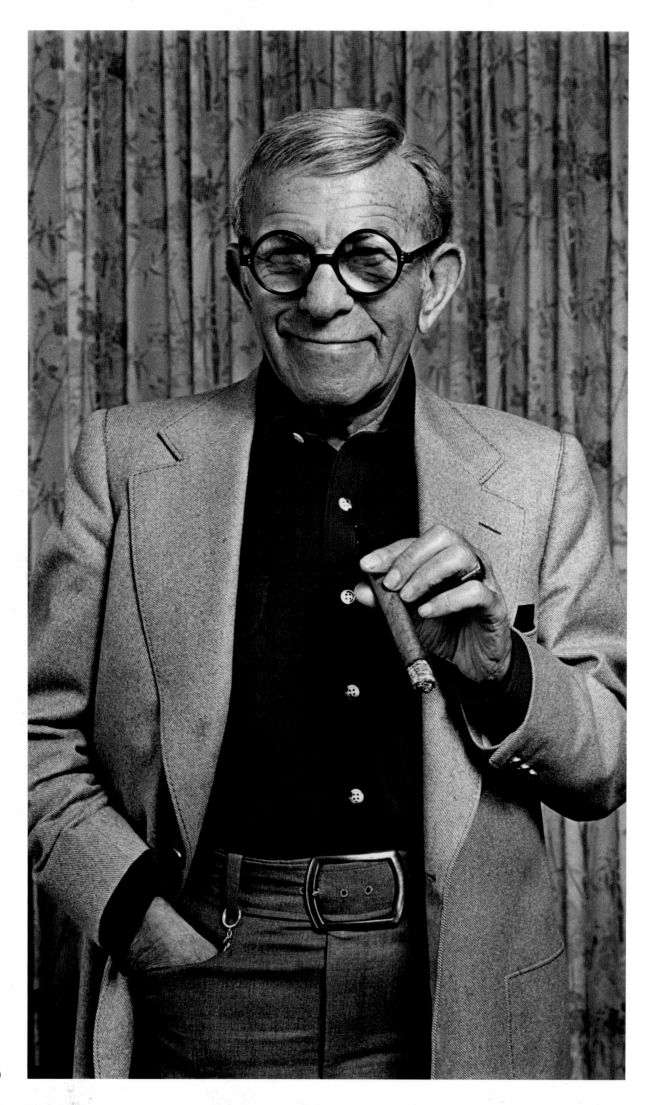

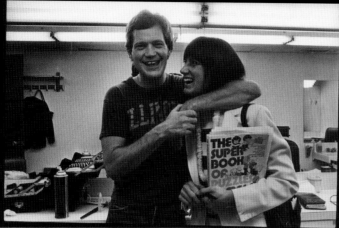
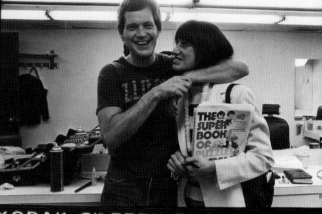

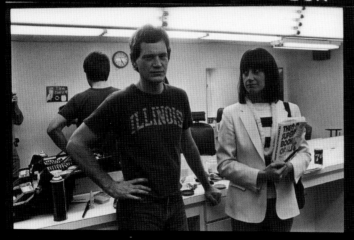
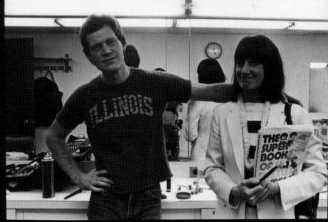

Left: George Burns, Beverly Hills, 1980
Above: David Letterman and Merrill Markoe, New York, 1982

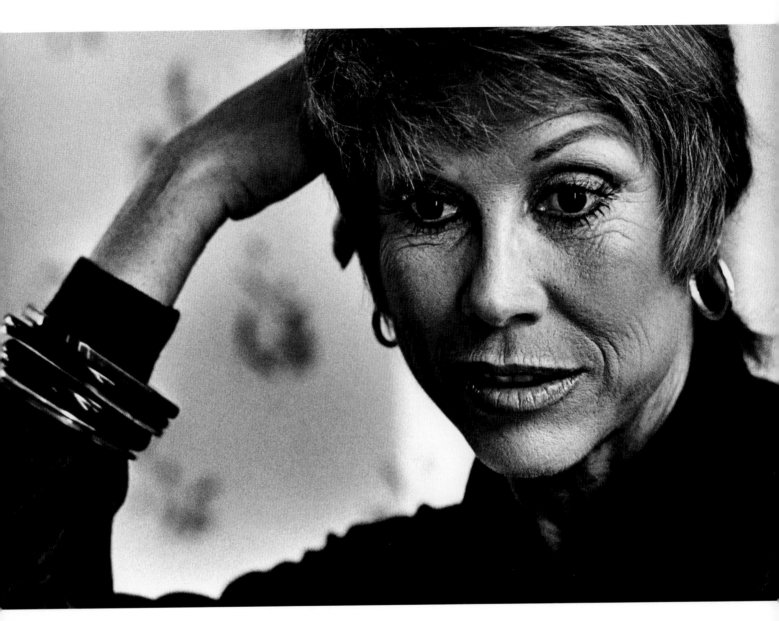

Mary Tyler Moore, Los Angeles, 1979

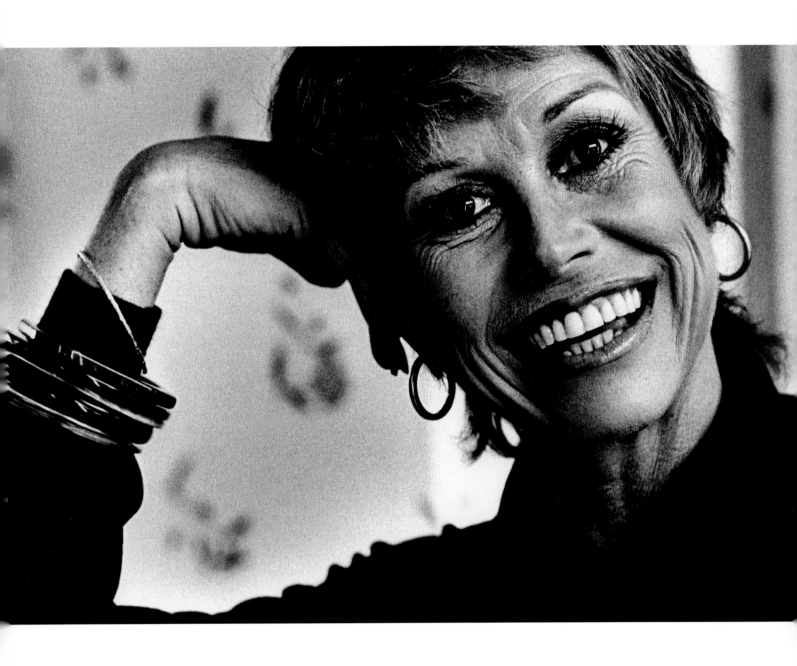

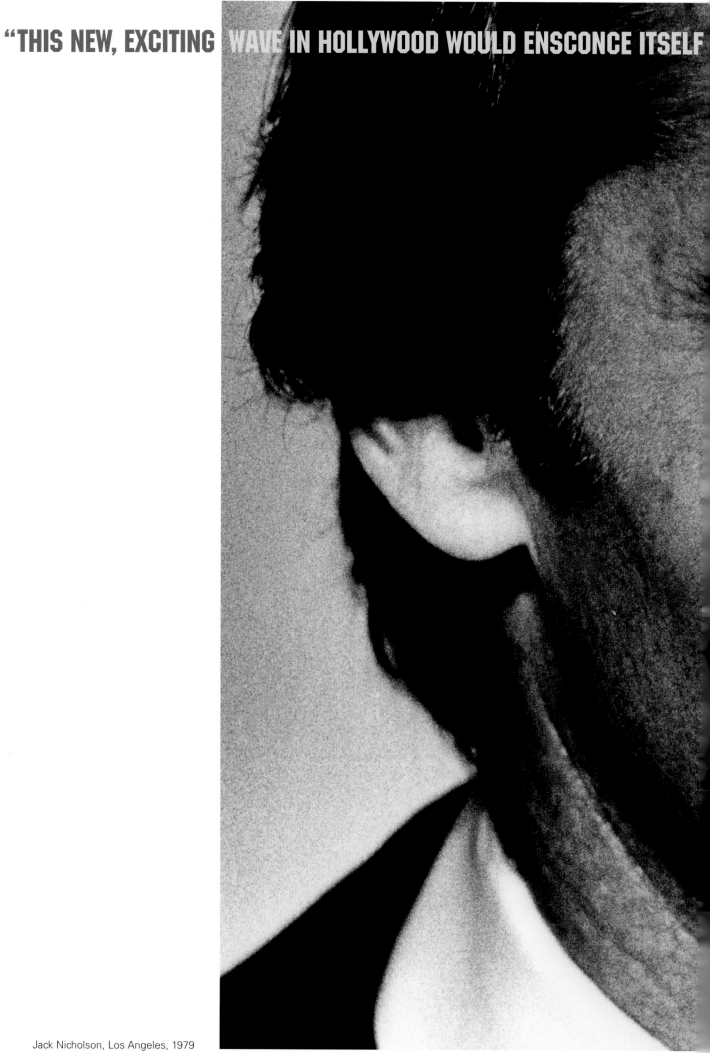

"THIS NEW, EXCITING WAVE IN HOLLYWOOD WOULD ENSCONCE ITSELF

Jack Nicholson, Los Angeles, 1979

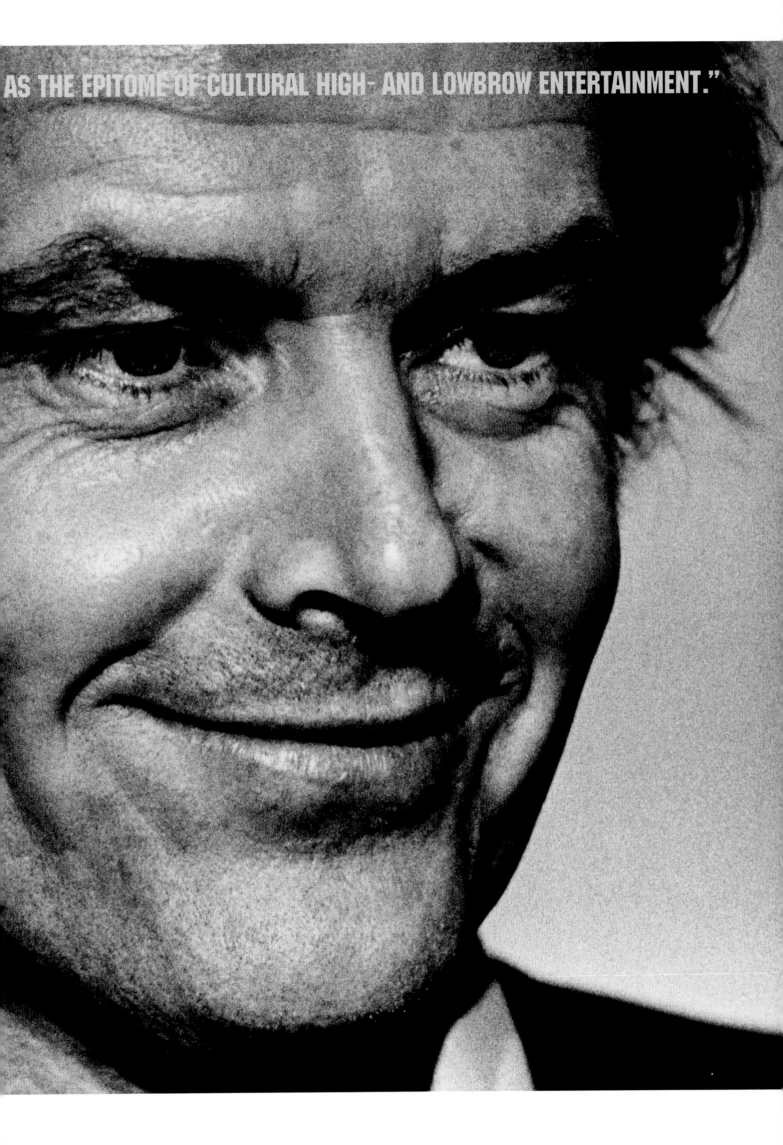

AS THE EPITOME OF CULTURAL HIGH- AND LOWBROW ENTERTAINMENT."

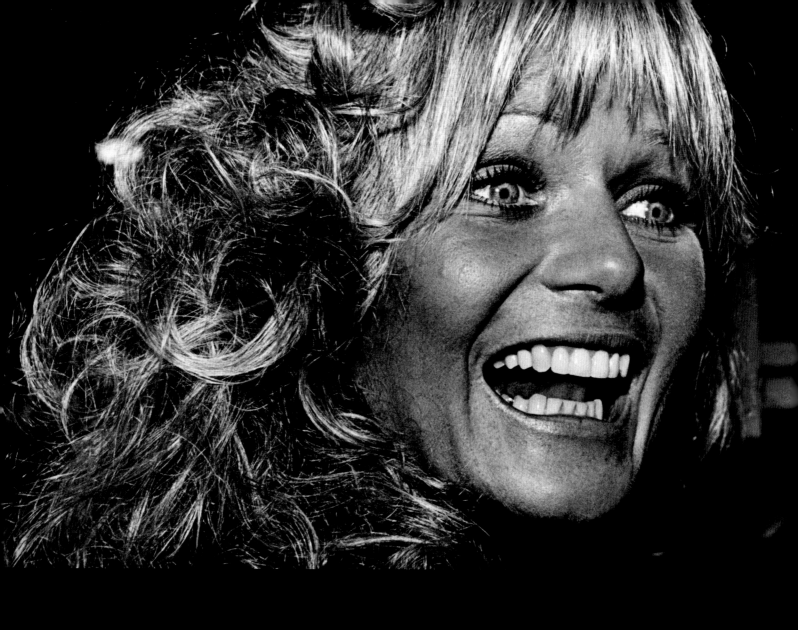

Above: Valerie Perrine, Los Angeles, 1978
Top right: Olivia Newton-John and
John Travolta, Hollywood, 1978
Bottom right: Farrah Fawcett, Los Angeles, 1978
Overleaf: The Premiere of *Grease*, Hollywood, 1978

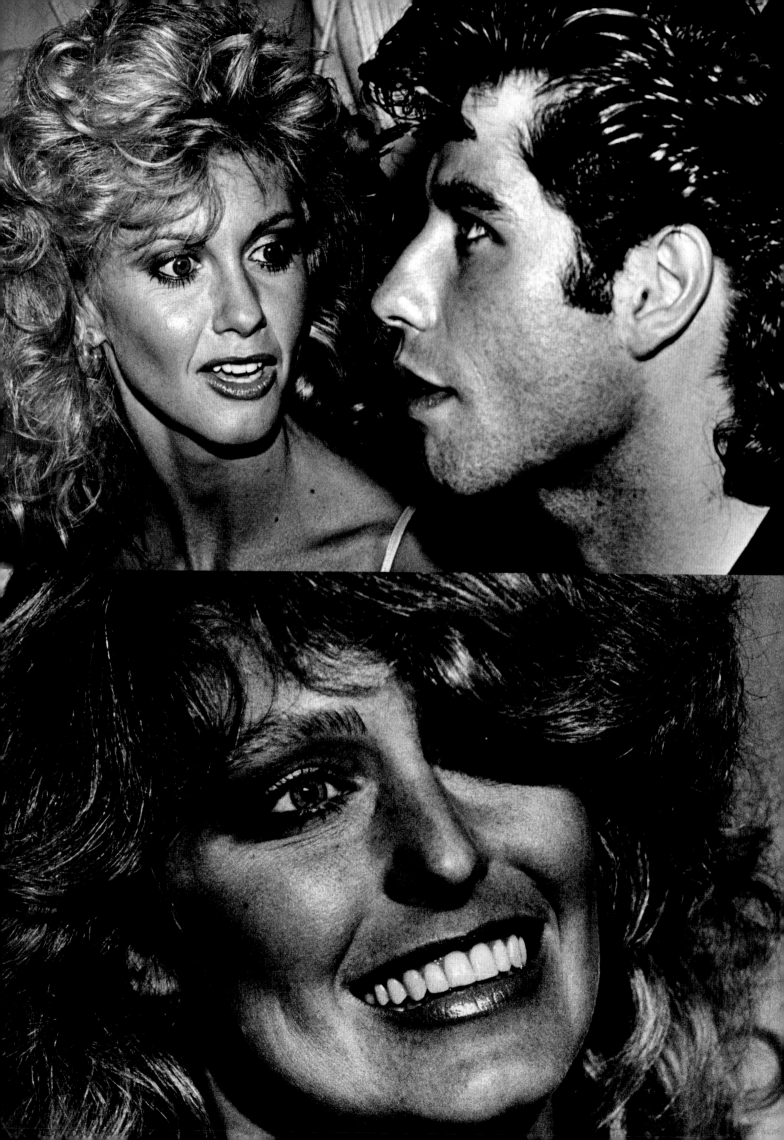

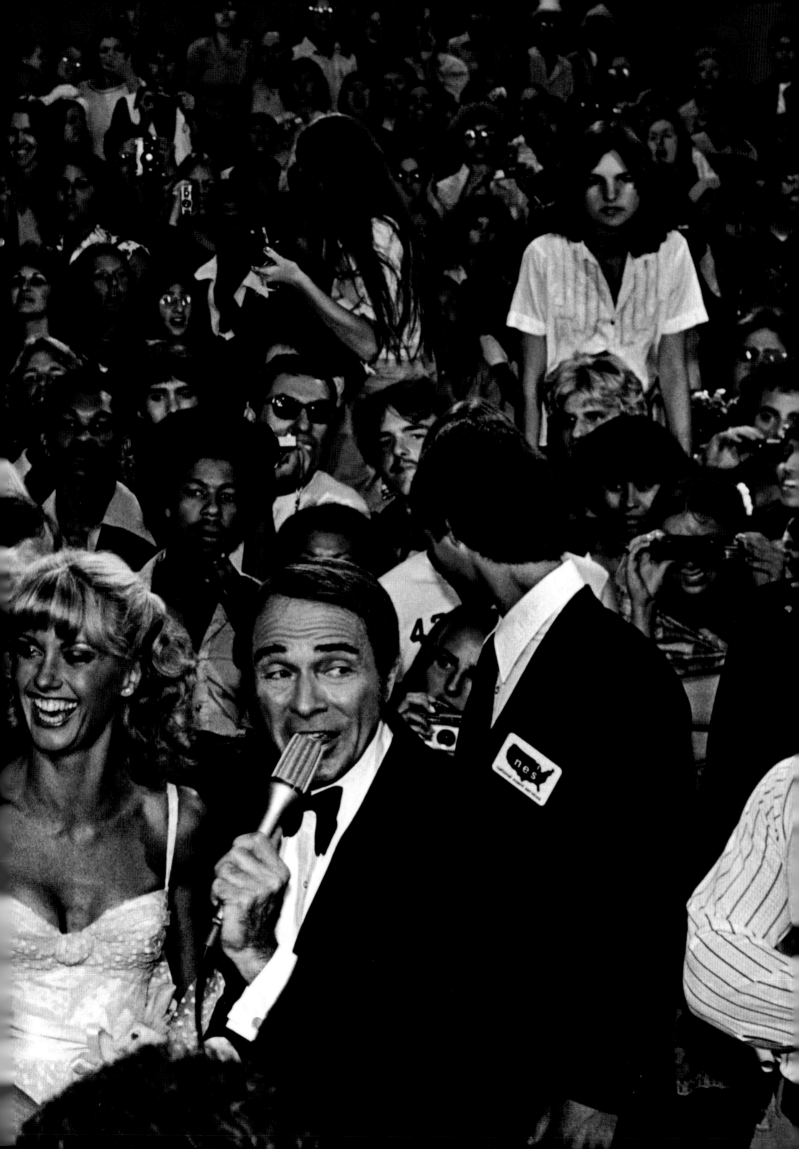

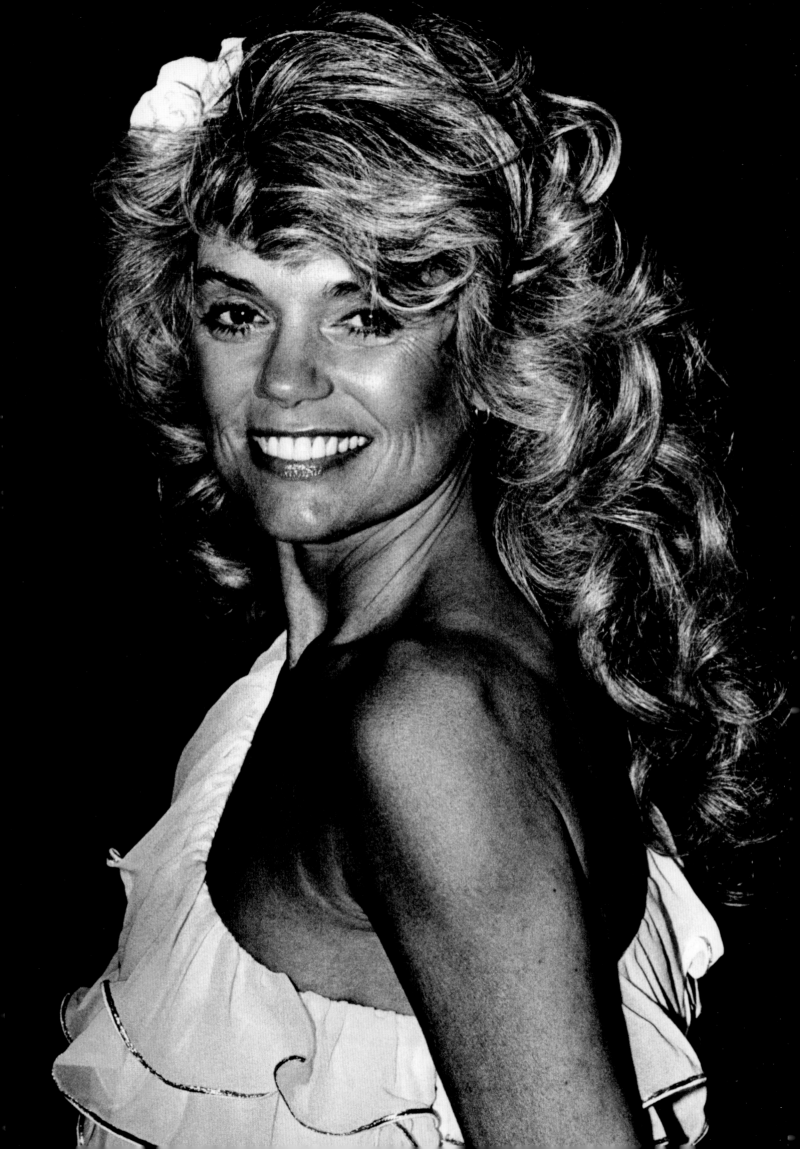

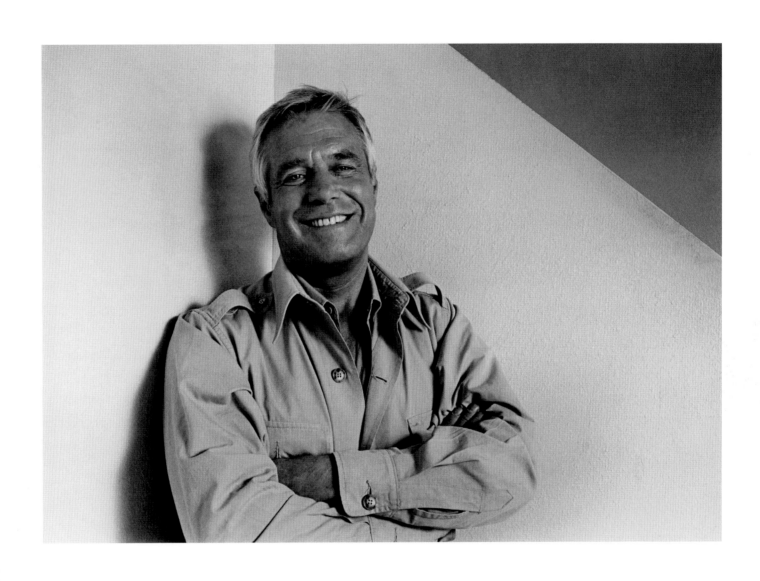

Left: Dyan Cannon, Los Angeles, 1979
Above: George Peppard, Hollywood, 1980

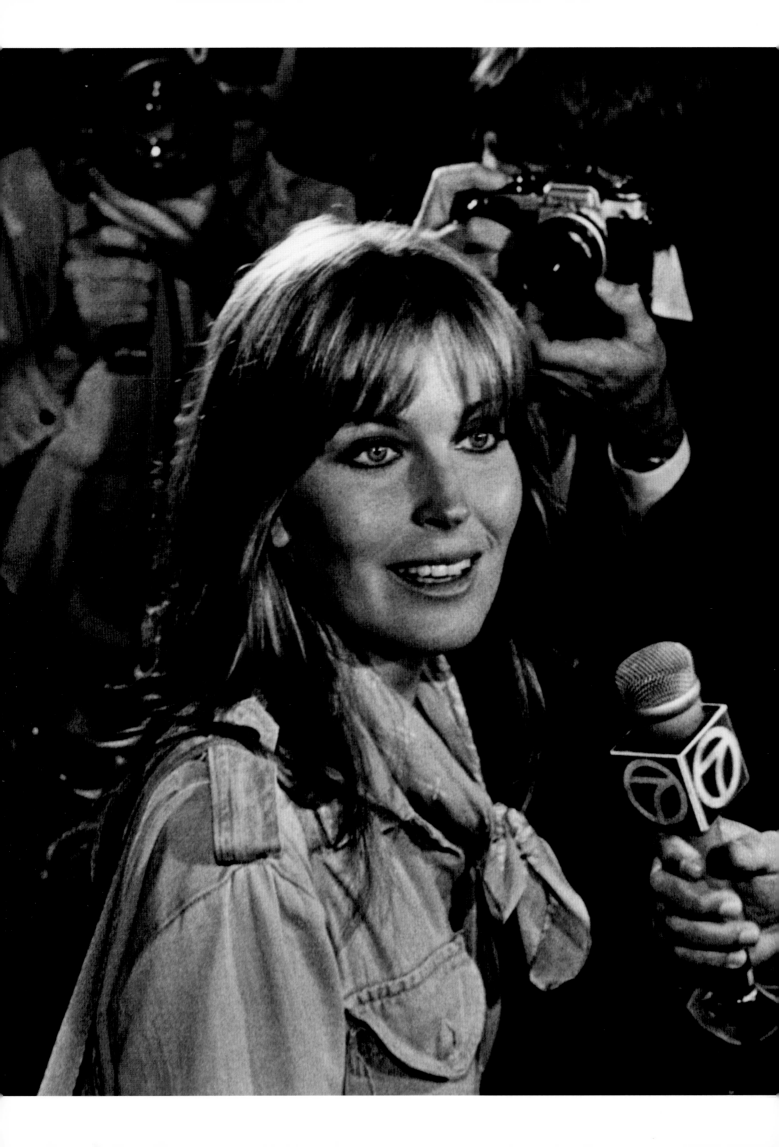

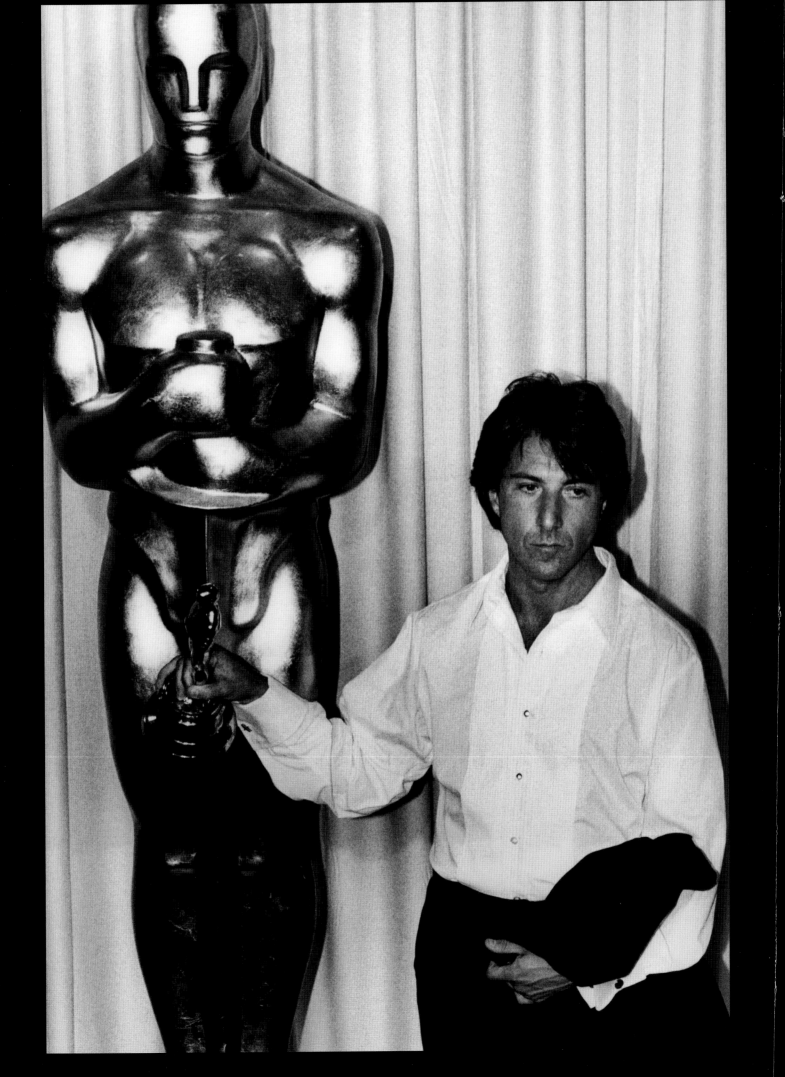

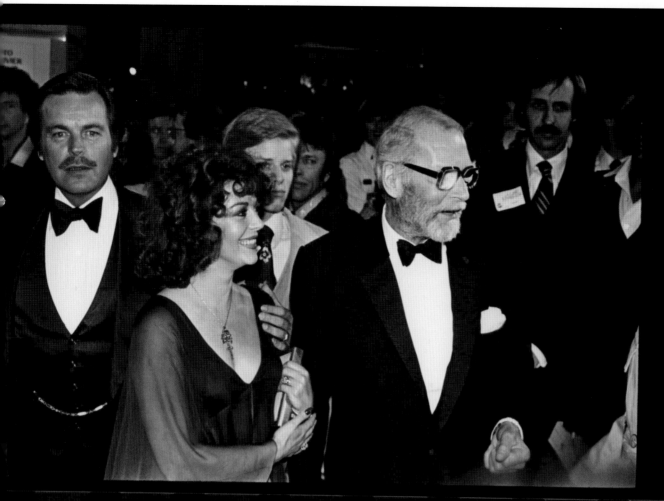

KODAK SAFETY FILM 5063

→31 →31A

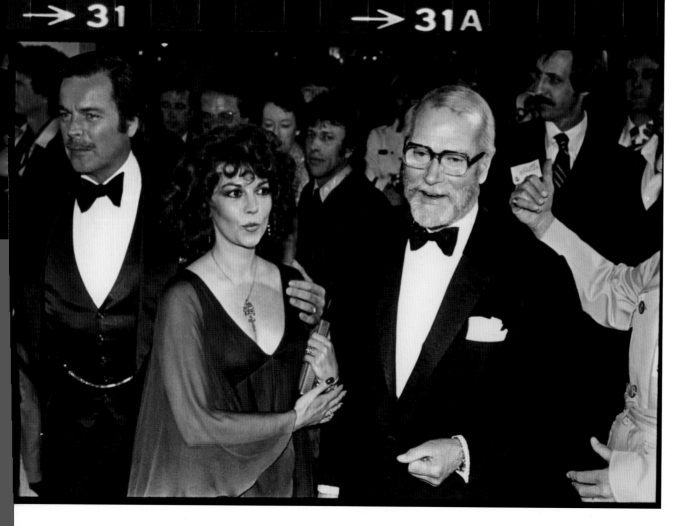

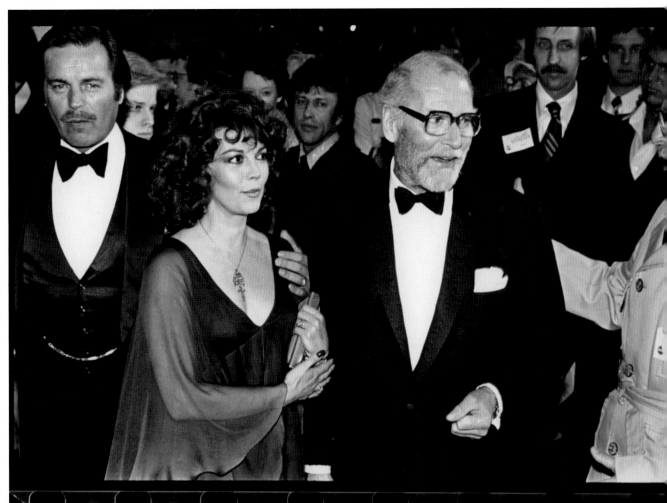

AK SAFETY FILM 5063

→30 →30A

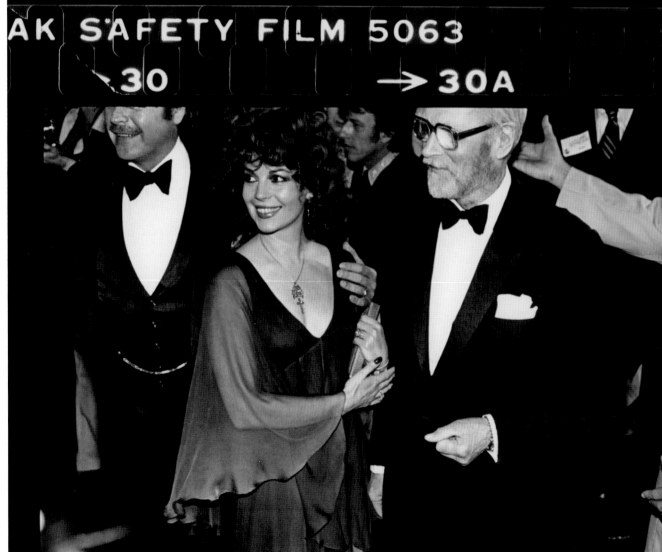

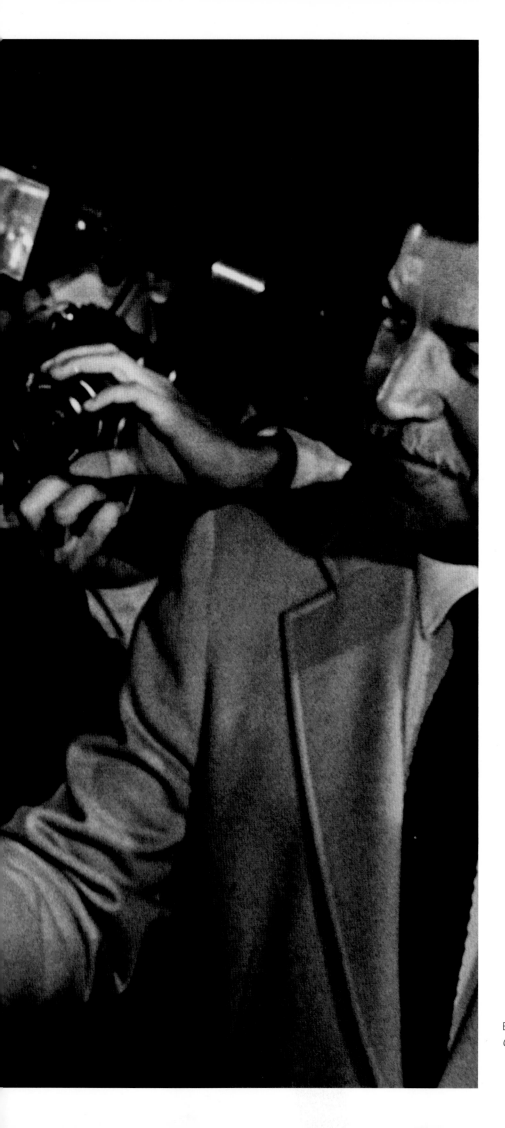

Bo Derek, Los Angeles, 1980
Overleaf: Natalie Wood, Century City, 1979

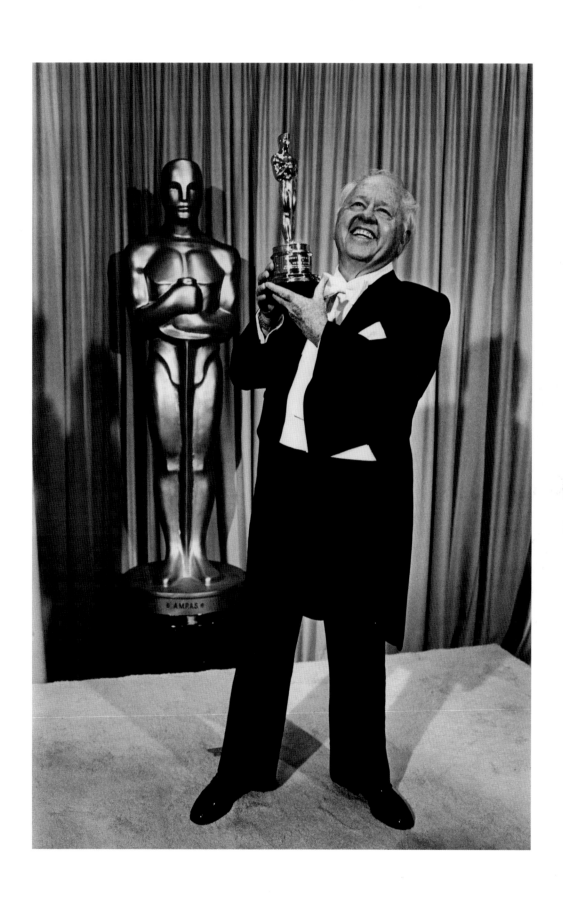

Left: Dustin Hoffman, Los Angeles, 1979
Above: Mickey Rooney, Los Angeles, 1982

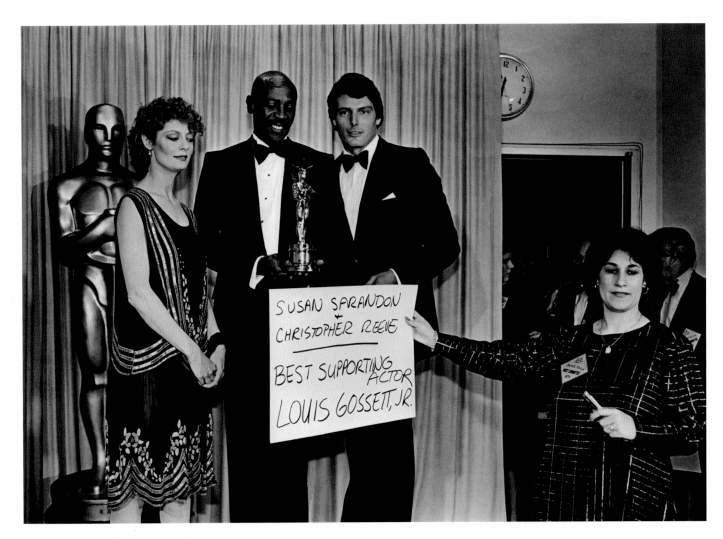

Louis Gossett Jr., Los Angeles, 1983

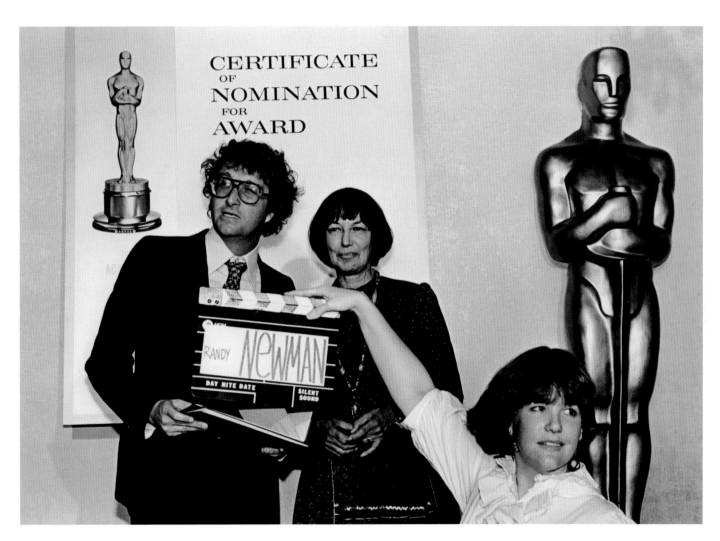

Randy Newman, Beverly Hills, 1981
Overleaf: Frank Sinatra and Friends, Las Vegas, 1979

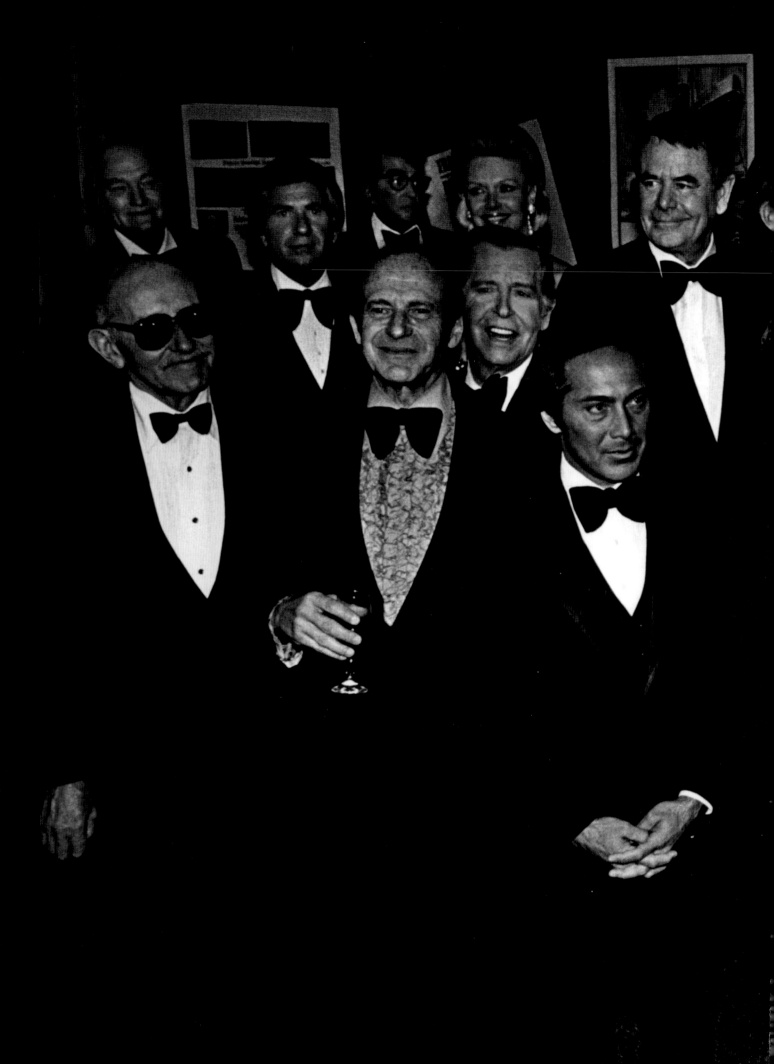

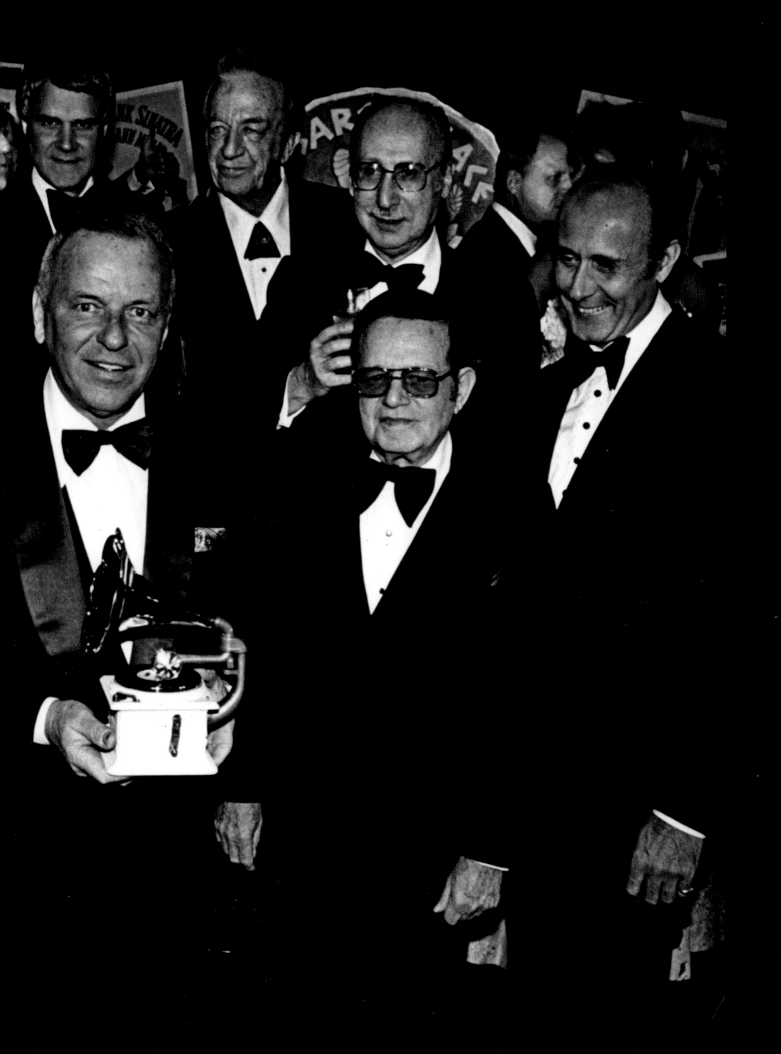

"FROM THE GRAMMYS TO THE EMMYS, THE GOLDEN GLOBES

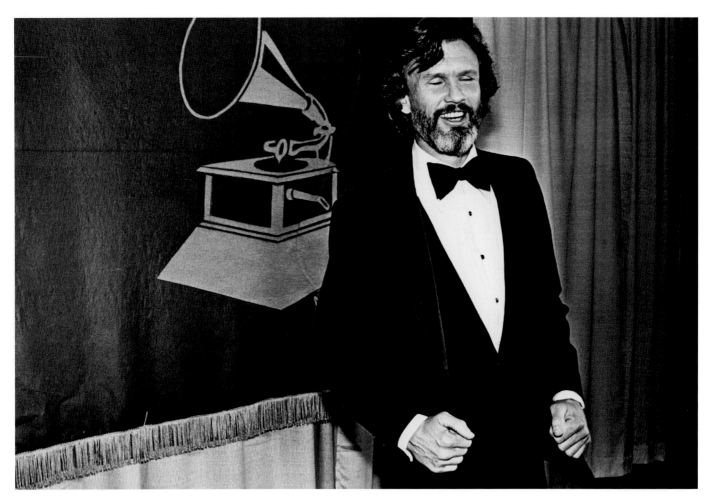

Kris Kristofferson, Los Angeles, 1979

TO THE OSCARS, HOLLYWOOD LOVES TO CELEBRATE ITSELF."

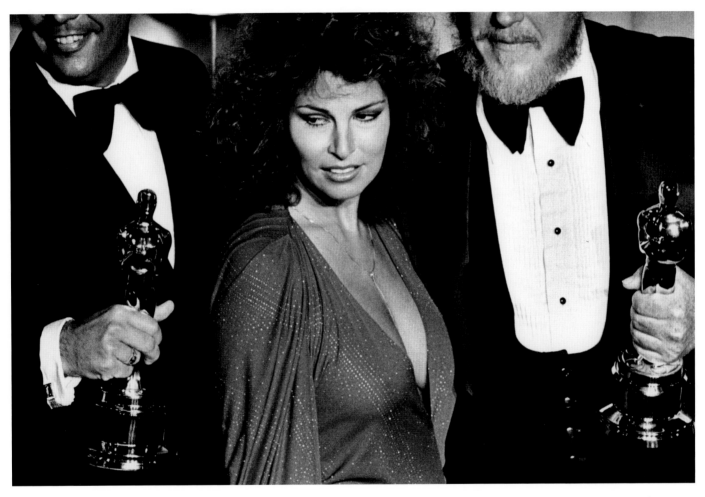

Raquel Welch, Los Angeles, 1980
Overleaf: Henry Fonda, Beverly Hills, 1981

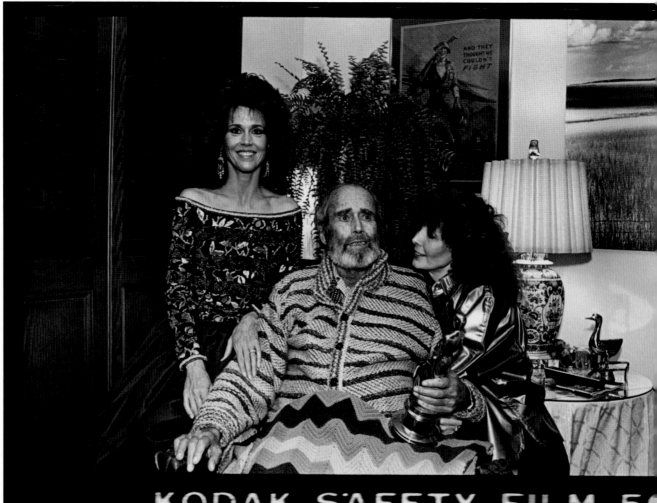

KODAK SAFETY FILM 5

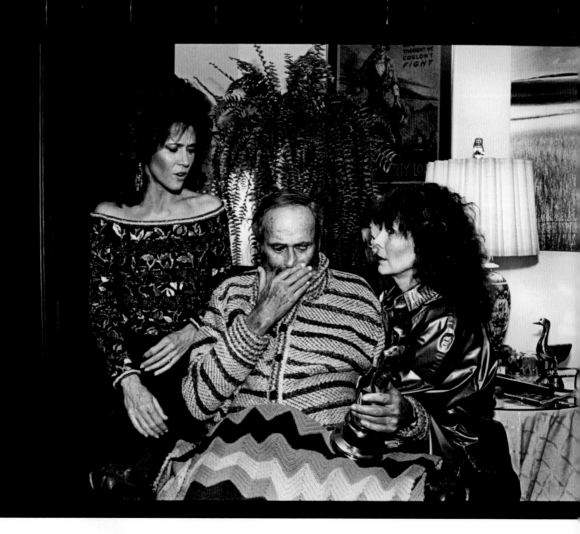

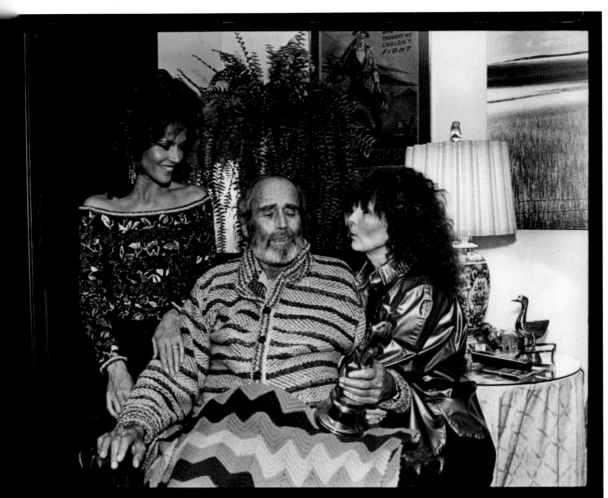

KODAK SAFE

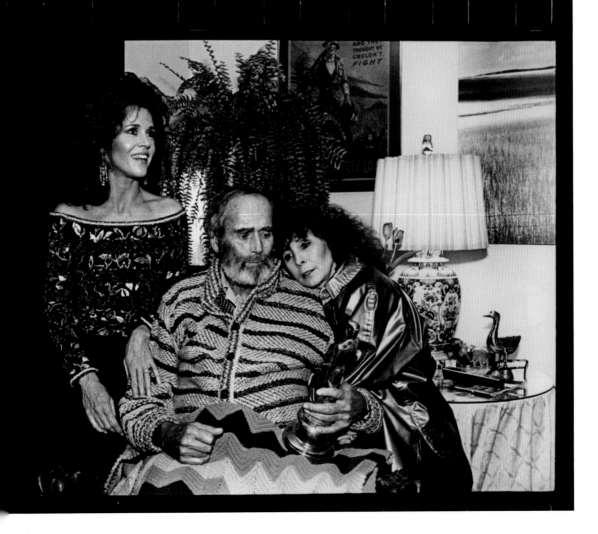

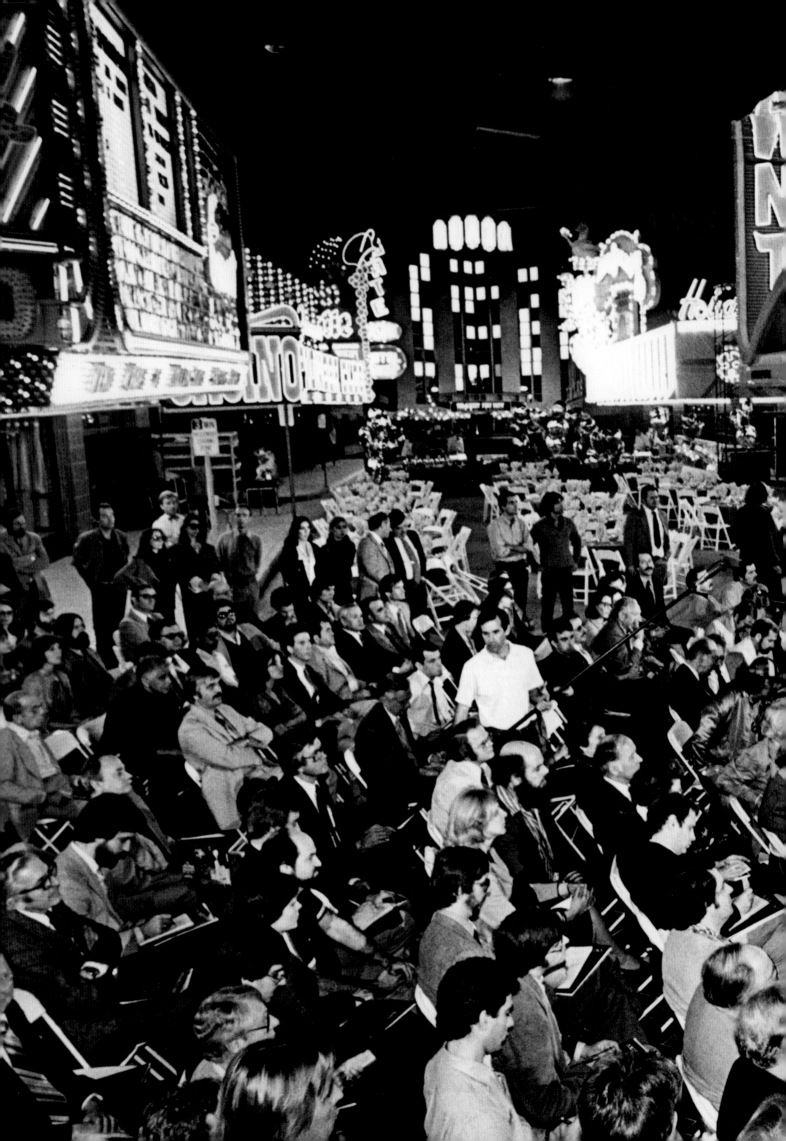

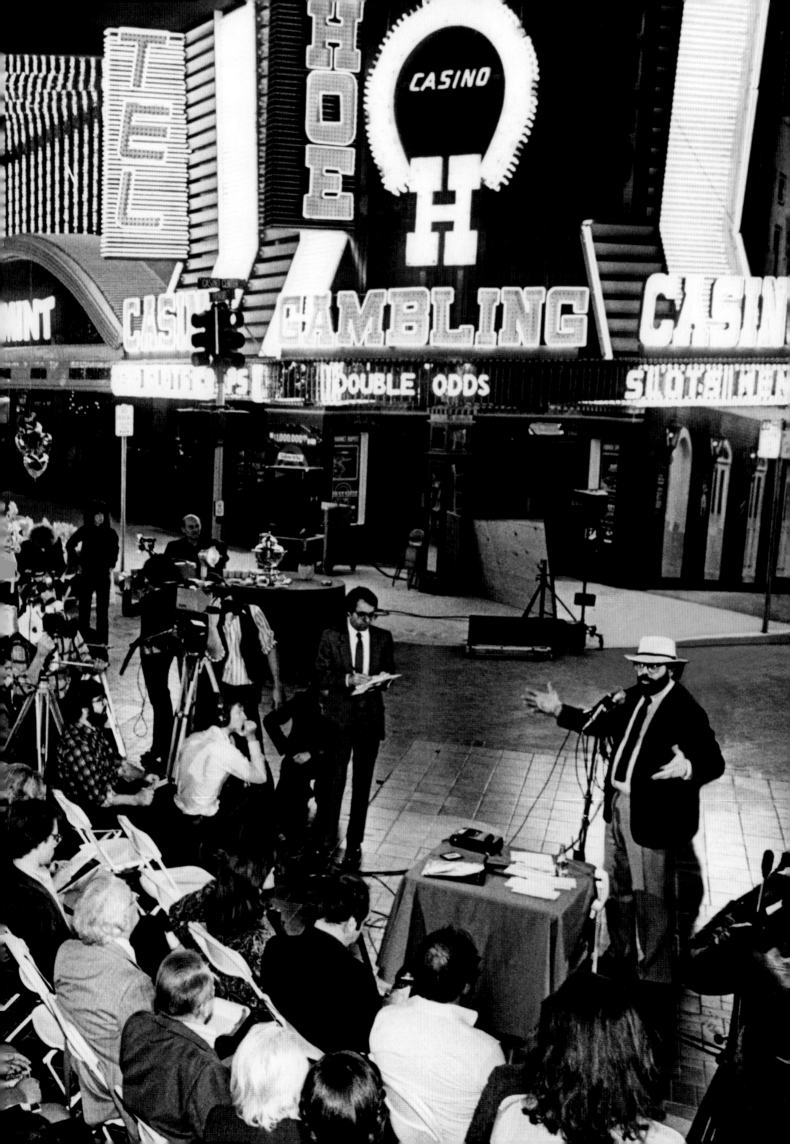

"NO FADE TO BLACK, NO MEMORABLE LINES.

HOLLYWOOD WOULD BE NOTHING WITHOUT WRITERS."

Preceding pages 136–137: Francis Ford Coppola, Hollywood, 1981
Left: Nora Ephron, Los Angeles, 1976
Above: Robert Towne, Beverly Hills, 1981

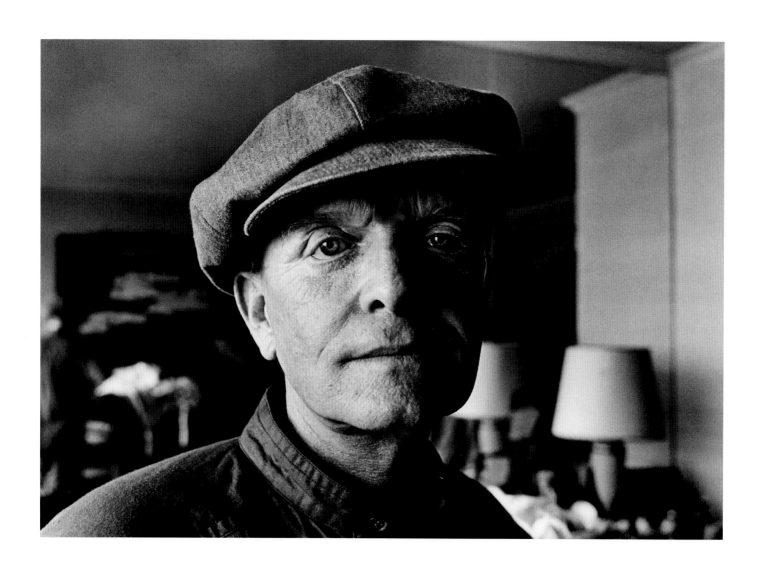

Above: Truman Capote, New York, 1980
Right: Brian Moore, Malibu, 1979

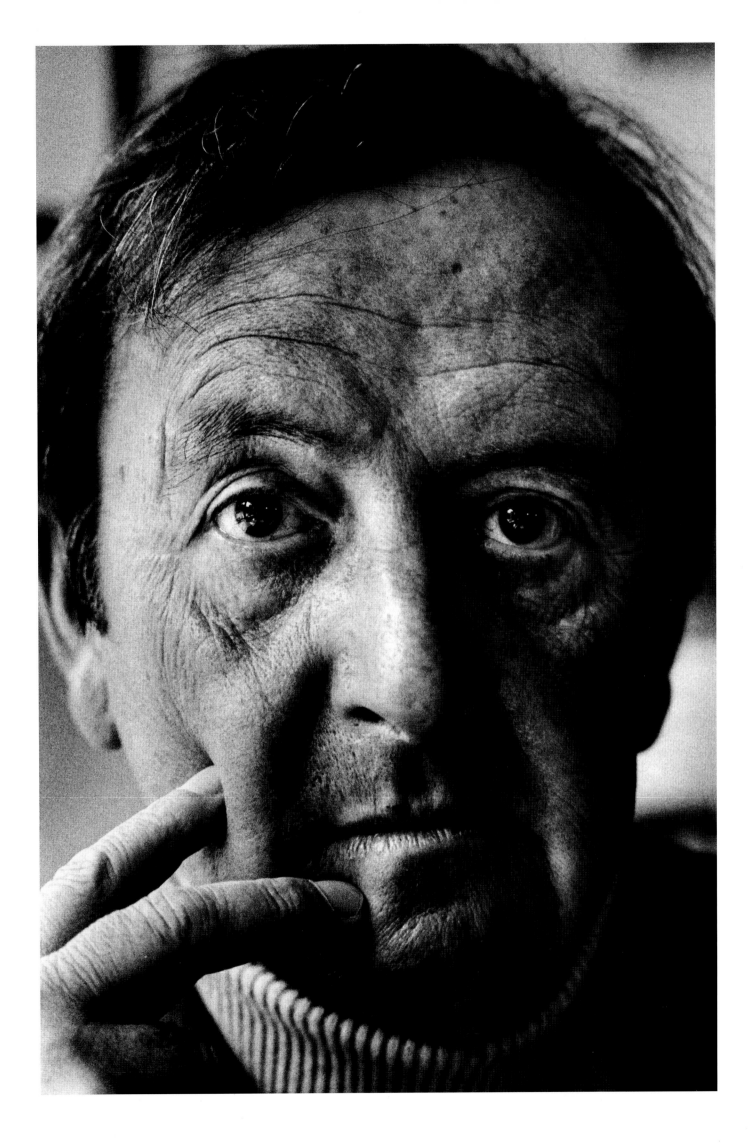

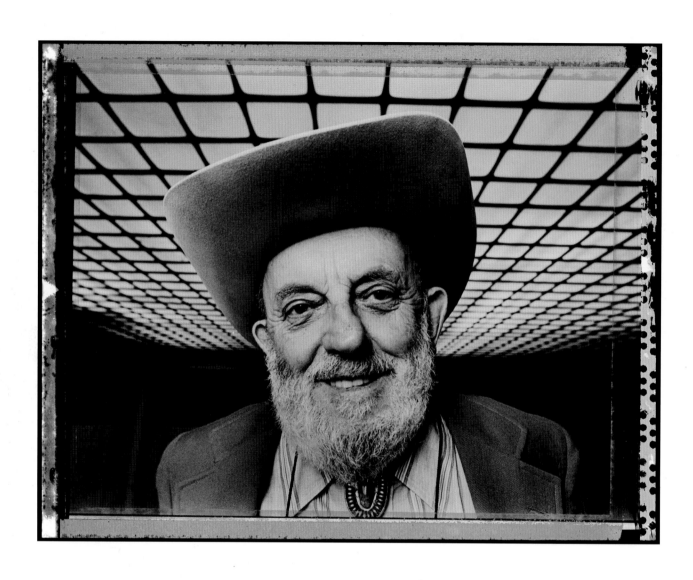

142

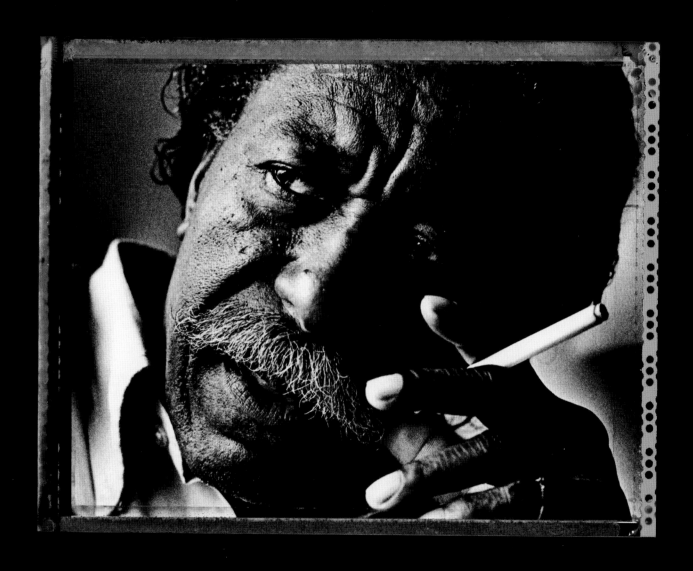

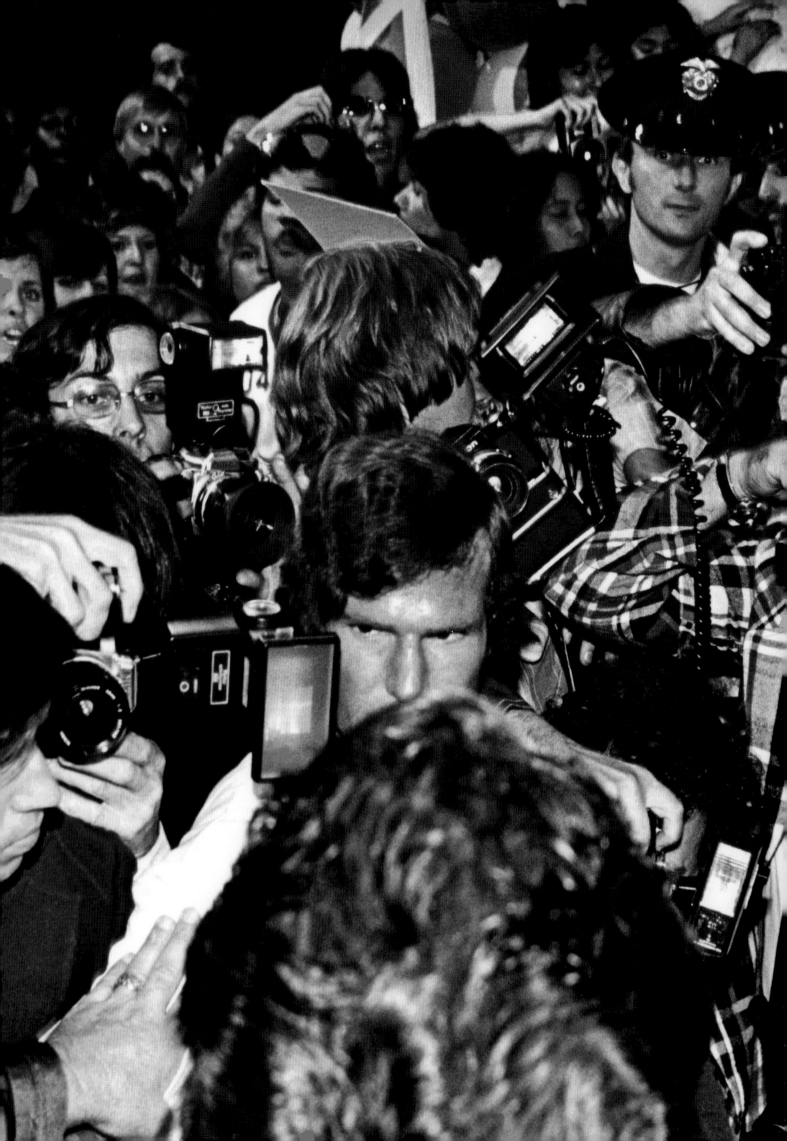

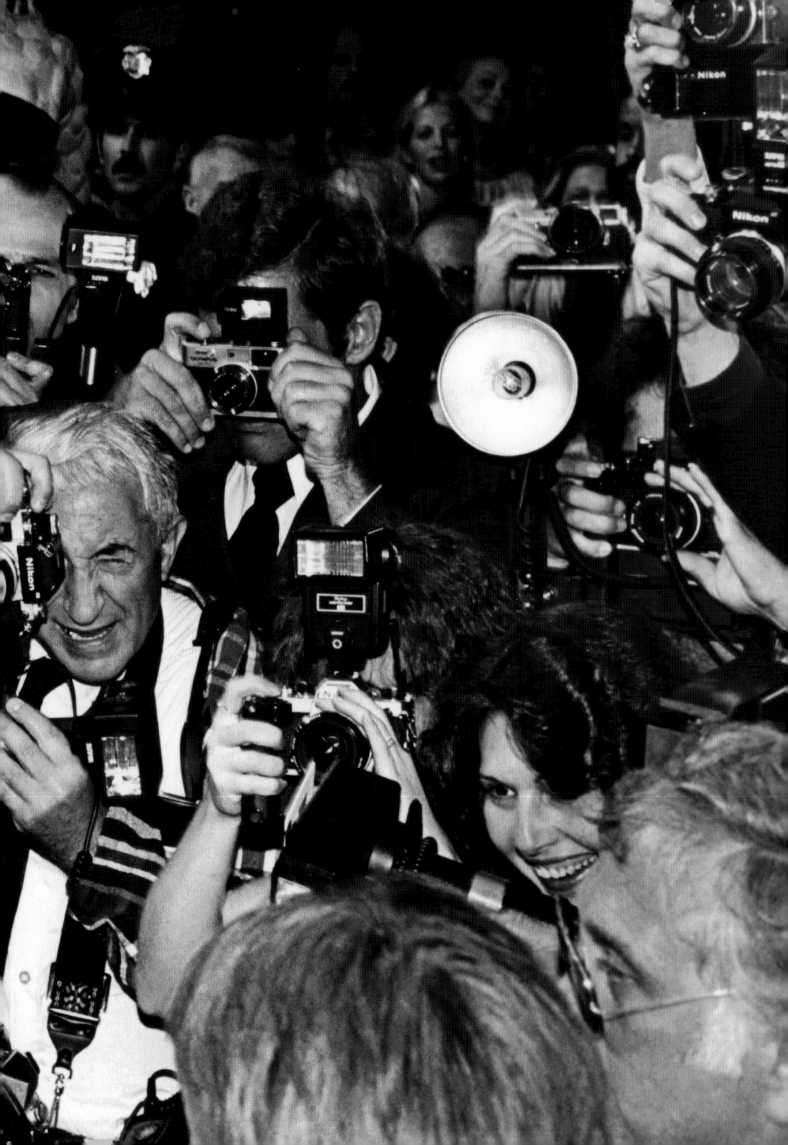

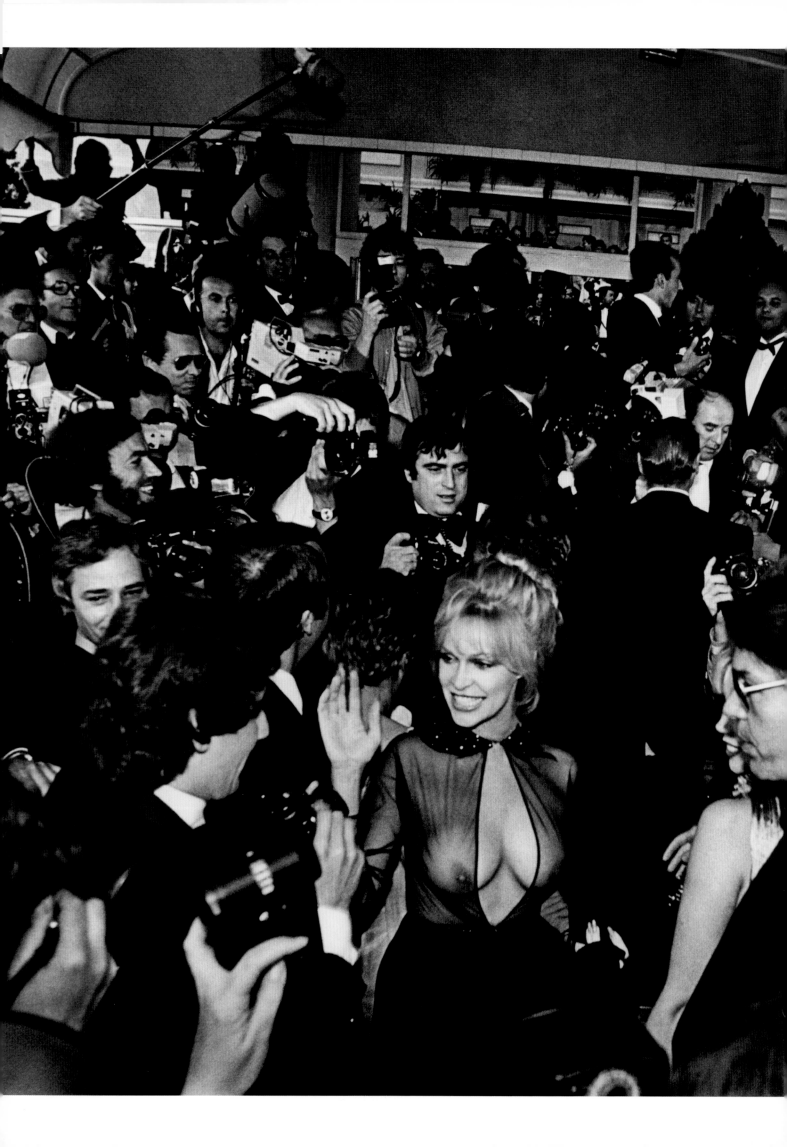

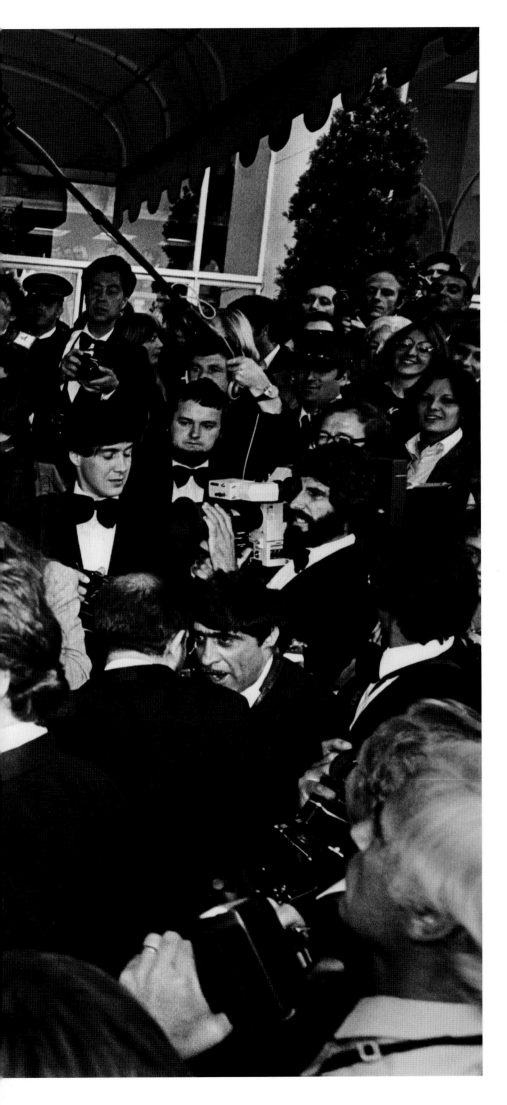

Bobbie Bresee, Cannes, France, 1980 147

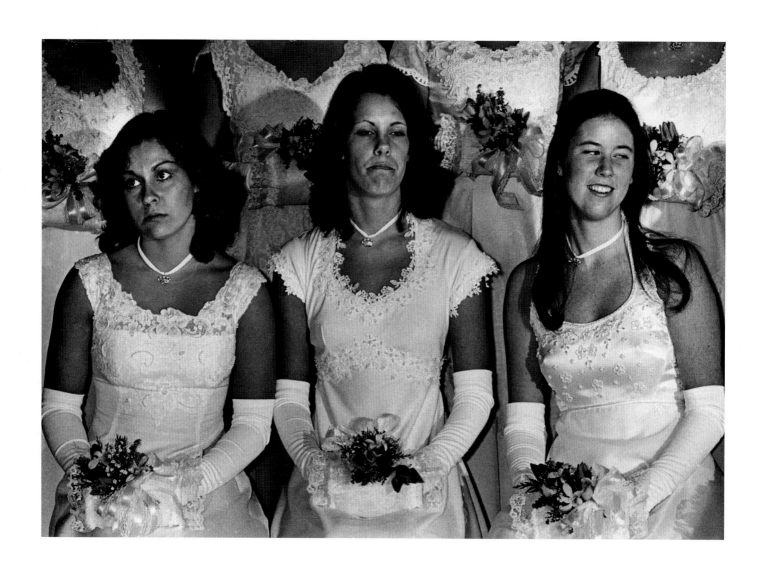

"THE RAUCOUS EDGES OF SHOWBIZ CULTURE MADE LA THE MELTING POT

Above: Debutante Ball, San Marino, 1978
Right: Punk Girls, Los Angeles, 1979

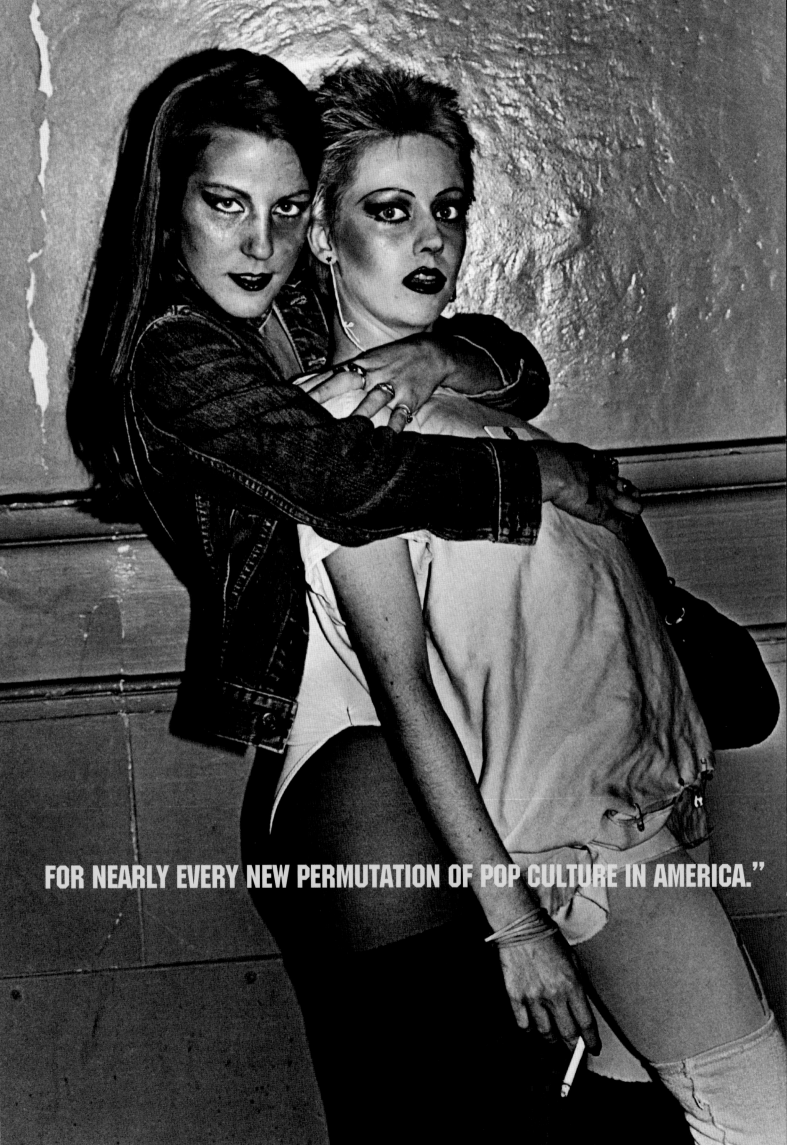

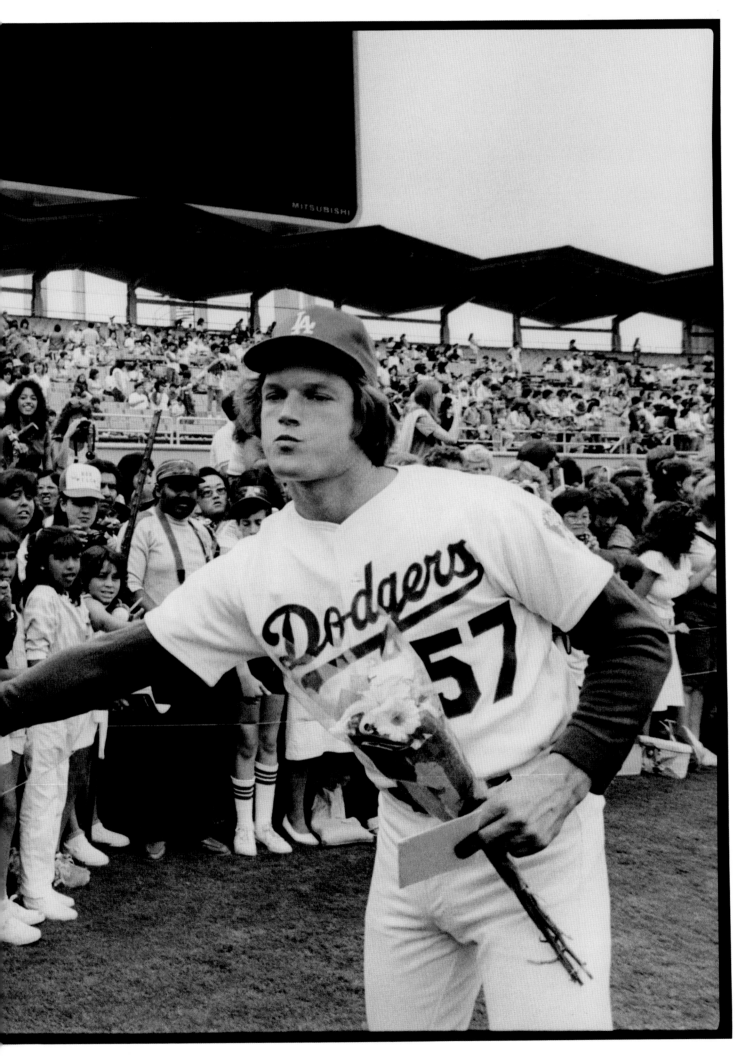

Steve Howe, Los Angeles, 1981 151

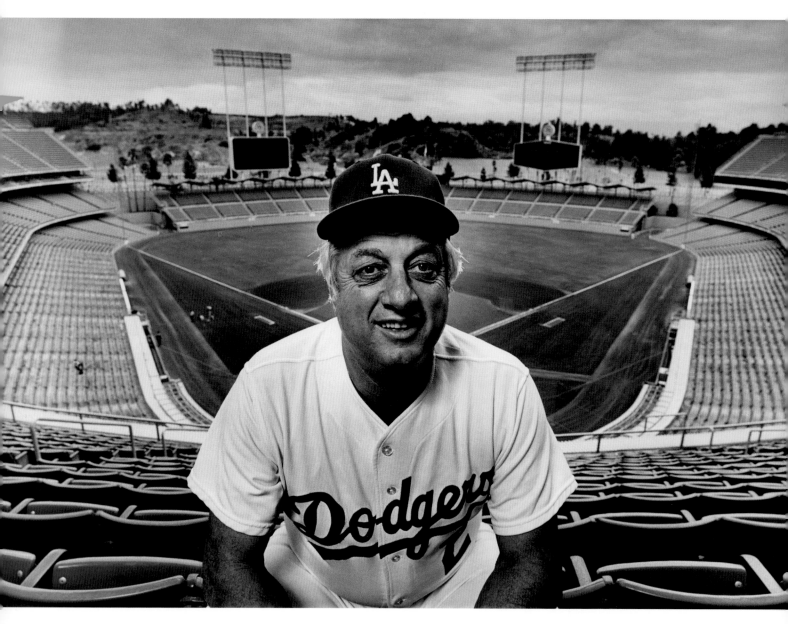

Tommy Lasorda, Los Angeles, 1980

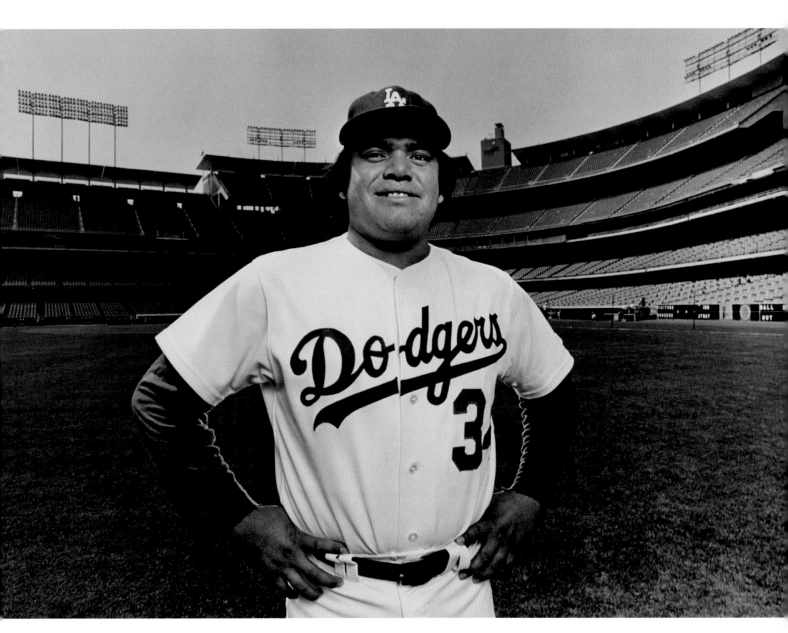

Fernando Valenzuela, Los Angeles, 1980

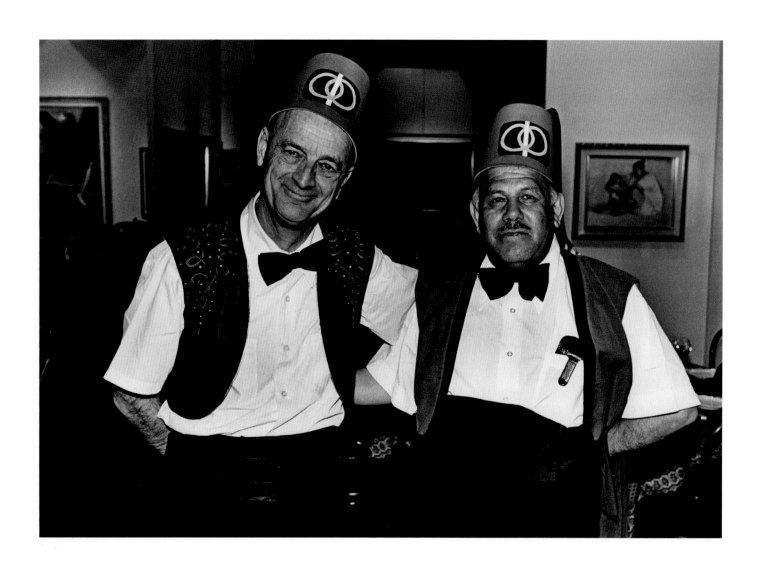

Above: Waiters at Chasen's Restaurant, Beverly Hills, 1979
Right: Allan Carr, Los Angeles, 1980

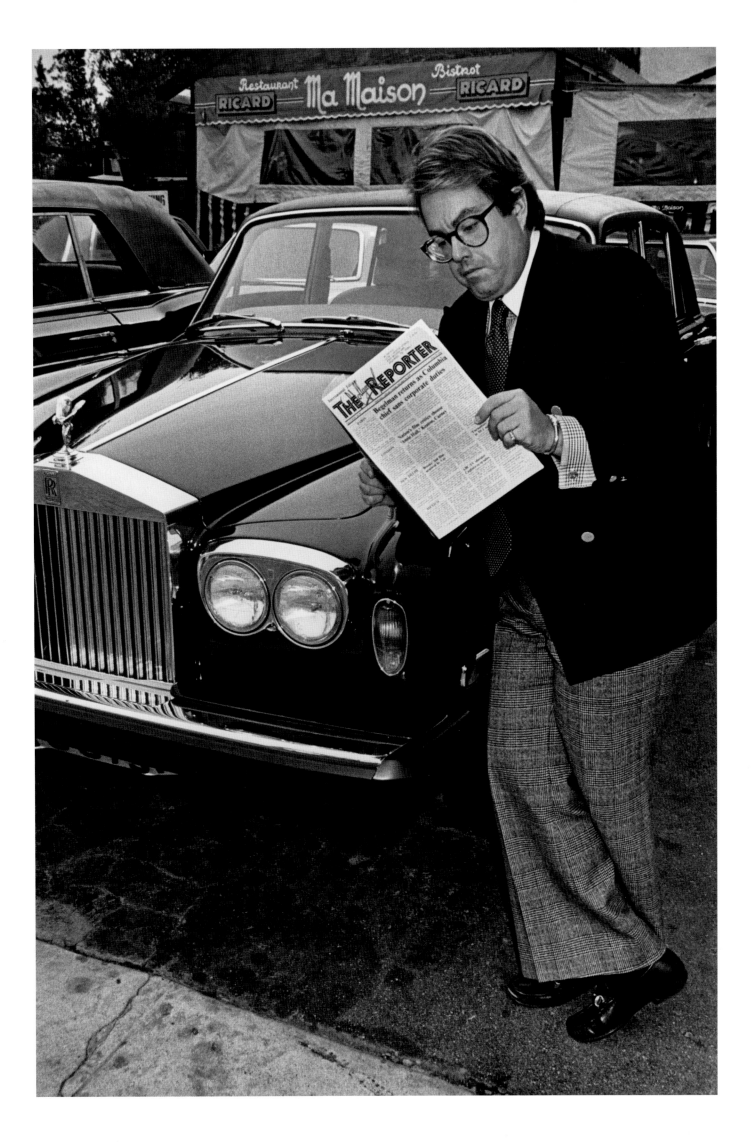

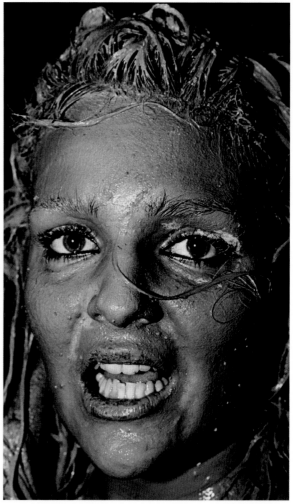

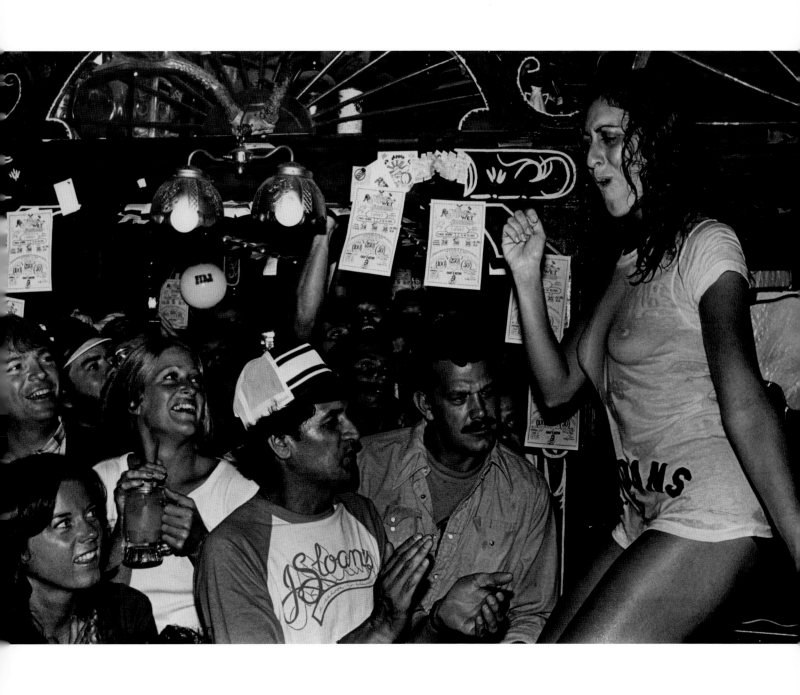

Left: Female Mud Wrestling, Hollywood, 1980
Above: Wet T-Shirt Contest, Hollywood, 1979

Willie and Cynthia Shoemaker,
Los Angeles, 1979

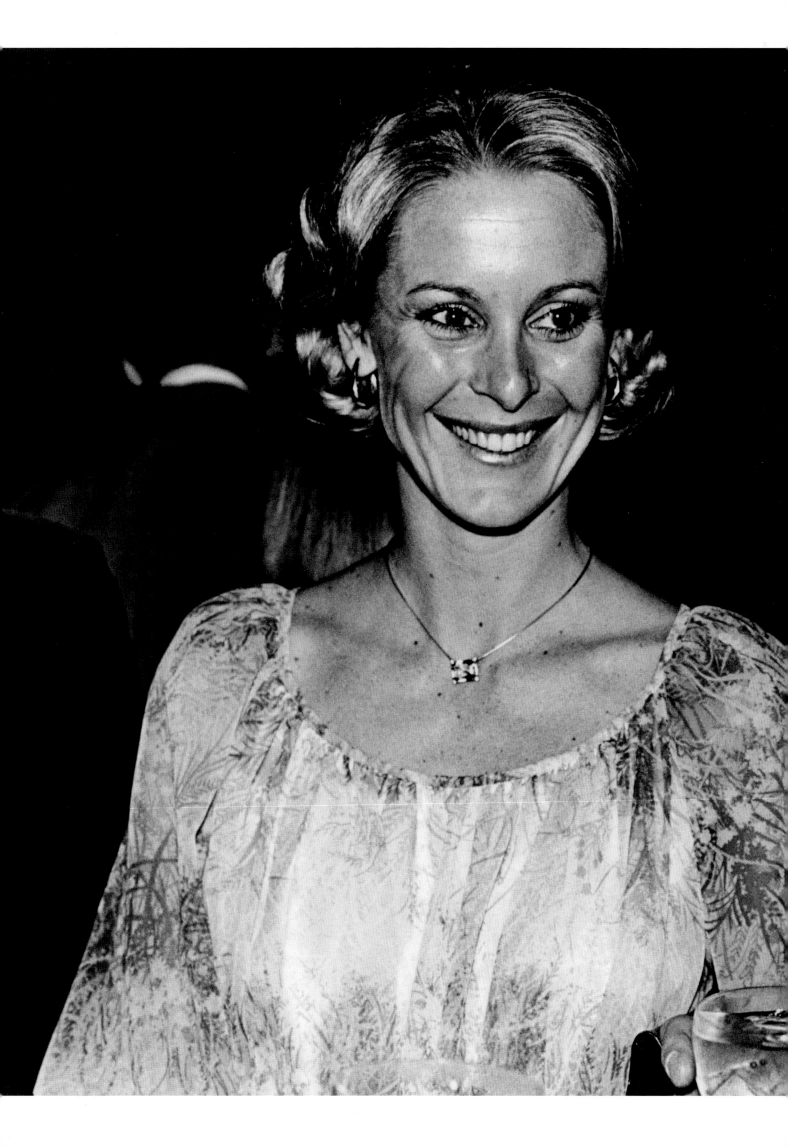

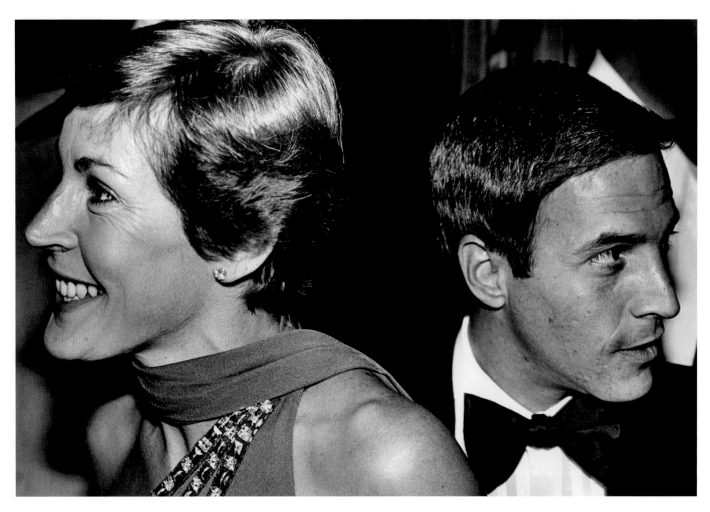

Helen Reddy and Jeff Wald, Los Angeles, 1979

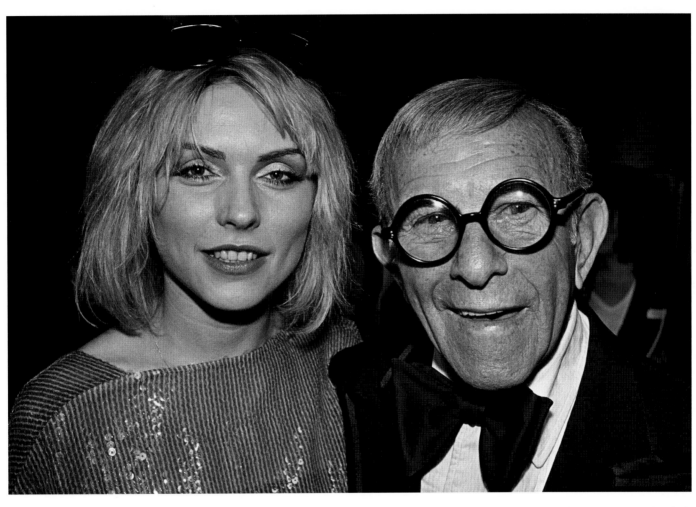

Deborah Harry and George Burns, Los Angeles, 1980

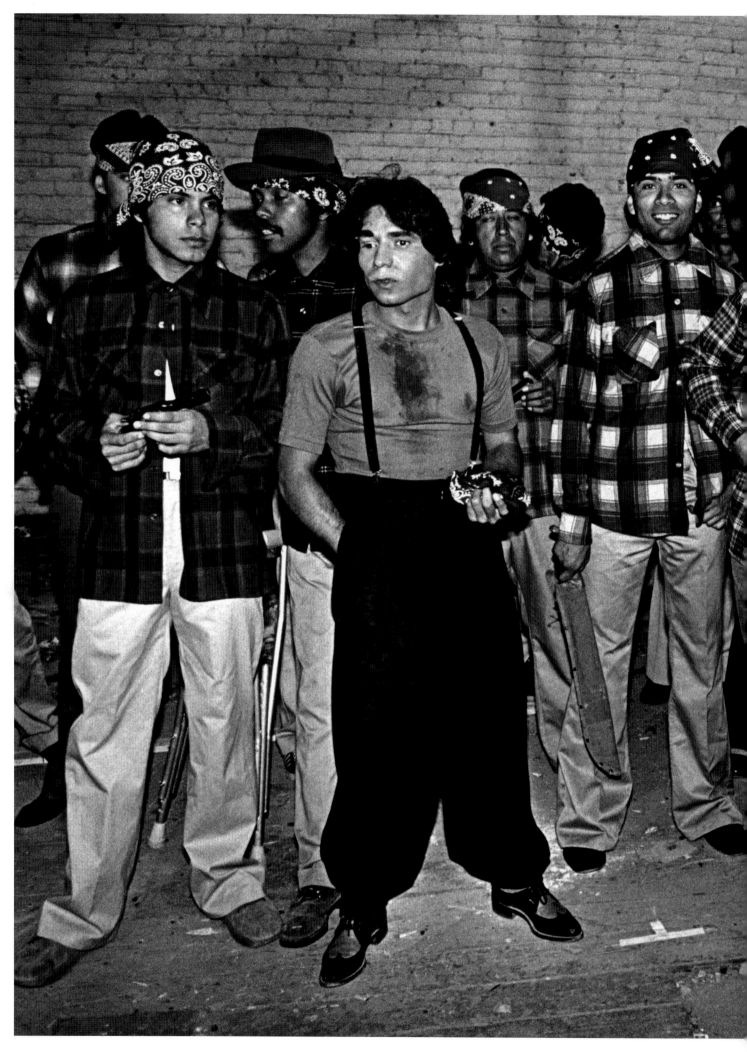

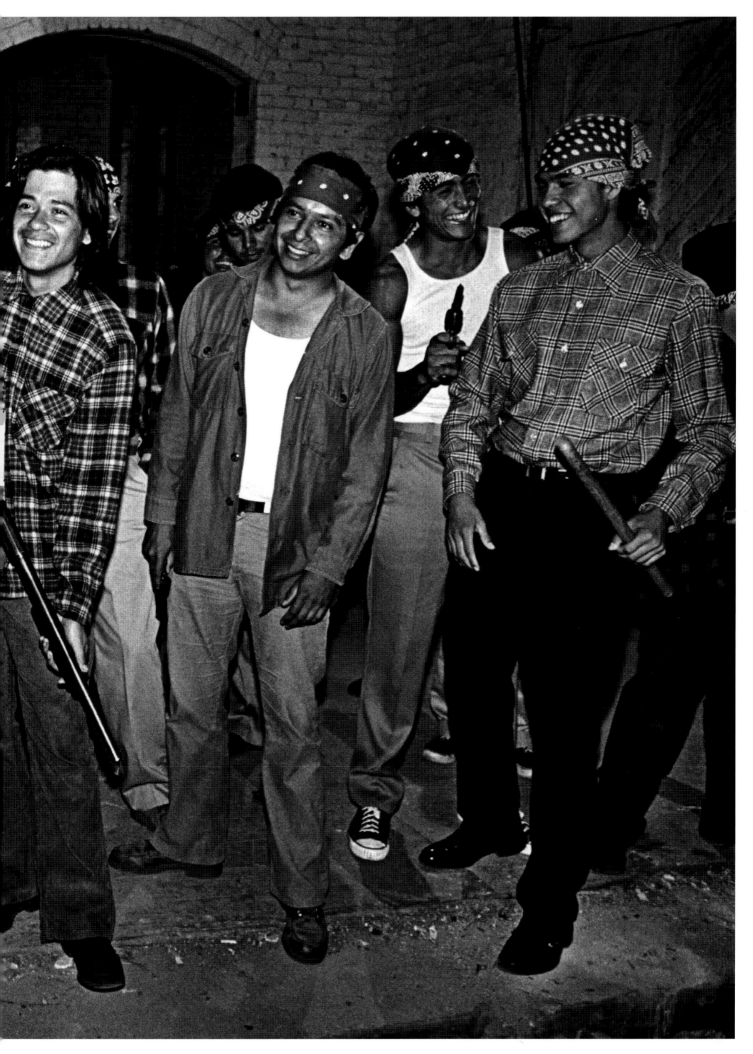

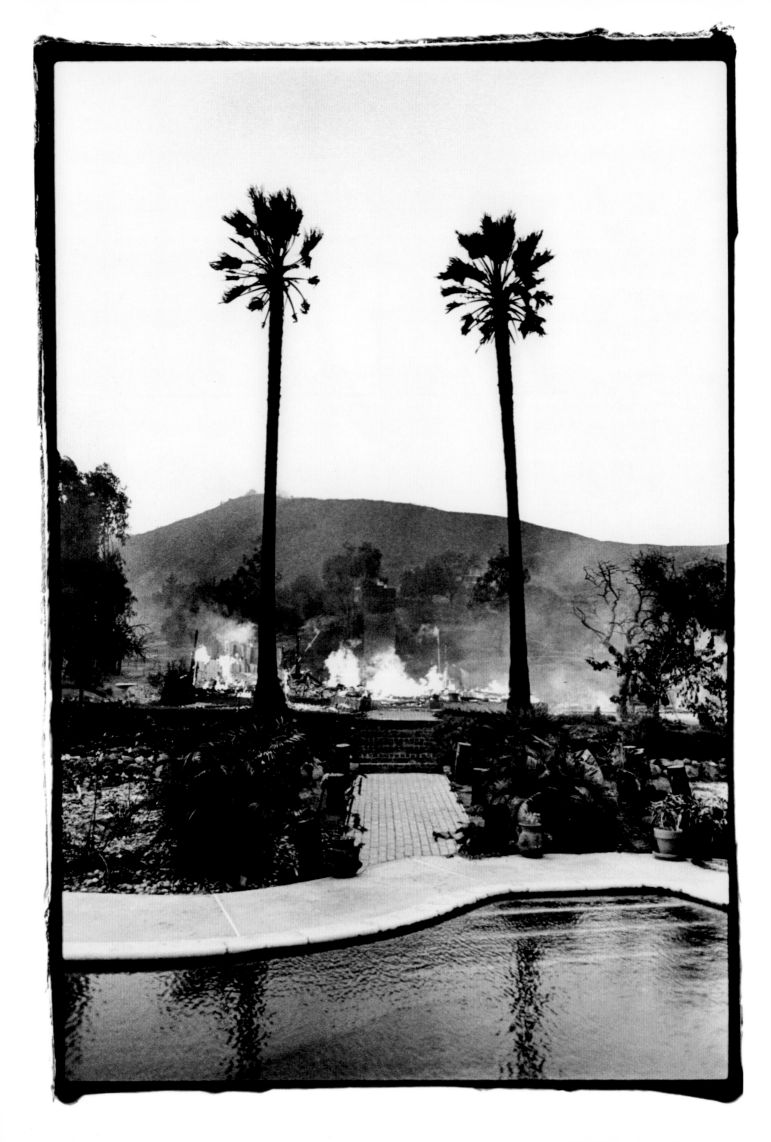

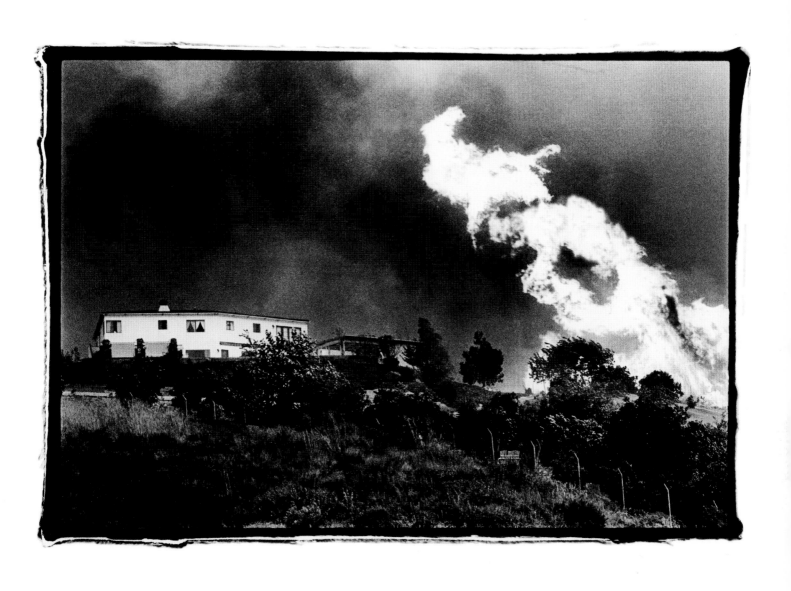

Malibu Fire, Malibu, 1978
Overleaf: Sneak Preview, West Los Angeles, 1978

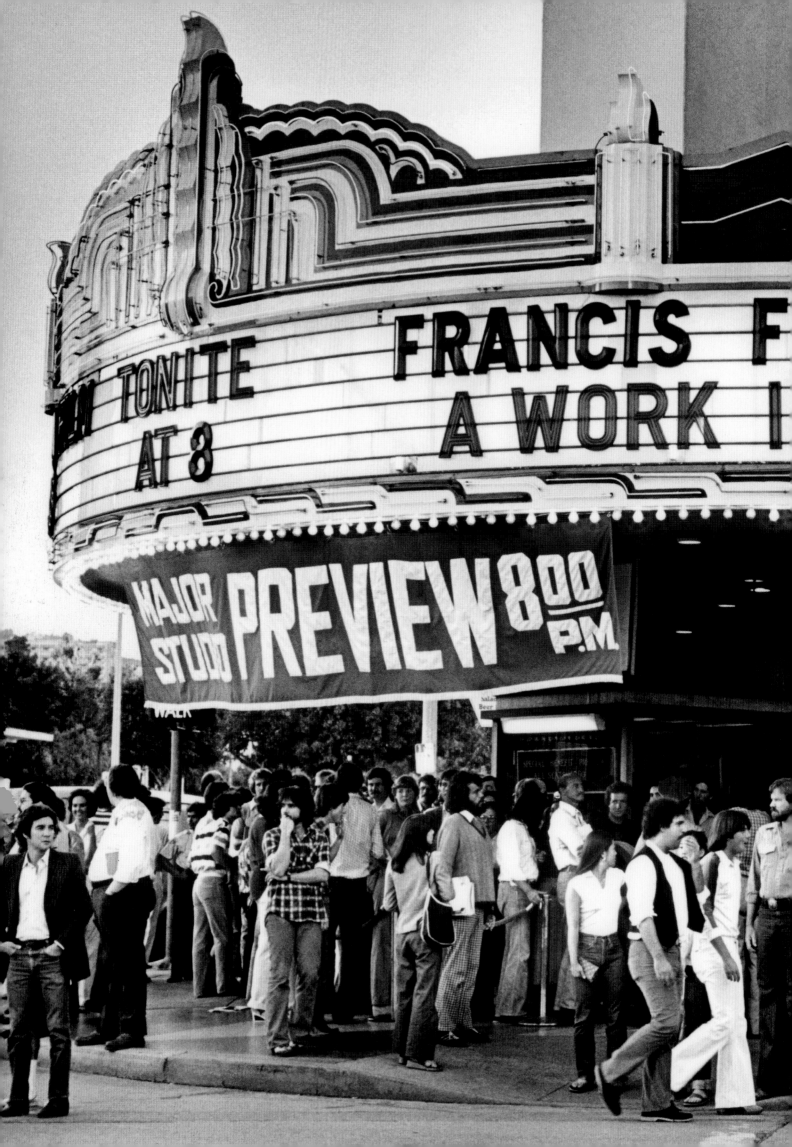

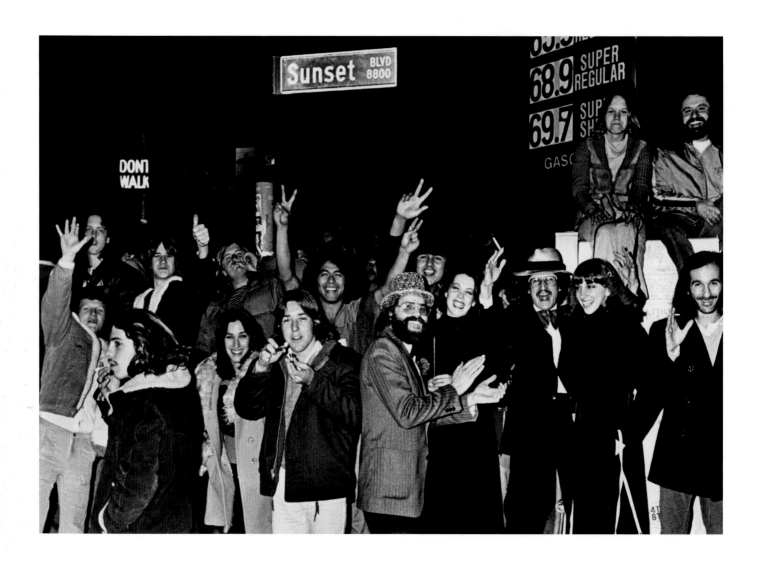

Above: New Year's on Sunset Boulevard, West Hollywood, 1979

Right: Hollywood Moonrise, Hollywood, 1979

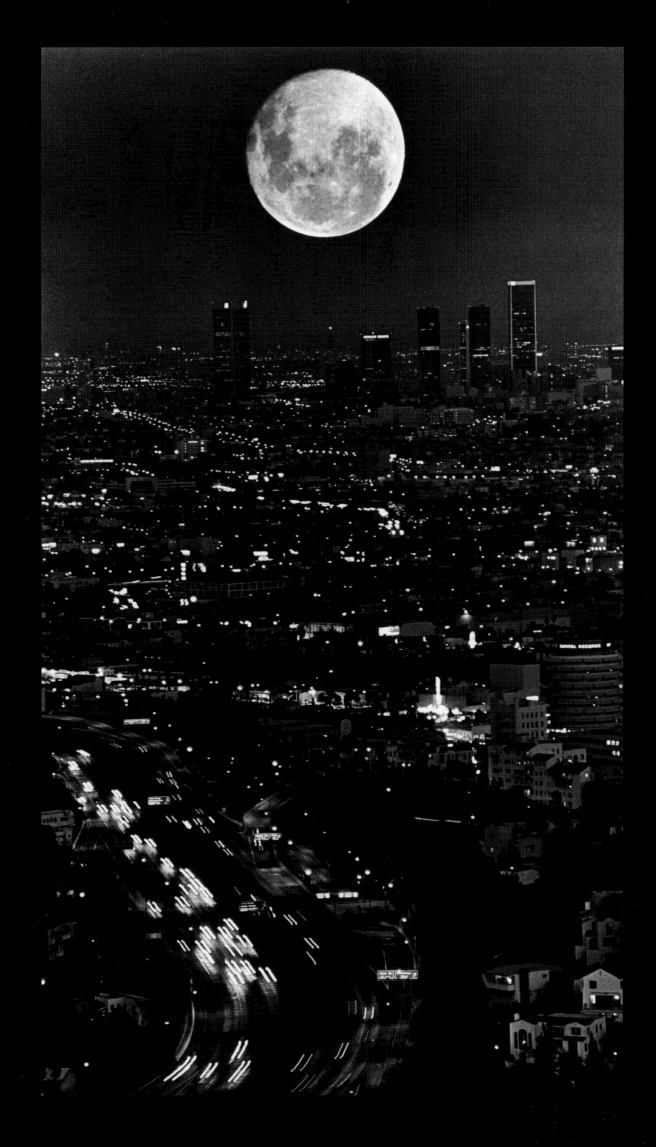

BEHIND THE SCENES

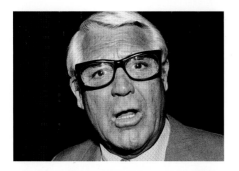

Cary Grant, Beverly Hills, 1980, p. 1
The handsome and elderly Cary Grant appears a bit startled as I move in for a quick, close photo. Grant was attending a private party at the trendy Beverly Hills restaurant Bistro Garden, now the site of Wolfgang Puck's Spago.

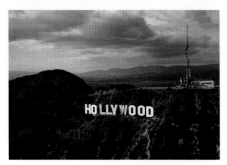

Hollywood Sign, Hollywood Hills, 1983, pp. 2–3
One of Southern California's most recognizable landmarks, the Hollywood sign is perched majestically on a mountain separating Hollywood and the San Fernando Valley.

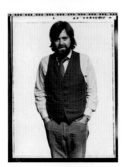

George Rose, Los Angeles, 1980, p. 6
It was fellow *Los Angeles Times* photographer Larry Armstrong who took this picture of me. I was testing out the Richard Avedon white-backdrop look that would ultimately be used for the 1980 Presidential Candidates portrait series and New Los Angeles Bands portrait series.

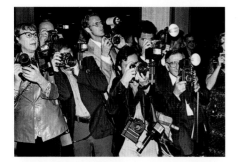

Hollywood Paparazzi, Hollywood, 1973, pp. 12–13
Though I never considered myself one of the street paparazzi, I had to get down and dirty with them on numerous Hollywood nights. Today, most paparazzi are armed with digital video cameras to capture every moment of a celebrity sighting.

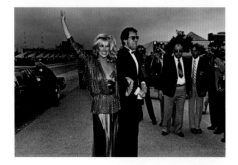

Suzanne Somers, Pasadena, 1978, pp. 14–15
The misunderstood diva of *Three's Company* arrives on the red carpet at the Emmy Awards with her husband and manager, Alan Hamel. In 1978, Somers was at the height of her television career, and she strutted past the Emmy press gauntlet like a proud peacock.

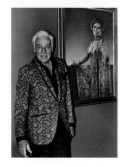

Cesar Romero, Beverly Hills, 1979, p. 16
I knew him as "The Joker" on TV's *Batman*. My parents knew him as the "Latin lover," a character actor starring in dozens of films during the 1930s and 1940s. Romero is shown in the foyer of famed Beverly Hills residence, Pickfair. The painting over Romero's shoulder is of the former owner of the estate, actress Mary Pickford, who was married to Douglas Fairbanks.

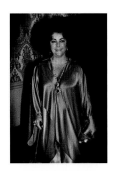

Elizabeth Taylor, Beverly Hills, 1979, p. 17
Walking with the aid of a cane after a recent surgery, the ever-radiant Elizabeth Taylor pops out of the Beverly Hills Hotel kitchen and into the ballroom to attend a holiday fundraising event. Her publicist told me exactly where to stand in order to grab the shot of her entrance.

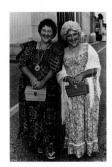

Movie Fans, Hollywood, 1980, p. 18
I bumped into these two rather freaky movie fans on the back lot of Paramount Studios while on my way to photograph Persis Khambatta, one of the stars of *Star Trek: The Movie*. Looking like something out of a Diane Arbus photo shoot, the apparent twins were headed to a taping of one of Paramount's TV shows.

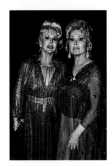

Zsa Zsa and Eva Gabor, Los Angeles, 1979, p. 19
The Paris and Nicky Hilton of their day, the Gabor sisters were quite famous for, well, being famous and for being married to famous people. Minor C-grade actresses, the Gabor sisters attended nearly all of the Beverly Hills parties, the Hollywood premieres, and, when things got slow, celebrity funerals.

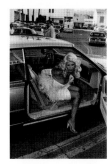

Porn Star Arrives, Hollywood, 1980, p. 20
A buxom starlet arrives on the red carpet at the Adult Entertainment Awards held at the Palladium.

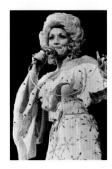

Dolly Parton, Universal City, 1981, p. 21
During the middle of her concert at the Universal Amphitheatre, the endowed country singer actually attempted to hand me the microphone so that I could join her in singing "A Coat of Many Colors." She gave me a wink as I waved her off while kneeling in the orchestra pit.

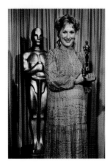

Meryl Streep, Los Angeles, 1983, p. 22
The beautiful and very pregnant actress wins her second Academy Award, for *Sophie's Choice*. She would be nominated many more times in her long and distinguished career.

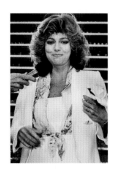

Sally Field, Los Angeles, 1980, p. 23
The actress is seen chatting on the red carpet at the Academy Awards just prior to winning Best Actress for her role in *Norma Rae.*

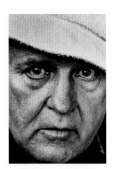

Rod Steiger, Malibu, 1979, p. 24
I photographed Steiger on his back porch overlooking the Pacific Ocean. He is probably best known for his Oscar-winning role in *In the Heat of the Night,* starring opposite Sidney Poitier.

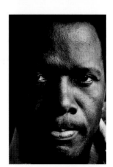

Sidney Poitier, Beverly Hills, 1978, p. 25
Photographed in his Wilshire Boulevard office using light from a nearby window, this stark black-and-white close-up was mangled by poor printing quality when it appeared in the *Los Angeles Times.* Needless to say, I received a note from Poitier's agent chastising me for such a "terrible photo."

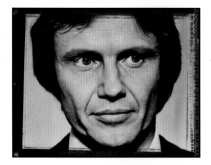

Jon Voight, Los Angeles, 1979, pp. 26–27
The Academy Award–winning actor (and father of Angelina Jolie) greets the press backstage after winning Best Actor for his role in *Coming Home.*

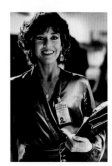

Jane Fonda, Las Vegas, 1978, pp. 28–29
Actress Jane Fonda plays an intrepid reporter who falls for Robert Redford in *The Electric Horseman.* She is seen here adjusting her makeup on set.

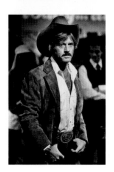

Robert Redford, Las Vegas, 1978, pp.30–32
The rugged movie star, dressed in full cowboy regalia, was in Las Vegas to film *The Electric Horseman* with Jane Fonda and Willie Nelson. In this scene, Redford's disillusioned character decides to take matters into his own hands.

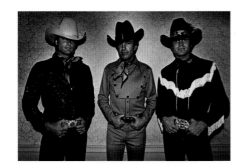

Cowboy Models, Beverly Hills, 1980, p. 33
Three models dressed in their finest urban cowboy gear pose in a hallway just prior to a runway show at the Wilshire Boulevard Saks Fifth Avenue store.

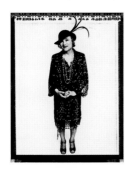

Aida Grey, Beverly Hills, 1980, p. 34
The aging beauty expert and owner of the Paris, New York, and Beverly Hills Aida Grey spas, appears in her finest, or what can only be described as a throwback to the flapper era.

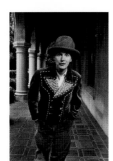

Malcolm McLaren, West Hollywood, 1981, p. 35
Creator and manager of such musical acts as the Sex Pistols and Bow Wow Wow, McLaren was a fashion designer early in his career and was briefly married to Vivienne Westwood. This portrait was taken in the colonnade of Chateau Marmont.

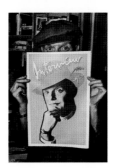

Truman Capote, New York, 1980, p. 36
The famed writer of *In Cold Blood* was quite playful and coy during an hour-long photo shoot in his Upper East Side New York apartment. Here, he holds up a cover of *Interview* magazine featuring his likeness. He appeared to live alone and was surrounded by piles of books, newspapers, art, and a great view of the East River.

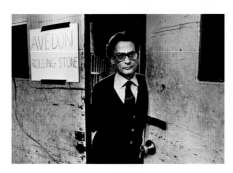

Richard Avedon, New York, 1976, p. 37
I found the famed photographer in a makeshift studio within the depths of Madison Square Garden, where he and his staff were shooting portraits of celebrities and politicians brought in off the floor of the Democratic National Convention. Shot on an eight-by-ten-inch view camera, these portraits became part of his Power in America series, which was later published in *Rolling Stone* magazine.

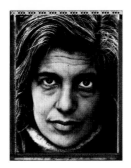

Susan Sontag, Beverly Hills, 1979, p. 38
Philosopher, writer, and friend of photographers, Susan Sontag posed for this one-minute portrait in the lobby of the Beverly Hills Hotel.

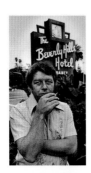

Pete Hamill, Beverly Hills, 1979, p. 39
The Beverly Hills Hotel was apparently the must-stay place for New York literati when visiting the West Coast. Here, the famed New York journalist and editor Pete Hamill appears for a picture outside the hotel's Sunset Boulevard entrance.

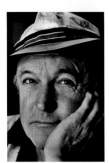

Gene Kelly, Beverly Hills, 1979, p. 40
An aging Gene Kelly poses at his Beverly Hills home. Always seen with a toupee in public, the elderly dancer, actor, director, and producer is shown here in his house wearing just a golf hat.

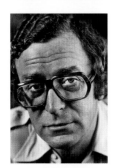

Michael Caine, Beverly Hills, 1982, p. 41
I photographed the British-born actor in his Beverly Hills home. He had recently completed the filming of *Deathtrap*, with Christopher Reeve.

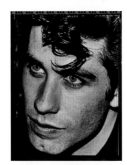

John Travolta, Hollywood, 1978, p. 42
Actor Travolta sports a 1950s hairstyle for the premiere of his film *Grease*. Here, he is captured close-up at the after-party, where the gym at Hollywood High was made over to look like the fictitious Rydell High School.

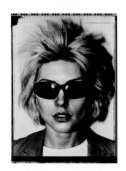

Deborah Harry, Century City, 1980, p. 43
The lead singer of the rock group Blondie poses Warhol-esque against a hallway wall outside her Century City agent's office. Harry was riding the new wave music success that catapulted her to the top of the music charts and into many fashion magazines.

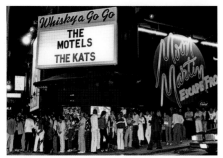

Outside the Whisky a Go Go, West Hollywood, 1979, pp. 44–45
The Whisky a Go Go has been, and will always be, ground zero for new music. The Sunset Boulevard nightclub—which always seems to be as interesting outside as it is inside—is host on this night to two new acts, the Motels and the Kats. The Motels went on to score a huge hit with "Only the Lonely."

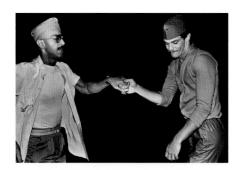

Disco Dancers, West Hollywood, 1978, p. 46
Two guys dressed in their finest military garb tear up the dance floor at the famed West Hollywood gay nightclub Circus Disco.

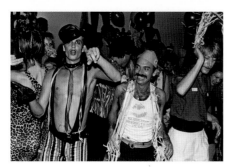

New Year's Party, West Hollywood, 1979, p. 47
Revelers dance to a loud, hypnotic beat at a wild New Year's Eve party at the gay nightclub Circus Disco in West Hollywood.

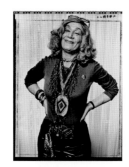

Sylvia Miles, Beverly Hills, 1980, p. 48
Veteran actress Sylvia Miles, who was nominated for an Academy Award for her brief role in the 1969 film *Midnight Cowboy*, poses proudly in her Beverly Hills Hotel room.

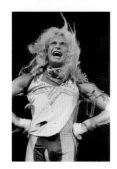

David Lee Roth, Inglewood, 1980, p. 49
The lead singer of the rock group Van Halen (who appears to have padded his package) salutes the audience while on stage at the Fabulous Forum.

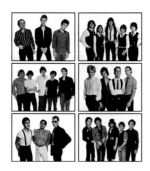

New Los Angeles Bands, Los Angeles, 1980, p. 50
This grouping of images is part of a series of portraits of new musical bands on the LA scene shot over the course of a year. Here on display are (clockwise from the upper left) Code Blue, the Heaters, the Screamers, the Motels, the Plugz, and the Last.

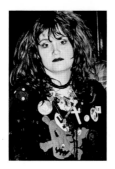

Exene Cervenka, Los Angeles, 1979, p. 51
Lead singer of the eclectic punk rock band X, Cervenka is shown in contemporary late-seventies punk fashion while attending, of all things, a punk rock festival at the Elks Club near downtown. Though X never had a mainstream hit, the band was considered one of the most influential groups on the LA music scene at the time.

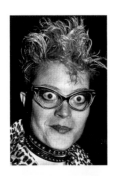

Punk Music Fan, Los Angeles, 1979, p. 52

Someone thought the person in this picture was the art director of *California* magazine. I honestly don't know who the person is, but I do know that it is one of my most popular prints, prized by collectors of fine art photography. The image pretty much sums up the entire history of the punk movement in America—the shocking imagery over the sociological substance.

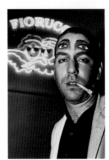

Lloyd Ziff, Beverly Hills, 1979, p. 53

The innovative art director at *New West* magazine sports an extra pair of eyes while attending the opening of a Fiorucci store in Beverly Hills. *New West* magazine, a supplement to the *Los Angeles Times* Sunday newspaper, was the model for future glossy "city" magazines, and Lloyd Ziff was its creative lightning rod.

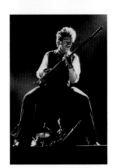

Bruce Springsteen, Bloomington, Minnesota, 1978, p. 54

Following his hyped covers on *Time* and *Newsweek* magazines, the up-and-coming rock-and-roll star seemed to feel the need to prove himself at virtually every concert he performed. Most of the dozen or so Springsteen concerts I attended were a minimum of three hours long.

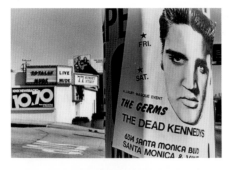

Punk Show Flyer, West Hollywood, 1979, p. 55

A poster on a Sunset Boulevard street pole heralds the arrival of the Dead Kennedys and the Germs, two of LA's hottest and most notorious punk bands. Though the Dead Kennedys were a product of San Francisco, the band spent considerable time touring around Southern California.

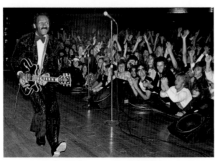

Chuck Berry, Hollywood, 1980, pp. 56–57

The rock-and-roll legend performs his trademark "duck walk" across the stage in front of an adoring Palladium crowd. Even in 1980, Berry still hit all the notes, and he wound up having something of a renaissance during the eighties.

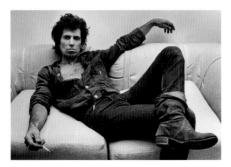

Keith Richards, New York, 1982, p. 58

One of rock's bad boys seems relaxed and devoid of pretense in this image. During a twenty-minute photo session at his record company's office, Richards was a complete gentleman, in his quirky way.

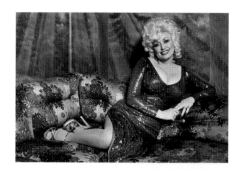

Dolly Parton, Lake Tahoe, 1980, p. 59
Photographed in her Harrah's Lake Tahoe backstage dressing room, the delightfully bubbly (and tiny) Dolly Parton almost seems like a caricature of herself, flashing her spectacular bosom, great legs, and stacked hair.

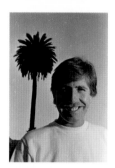

Graham Nash, Los Angeles, 1982, p. 60
The former singer for the Hollies and bandmate of supergroup Crosby, Stills, Nash, and Young, Nash stands under a palm tree outside his Los Angeles home. In an interesting bit of trivia, Nash had become one of the country's top collectors of fine art photography during the seventies and eighties.

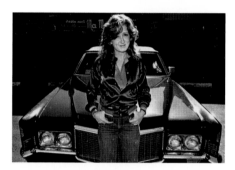

Bonnie Raitt, Los Angeles, 1980, p. 61
The daughter of Broadway star John Raitt was about to hit it big as a singer in her own right. I managed to grab a shot of her outside of the original Ma Maison restaurant on Melrose Avenue.

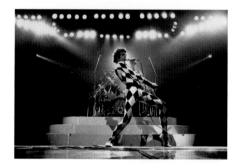

Freddie Mercury, Inglewood, 1978, p. 62
Dressed in a checkerboard jumpsuit, the lead singer of Queen rips through a set of hit songs, including the sports anthems "We Will Rock You" and "We Are the Champions." The ultimate arena-rock band, Queen was in the middle of their worldwide Jazz album tour.

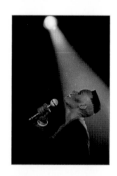

Grace Jones, New York, 1981, p. 63
Jones was perhaps the most cinematic of all the performers I photographed. Her music—a mix of disco, rap, and reggae—was sung live to a prerecorded soundtrack, allowing her to focus on the more theatrical aspects of her performance.

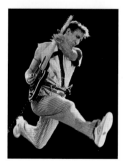

Pete Townshend, New York, 1982, pp. 64–65
Billed as a farewell concert, this performance by the Who at New York's Shea Stadium featured the Clash as the opening act. Townshend left no doubt that he was still the reigning king of guitarist stage showmanship.

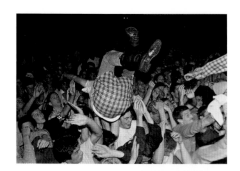

Mosh Pit, Reseda, 1982, pp. 66–67

An exuberant punk rock fan stage dives into the crowd during a Fear concert at the Country Club, a popular rock venue in the San Fernando Valley. Attending a Fear concert was like watching a controlled riot on stage, with crazed fans trying to attack lead singer Lee Ving.

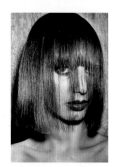

Disco Hairstyle, Beverly Hills, 1979, p. 68

A model displays the latest in disco hairstyles at a fashion show in Beverly Hills. A year later, the very same model showed me the latest in disco spandex pants.

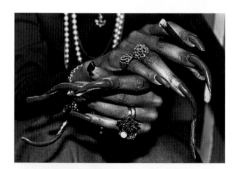

Fingernails, West Hollywood, 1979, p. 69

A woman attending the Soul Train Awards is quite proud of her bizarre fingernails. I don't suppose she can type eighty words per minute, but she held her own at one of the coolest parties of the year.

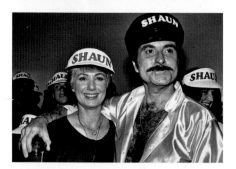

Shirley Jones and Marty Ingels, Anaheim, 1980, p. 70

Former member of TV's *Partridge Family*, Shirley Jones and her husband, comedian Marty Ingels, pose together at a Shaun Cassidy concert in Anaheim, California. Shaun Cassidy, son of Jones and actor Jack Cassidy, had risen to the heights of teen idol stardom, posing for covers for *Tiger Beat* magazine and singing gigs around the world.

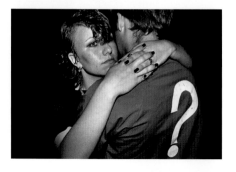

High School Sweethearts, Hollywood, 1979, p. 71

Two Hollywood high schoolers dance to the music of the Bronski Beat. The photo was taken at the *Grease* after-party.

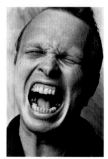

Phil Alvin, West Hollywood, 1982, p. 72

Phil Alvin, of the LA band the Blasters, lets off some steam in a backstage photo shoot at the Whisky a Go Go.

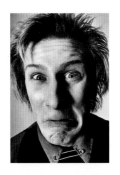

Spazz Attack, Los Angeles, 1980, p. 73
Performance artist Spazz Attack makes a freaky face. The *Los Angeles Times* refused to print the picture because, as one editor told me, it might offend people with disabilities.

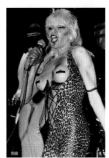

Wendy O. Williams, West Hollywood, 1980, p. 74
Lead singer of the punk rock band the Plasmatics, Wendy O. Williams brings one of her famously controversial performances to the Whisky a Go Go.

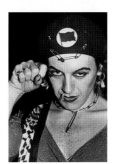

Punk Rock Fan, San Francisco, 1978, p. 75
This punk rock fan, sporting a beret and safety pins galore, was characteristic of the audience attending the Sex Pistols' famous last show at the Winterland Auditorium.

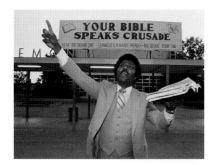

Little Richard, Oakland, 1981, pp. 76–77
With one hand on the Bible and one hand raised to heaven, Rock and Roll Hall of Famer Little Richard gives a dramatic sermon outside an Oakland school. He provided his own blend of Christian pop theatrics, preaching about the evils of cocaine, masturbation, and the loneliness of the road.

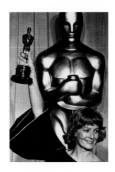

Vanessa Redgrave, Los Angeles, 1979, p. 78
A triumphant Redgrave raises her Academy Award high in the air backstage after winning Best Supporting Actress for her performance opposite Jane Fonda in the film *Julia*. Redgrave had recently been in the political hot seat for her unabashed support of the Palestinians.

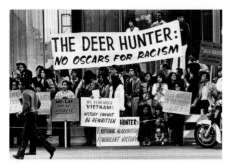

Academy Awards Protest, Los Angeles, 1979, p. 79
The Academy Awards is no stranger to controversy. The protests by Vietnamese and animal rights groups against the film *The Deer Hunter* were loud and raucous outside the Dorothy Chandler Pavilion.

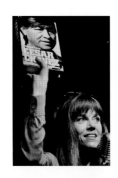

Jane Fonda, New York, 1976, p. 81
Actress Jane Fonda raises a book about civil rights leader Cesar Chavez during one of her many appearances at the 1976 Democratic Convention held at Madison Square Garden.

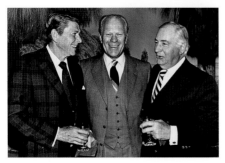

Political Heavyweights, Palm Springs, 1979, p. 82
Future president Ronald Reagan and former president Gerald R. Ford share a couple of laughs with media mogul Walter H. Annenberg at a fundraiser for the Betty Ford Center.

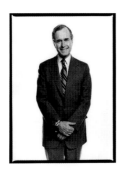

George H. W. Bush, Los Angeles, 1980, p. 83
George Herbert Walker Bush, one of the many candidates for president in 1980, poses for a portrait during his campaign. He would later settle for vice president under Ronald Reagan.

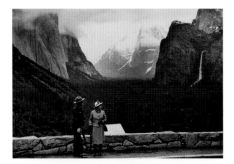

Queen Elizabeth, Yosemite, 1982, pp. 84–85
The Queen visits majestic Yosemite National Park on a rainy winter day. She had been on a tour of California, starting in San Diego and traveling up the coast, with a stop in Santa Barbara to visit President Reagan. Though you can't tell from this photo, behind me at the Yosemite overlook were approximately a hundred media correspondents from all over the world.

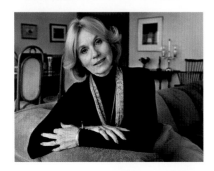

Eva Marie Saint, West Los Angeles, 1979, p. 86
Actress Eva Marie Saint, who won the Academy Award for her role in *On the Waterfront*, sits comfortably in her penthouse apartment.

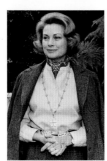

Princess Grace of Monaco, Bel-Air, 1978, p. 87
The Princess of Monaco (formerly known as Grace Kelly) looks serenely regal in the garden at the Bel-Air Hotel.

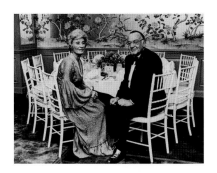

Edmund and Bernice Brown, Beverly Hills, 1979, pp. 88–89
Former governor of California Edmund "Pat" Brown and his wife, Bernice Layne Brown, pose for a photograph in a side room of Jimmy's restaurant during a small fundraiser. The Browns are the parents of Edmund "Jerry" Brown, who was known in certain circles as California's "Governor Moonbeam."

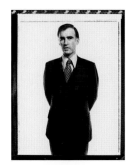

Edmund "Jerry" Brown, Los Angeles, 1980, p. 90
The former governor of California poses in his Wonderland Drive home during his 1980 run for the White House.

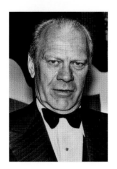

President Gerald R. Ford, Palm Springs, 1979, p. 91
Former president Gerald R. Ford gets a little nervous as I move in for a closer headshot at a Betty Ford Center fundraiser.

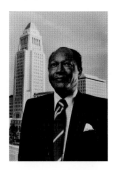

Tom Bradley, Los Angeles, 1980, p. 92
The mayor of Los Angeles poses on the roof of the *Los Angeles Times* with City Hall appropriately behind him.

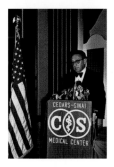

Henry Kissinger, Beverly Hills, 1979, p. 93
The former Nixon administration secretary of state addresses a fundraiser at Cedars-Sinai Medical Center.

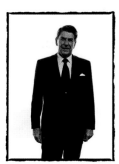

Ronald Reagan, Century City, 1980, p. 94
Presidential candidate and former governor of California Ronald Reagan poses in his Century City office. The affable Reagan enjoyed his ten-minute photo shoot.

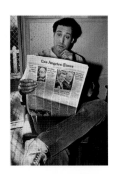

Chevy Chase, West Hollywood, 1981, p. 95
The former *Saturday Night Live* actor takes a break between scenes during the filming of *Under the Rainbow*. The actor was riding a wave of success after his 1980 film *Caddyshack*.

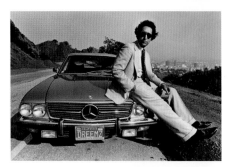

Ben Stein, Hollywood Hills, 1980, pp. 96–97
Later known for his role in *Ferris Bueller's Day Off*, Ben Stein was an accomplished speechwriter for the Nixon administration and a columnist for the *Los Angeles Herald-Examiner*. Here, he's promoting *Dreemz*, his new book about living the Hollywood high life while on copious amounts of quaaludes.

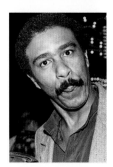

Richard Pryor, Hollywood, 1979, p. 98
The edgy comedian sticks his tongue out at me on the red carpet at the premiere of *Meatballs*.

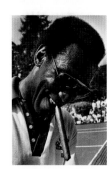

Bill Cosby, Los Angeles, 1978, p. 99
An avid cigar smoker, comedian Bill Cosby takes a break between sets at a charity tennis tournament at the Playboy Mansion.

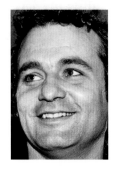

Bill Murray, Hollywood, 1979, pp. 100–101
Another alum of *Saturday Night Live*, Murray mugs for the camera on the red carpet of his film *Meatballs*. The premiere took place on the Paramount Studios back lot.

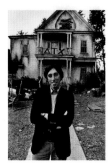

Ivan Reitman, Hollywood, 1978, p. 103
The comedy film producer and director stands in front of the Delta House, featured prominently in his popular film *Animal House*. The stand-in for Faber College in the film was the University of Oregon in Eugene, but a Delta House was constructed on a Hollywood back lot for many scenes.

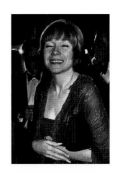

Shirley MacLaine, Century City, 1979, p. 104
The Academy Award–winning actress is all smiles on the red carpet at the premiere of her film *Being There*, in which she costarred with Peter Sellers.

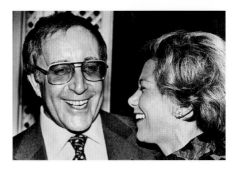

Peter Sellers and Marsha Mason, Beverly Hills, 1979, p. 105
British actor Peter Sellers shares a joke with actress Marsha Mason during a private fundraiser. During this time, Sellers was gaining accolades for his performance in *Being There*, a role that would garner him an Oscar.

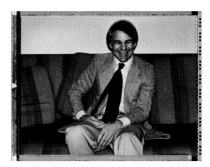

Steve Martin, West Los Angeles, 1978, p. 106
The manic comedian sits backstage at UCLA's Royce Hall in anticipation of accepting the Jack Benny Award for Comedy.

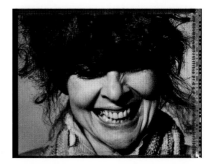

Diane Keaton, Los Angeles, 1978, p. 107
Woody Allen's muse and Warren Beatty's girlfriend, Diane Keaton strikes a capped-tooth grin backstage after winning the Best Actress Academy Award for her role in Allen's 1977 film *Annie Hall*.

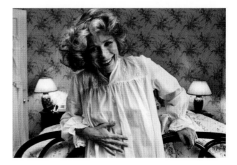

Joan Hackett, Beverly Hills, 1978, p. 108
The wonderful and sexy character actress Joan Hackett lures the unsuspecting photographer into the bedroom for a photo shoot.

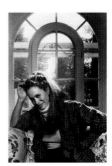

Karen Black, Los Angeles, 1982, p. 109
The prolific film actress, best known for her role opposite Jack Nicholson in *Five Easy Pieces*, poses in her living room.

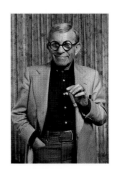

George Burns, Beverly Hills, 1980, p. 110
The elderly comedian, entertainer, and star of the 1977 film *Oh, God!* was at the top of his game when I photographed him, cracking jokes and singing little ditties about young women.

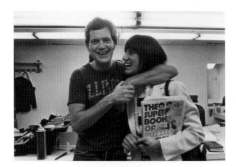

David Letterman and Merrill Markoe, New York, 1982, p. 111
The comedian and his girlfriend play around in the dressing room before a taping of his New York TV show, *Late Night with David Letterman*

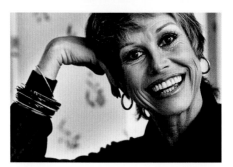

Mary Tyler Moore, Los Angeles, 1979, pp. 112–113
"Why would such a nice young man want to ruin my career," said the voice on the phone. It was Mary Tyler Moore, the day after these pictures appeared in the *Los Angeles Times*. Needless to say, not many people had ever seen TV's Laura Petrie in such unflattering light.

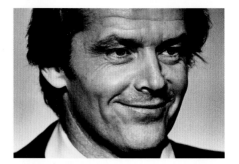

Jack Nicholson, Los Angeles, 1979, pp. 114–115
Nicholson as a presenter appears in raffish character backstage at the Academy Awards. Jack always seemed to have that "cat that swallowed the canary" look about him.

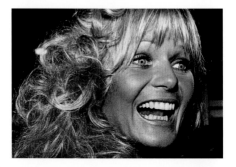

Valerie Perrine, Los Angeles, 1978, p. 116
Perrine became an annual Academy Awards red carpet staple after her Best Actress nomination in the 1974 movie *Lenny*.

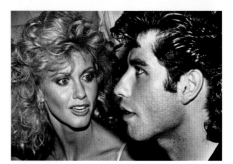

Olivia Newton-John and John Travolta, Los Angeles, 1978, p. 117
The costar of *Grease* looks ravishing as she gives a glance to John Travolta at the movie's premiere after-party.

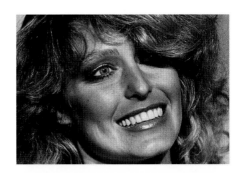

Farrah Fawcett, Los Angeles, 1978, p. 117
The Hollywood "it" girl bares her pearly whites and glistening hair backstage at the Academy Awards.

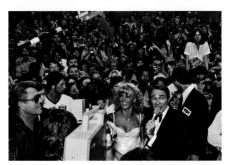

The Premiere of *Grease*, Hollywood, 1978, pp. 118–119
Daily Variety's Army Archerd interviews Olivia Newton-John at the premiere of the film *Grease*. The event was held in the middle of Hollywood Boulevard outside the Grauman's Chinese Theatre. This was the kind of pandemonium that Nathanael West must have had in mind when he wrote his book *The Day of the Locust*.

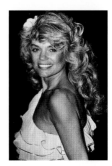

Dyan Cannon, Los Angeles, 1979, p. 120
The ex-wife of Cary Grant and star of the 1969 film *Bob and Carol and Ted and Alice* walks the red carpet at the Academy Awards.

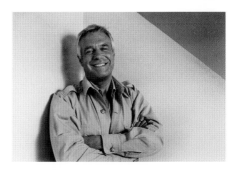

George Peppard, Hollywood, 1980, p. 121
The star of TV's *The A-Team* and Hollywood leading man boasts a tan that puts George Hamilton to shame.

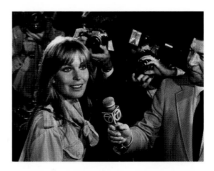

Bo Derek, Los Angeles, 1980, pp. 122–123
Bo Derek mania struck at the heart of Hollywood following her role in the hit film *10*. Here, she faces a barrage of photographers and press.

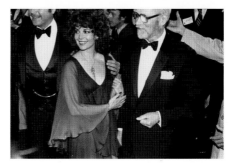

Natalie Wood, Century City, 1979, pp. 124–125
Film actress Natalie Wood is escorted by her husband Robert Wagner (left) and Sir Laurence Olivier (right) to the opening of the film festival Filmex. It was also the premiere of Olivier's film *A Little Romance*. One year later, Wood would drown in an accident off of Catalina Island.

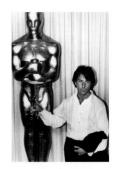

Dustin Hoffman, Los Angeles, 1979, p. 126
The quirky actor clowns around backstage at the Academy Awards, turning his award into a makeshift Oscar penis. Hoffman had just won the Best Actor award for his role in *Kramer vs. Kramer.*

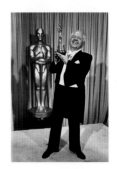

Mickey Rooney, Los Angeles, 1982, p. 127
The child actor finally earns an honorary Academy Award for his years of film work stretching all the way back to 1939. I just wish Judy Garland had been around to see his beaming face that night.

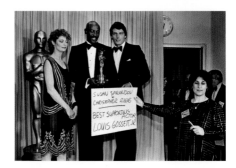

Louis Gossett Jr., Los Angeles, 1983, p. 128
Presenters Christopher Reeve and Susan Sarandon flank Gossett in the "deadline" photo room (a special spot for two or three photographers located just off the stage), following his Academy Award win for Best Supporting Actor.

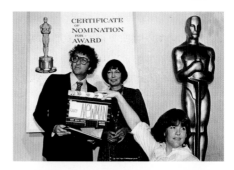

Randy Newman, Beverly Hills, 1981, p. 129
A different kind of Academy Award ceremony takes place in Beverly Hills, usually a week earlier, when all the nominees are "certified" at a luncheon in their honor. Here, 1981 nominee Randy Newman gets his picture taken with the president of the Academy, Fay Kanin.

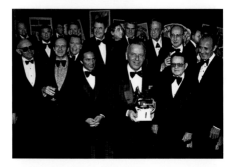

Frank Sinatra and Friends, Las Vegas, 1979, pp. 130–131
Entertainer Frank Sinatra is surrounded by a rogues' gallery of celebrities in a small meeting room in Caesars Palace. The ceremony to honor the crooner for his years of charity fundraising was attended by more than one thousand people. Some of the stars in the photo include Dean Martin, Phil Harris, Red Skelton, and Dina Merrill.

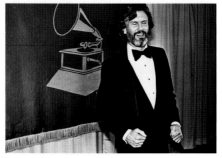

Kris Kristofferson, Los Angeles, 1979, p. 132
The original country-music-outlaw-turned-actor, Kris Kristofferson appears a bit perplexed by all the media attention backstage at the Grammy Awards.

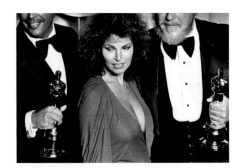

Raquel Welch, Los Angeles, 1980, p. 133
Though I'm not entirely sure why Raquel Welch was invited to be a presenter at the Academy Awards every year, it may have had something to do with her well-endowed presentation skills.

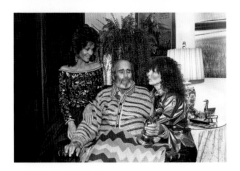

Henry Fonda, Beverly Hills, 1981, pp. 134–135
Henry Fonda won the Academy Award for Best Actor for his role in the movie *On Golden Pond*, but he was too ill to attend the ceremony. His daughter, Jane Fonda, accepted the award on his behalf and later, with his wife, Shirley, presented the award to him back at his home. Only two photographers were allowed to photograph this touching moment—John Bryson of *Life* magazine and myself, representing the *Los Angeles Times*. Henry Fonda died several months later.

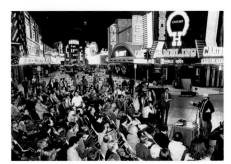

Francis Ford Coppola, Hollywood, 1981, pp. 136–137
Film director Coppola invites the media to the unveiling of his Zoetrope Studios, where he has been busy making *One from the Heart*, which was filmed entirely on a soundstage that had been built up to look like Las Vegas.

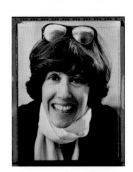

Nora Ephron, Los Angeles, 1976, p. 138
The intelligent writer and filmmaker of such film hits as *When Harry Met Sally* and *Sleepless in Seattle*, Nora Ephron would probably love to purchase the negatives of this photo, given the success of her recent book *I Feel Bad About My Neck*.

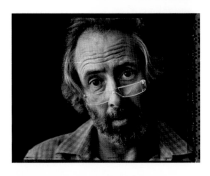

Robert Towne, Beverly Hills, 1981, p. 139
This portrait of Towne, the screenwriter behind such films as *Chinatown* and *Shampoo*, is a classic example of my five-minute, in-home portrait technique.

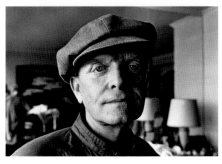

Truman Capote, New York, 1980, p. 140
Shown earlier on page 36, Capote was a charming host, allowing me to roam freely and quickly through his Upper East Side apartment.

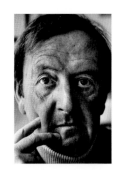

Brian Moore, Malibu, 1979, p. 141
Irish-American novelist Moore proved to be an intense subject. This photograph was taken at his beachfront home in about ten minutes.

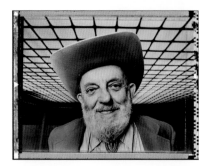

Ansel Adams, Los Angeles, 1981, p. 142
Adams was one of my photography heroes. I actually had the opportunity to participate in several of his Yosemite and Carmel workshops. I adapted his large-format landscape style using his perfected Zone System for 35mm Tri-X film. Most of the images in this book were made using a modified version of the Zone System of overexposing film, and then underdeveloping it to reveal more tonal quality.

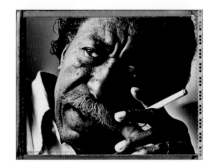

Gordon Parks, Beverly Hills, 1981. p. 143
Life magazine photographer, film director, novelist, and musician—this is exactly the kind of Renaissance man I aspired to be. I captured this shot of Parks in his hotel room in exactly two minutes. We then spent the remaining fifty-eight minutes of the shoot talking about photography.

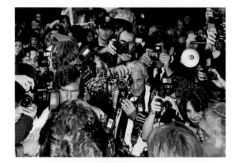

Hollywood Paparazzi, Hollywood, 1979, pp. 144–145
I never tire of watching a pack of Hollywood paparazzi pounce upon their prey. On occasion, I felt the need to behave just like them. Though the style of cameras has changed over the years, the predatory behavior has not.

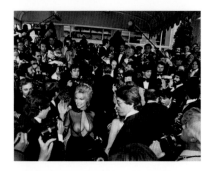

Bobbie Bresee, Cannes, France, 1980, pp. 146–147
International B-movie starlet Bobbie Bresee sets hearts aflutter during her appearance on the red carpet at the Cannes Film Festival. It's no wonder why her every move up the stairs and into the film Palais was well documented.

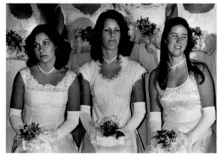

Debutante Ball, San Marino, 1978, p. 148
Three young girls, products of the wealthy and secluded Pasadena enclave known as San Marino, appear to be having a difficult time at their coming-out party held at the Huntington Hotel.

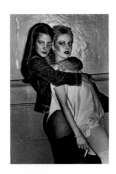

Punk Girls, Los Angeles, 1979, p. 149
Young punk girls attend the first annual Punk Festival at the Los Angeles Elks Club on Wilshire Boulevard.

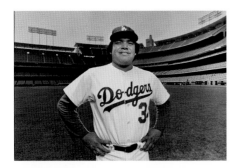

Steve Howe, Los Angeles, 1981, pp. 150–151
One of the most talented young rookies ever to hit the National League and a Cy Young Award winner, Steve Howe was pitching the best games of his life while addicted to cocaine.

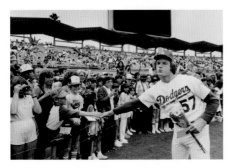

Tommy Lasorda, Los Angeles, 1980, p. 152
The man who claimed that he "bleeds Dodger blue," Tommy Lasorda was the glue that held the great LA baseball team together for more than fifty years. Here, he is photographed high above home base at Dodger Stadium for the twenty-fifth anniversary of the Dodgers' move from Brooklyn to Los Angeles.

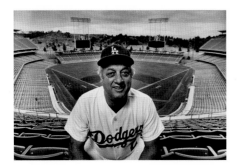

Fernando Valenzuela, Los Angeles, 1980, p. 153
I photographed the Dodger pitching sensation in the outfield for the twenty-fifth anniversary promotion. The savvy Dodger organization rode Fernando-mania all the way to the bank.

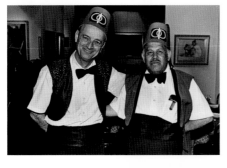

Waiters at Chasen's Restaurant, Beverly Hills, 1979, p. 154
Two Chasen's restaurant waiters pose together in full regalia. The famous steakhouse was a hangout for many celebrities, and it was said to be Ronald and Nancy Reagan's favorite place to dine.

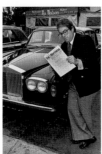

Allan Carr, Los Angeles, 1980, p. 155
Flamboyant film producer Allan Carr reads a copy of *Daily Variety* while leaning against his Rolls Royce parked outside the trendy eatery Ma Maison. Carr produced such hits as *Grease* and *Can't Stop the Music*.

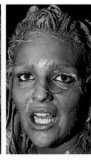

Female Mud Wrestling, Hollywood, 1980, p. 156
Mud wrestling became the rage at a number of Hollywood clubs and bars in the early 1980s. The women were usually strippers pressed into becoming wrestlers by the club managers.

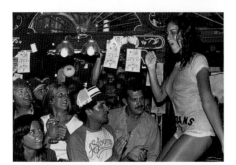

Wet T-Shirt Contest, Hollywood, 1979, p. 157
A fad that continues to this day in Hollywood, wet t-shirt contests prove only one thing: men will pay to see women get semi-naked.

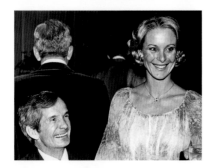

Willie and Cynthia Shoemaker, Los Angeles, 1979, pp. 158–159
Willie Shoemaker was the winner of eleven Triple Crown horse races and one of the leading thoroughbred jockeys in the world. Here, the four-foot-eleven-inch-tall "Shoe" is seen standing next to his six-foot-tall wife at a Breeder's Cup cocktail party.

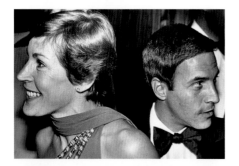

Helen Reddy and Jeff Wald, Los Angeles, 1979, p. 160
Record producer Jeff Wald and his wife, Australian pop singer Helen Reddy, appear together at the Grammy Awards. They were about to separate in an ugly divorce when this photo was taken.

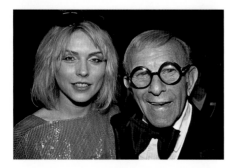

Deborah Harry and George Burns, Los Angeles, 1980, p. 161
Deborah Harry and George Burns had to be one of the oddest couples ever to attend the Grammy Awards.

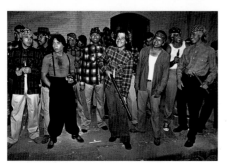

Gangs, Culver City, 1979
What may look like a Los Angeles street gang is actually a group of actors playing a scene on the set of the film *Gangs*.

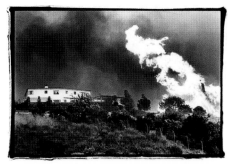

Malibu Fire, Malibu, 1978, pp. 164–165
Driving straight into the 1978 Malibu fire was perhaps one of the most stupidly courageous acts of my life. I found myself trapped inside the fire line, as the fast-moving brush fire destroyed hundreds of homes in its path. The only way I could get the film back to the newspaper in time for the 10 p.m. deadline was to have the *Los Angeles Times* helicopter, which had been circling above, land nearby at Will Rogers State Beach. My images made the next morning's paper, including the photo on page 165, which was prominently featured on the front page.

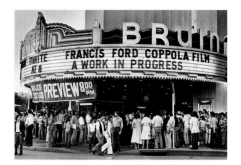

Sneak Preview, West Los Angeles, 1978, pp. 166–167
Moviegoers wait to sneak a peak at Francis Ford Coppola's long-awaited film *Apocalypse Now* at the Bruin Theater in Westwood. I don't remember which ending Coppola used at the preview, but I do remember being deeply moved by the film and thinking it may top *Citizen Kane* as one of my all-time favorite films.

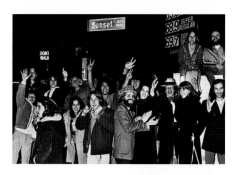

New Year's on Sunset Boulevard, West Hollywood, 1979, p. 168
Revelers on the Sunset Strip, across from the Whisky a Go Go, get wild and crazy on New Year's Eve.

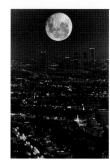

Hollywood Moonrise, Hollywood, 1979, p. 169
This is a fanciful composite of two images, one of Hollywood and Los Angeles, and the other, a full moon shot with a 600mm telephoto lens. I remember taking the picture of the cityscape with Bob Seger's anthem "Hollywood Nights" blasting on my car stereo. It is a view from the Hollywood Hills that is breathtaking day or night.

ACKNOWLEDGMENTS

Most of the images in this book were taken while in the employment of the *Los Angeles Times*. The remaining photos were taken as a freelancer working the Hollywood "night shift" in my off hours. All of the images were shot on Tri-X film loaded into Canon F-1 35mm or Mamiya 645mm cameras.

I'd like to thank Patrick Goldstein for his thoughtful words in the foreword, and Simon Elliott and the UCLA Library Department of Special Collections for giving me permission to use *Los Angeles Times* photos. I'd also like to thank Jennifer Barry for her contribution to the book design and for her determination to see this project through to publication. Also, special thanks go to Aaron Wehner, Brie Mazurek, and all the folks at Ten Speed Press; you have been a delight to work with.

Kudos goes to Pete Carucci, who has painstakingly spent the last eight years digitizing this collection of photos. Each digital file was recreated from original vintage print.

To my wife, Denise, thanks for your understanding and support of this project, for which numerous personal donations were made from the George and Denise Rose Fund for striving artists.

Thanks also go to Rick Meyer and Larry Armstrong, two of the best darkroom homies a young, wild, and crazy photographer could ever have. The collaborative process is an important ingredient in making quality images. (And by the way, Rick, I didn't mean to throw the scissors.)

And to all the editors and other photographers at the *Times* who put up with my youthful antics, I'll just say: it all worked out. My time spent on the streets of Los Angeles, Hollywood, and Beverly Hills was intense, prolific, and well worth the effort.

We'll never have those days back again, so let's just cherish the memories in photos.